Cigar Box Labels

Portraits of Life, Mirrors of History

Gerard S. Petrone

4880 Lower Valley Rd. Atglen, PA 19310 USA

Library of Congress Cataloging-in-Publication Data

Petrone, Gerard S.
Cigar box labels : portraits of life, mirrors of history / Gerard S. Petrone.
p. cm.
ISBN 0-7643-0409-7 (hardcover)
1. Cigar box labels--United States--History. 2. Cigar box labels--United
States--Catalogs. I. Title
NC1883.6.U6P48 1998 97-29084
741.6'92'0973--dc21 CIP

Layout by Bonnie M. Hensley

ISBN: 0-7643-0409-7
Printed in Hong Kong
1 2 3 4

Published by Schiffer Publishing Ltd.
4880 Lower Valley Road
Atglen, PA 19310
Phone: (610) 593-1777; Fax: (610) 593-2002
E-mail: schifferbk@aol.com
Please write for a free catalog.
This book may be purchased from the publisher.
Please include $3.95 for shipping.
Try your bookstore first.

We are interested in hearing from authors
with book ideas on related subjects.

————I dedicate this book to Moonbeam, the————
rather noisy pocket parrot who sat on my
shoulder during moments of writing and offered
bits of advice, none of which I found useful.

Acknowledgments

Few books are put together without the help of others; this one is no exception. I am extremely grateful and indebted beyond words to the following Californians who allowed me the privilege of browsing through and photographing their priceless collections: Si Bass of Oceanside, Sid Emerson and Ken Nichols, both of Escondido, and Chuck Kovacic of Panorama City.
I also want to thank Wayne Dunn of Mission Viejo and Ed Barnes of Lake Forest as well as Pennsylvania label dealers Jerry Striker of Lancaster and Dave Freiberg ("Cerebro") of East Prospect for their valuable information.

Table of Contents

"There are two things a man seldom forgets— his first love and his first smoke."

—Anonymous

Introduction

Once upon a time in America, cigar box labels played a vitally important role in the selling of cigars. It was in an era of horse-drawn streetcars, high-bustled dresses, and dime museums, and a time when men, some not able to read, depended upon the recognition of a paper image to guide them to their favorite box of cigars.

Cigar box labels first appeared in the United States in the late 1850s. Their need arose for the simple reason that wooden boxes holding cigars were coming into vogue in East Coast tobacco shops. The labels were utilized by early manufacturers to decorate the boxes and to identify their contents, namely, private brands of cigars. Originally costly to make and put to limited use, cigar box labels soon ushered in an age of specialized tobacco advertising and product identification that would last for decades.

It was the development and perfection of color printing processes (chromolithography) in the 1870s that improved the quality of cigar box labels. Later, assembly-line printing methods drove the unit cost of labels down to such a low figure that they were placed within easy reach of the most frugal of cigar manufacturers.

By the turn of the century, the brightly colored and richly gilded labels adorning boxes of cigars had turned into an exquisite art form that helped fuel the soaring public demand for cigars which, by the 1890s, reached mammoth proportions.

The strategy behind the use of cigar box labels was fundamentally simple—to sell cigars. As such, the labels were carefully and purposefully designed to capture the attention of men by offering a wide variety of visual images that were associated with a brand name, the very heart and soul of advertising.

As a result, subjects which the average American male held dearest to his heart were transformed into irresistible portraits which were then plastered all over the outside and inside of the cigar box. A few cigar manufacturers and label makers went the extra step by generating brand names and accompanying graphics that projected the joys and pleasures·of smoking their products, again through the power of imagery and suggestion.

But cigar box labels turned out to be far more than just pretty art rendered on paper. Not unlike the prints of Currier & Ives, cigar box labels happened to form a valuable and permanent record of down-home Victorian life in America, comprising, if you will, a decades-long social scrapbook.

The neatly designed and beautifully illustrated scraps of paper recorded symbols of national pride, economic prosperity, occupations, humor and amusements, nostalgia, war, and even social prejudices, as well as paying homage to a long list of famous men and women. They also chronicled important technological achievements and inventions such as the bicycle, automobile, and airplane that impacted and shaped the lives of the average American citizen.

It was a small thing, but cigar box labels also recorded changing patterns of contemporary speech. Cigar makers and lithographic artists, in their relentless search for fresh themes, often drew upon everyday language and expressions (especially slang) to formulate new brand names.

As a result, antiquated colloquialisms such as "hot wave," "dandies," "dudes," "too too", and "jolly girl" became forever etched in history as Victorian cigar brands and, at the same time, provided etymologists and name fanciers with a solid base of reference. Along the same vein, many of these commonplace expressions survived the years and are still used today—or variations of them—while others, fads for a while, fell by the wayside, never to be heard again.

Cigar box labels, produced in prolific numbers, left behind a rich legacy due to an unusual set of circumstances. Never before (or since) in the history of American business has a commercial product been made available to the public under so many different brand names as the cigar. An estimated three million brands were generated between 1880 and 1920, and this does not include tens of thousands more that were thought up and registered, but never used.

Official records of the U. S. Patent Office in Washington, D. C., beginning in the 1880s, overflow with cigar brand copyrights. These lists, of course, do not include the countless brands used by small-time operators that were never legally protected.

The following pages contain representative cigar box labels of the 1860–1910 era along with bits of cigar lore and lithographic history. Also included are anecdotes, short stories, and a few poems extracted from contemporary literature to add flavor of the times to the subject. Apologies are made in advance for omitting favorite labels or themes; the field is much too broad to be covered in a single book.

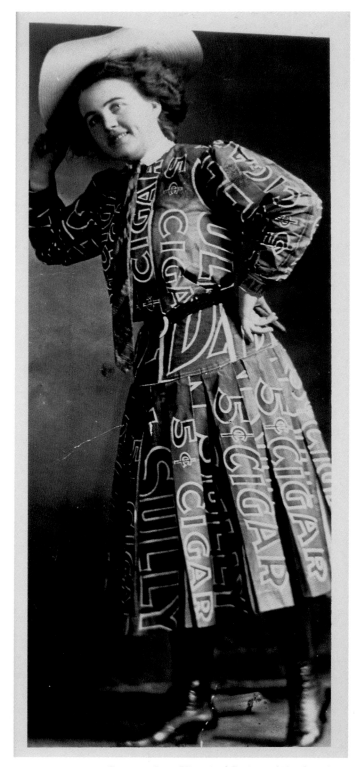

—*Courtesy State Historical Society of North Dakota*

Getting Started: America's First Cigar Box Labels (1857-1880)

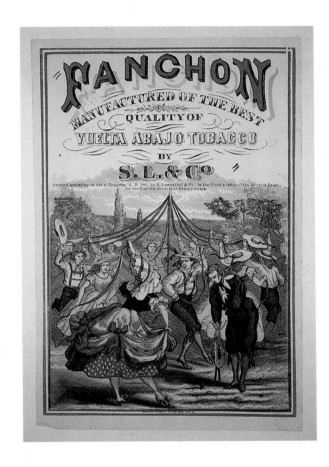

The Universal Cigar

YAWCOB STRAUSS

Aboriginal Indian tribes were the first to make cigars, long before the white man first set foot in the New World. Natives of Borneo, for example, smoked a black roll of tobacco, three inches long and tapered at both ends. The outer leaf was covered with a network of gray veins, like a cobweb, and was known in the vernacular as "dude killers."

They were smoked by the old Dyaks, who inhaled the smoke to intoxication. At weddings, the bride and groom held cigars in their hands and after their heads were knocked together three times, each placed the cigars between the lips of the other, completing the ceremony.

The Ahts of Vancouver Island originated a rough, dark cigar rolled in the husk of a plant. It deserves mention because it was smoked in the most bizarre cigar holder ever made. It was carved out of solid stone, ran about eight inches in length, and was covered with carved figures of men in canoes and images of fish, game, and the like. The holder was held upright. It was hollow with closed ends, but two holes were made in it, one on the bottom for inserting the cigar and the other on top for the mouth.

The chief lighted the cigar and, drawing at the upper hole, filled the tube with smoke. The mouth orifice was closed, the cigar withdrawn, and a plug fitted into its hole. The next smoker received the tube and filled his lungs from the top hole and passed the holder on to the next until no more smoke remained in the tube. Then the chief inserted the cigar, refilled the tube with smoke, and the ritual was repeated.

Columbus, on his voyages to the New World in the late fifteenth century, was the first white man to observe native Indians of the West Indies and Central America smoking rolled-up leaves of an indigenous plant.

The "modern" cigar of civilized society began in Spain. The first cigars made by the Spaniards were loosely rolled tobacco leaves held together by corn silk. A straw, running through the center of the cigar, was pulled out before smoking in order to ensure a good draw. These rudimentary smoking models were introduced in England in 1778 by the son of a Spanish grandee who was visiting London. From there, the style of the cigar spread throughout Europe.

By the dawn of the twentieth century, cigars, depending on the country in which they evolved, took on different characteristics and developed national reputations that varied widely. Egypt, for instance, was represented by a heavy black cigar, shaped like a barrel and not quite three inches long. It looked strong enough to draw a load of wood and the thick, white veins on the wrapper looked like pieces of string rolled around it.

Russians smoked simple, long rolls of evil-smelling tobacco that were favored by the "moujiks," or peasants.

Switzerland grew considerable tobacco and her cigars were long, straight, and black, dear to the memory of every English lad on holiday who learned to smoke them before the advent of cigarettes.

The cigars of Germany were notoriously bad. From those smoked by the emperor all the way down to the farmers, they were generally the vilest trash imaginable. This was due largely to public taste, which was not discriminating. Very good cigars were made in Germany, but demand for them was quite limited. Cheapness, not quality, ruled the market there.

The Italian cigar was a national institution—and also a nightmare—for traveling Americans who dared to smoke one. Called a "Virginia," it was about eight inches long with a straw in the middle, and remarkable in that it was virtually impossible to light.

Italian restaurants acknowledged this petty annoyance by serving a small candle with each cigar. At one side was a silver wire cradle to be used as a cigar rest while the candle bathed one end of the cigar in continuous flame until it burned down to an inch or so. Then, if the straw was not broken while pulling it out, the cigar could be smoked. If matches were used, twelve to a cigar was customary.

Composition of the asbestos-like Italian cigar remained a mystery. Although post-mortem examinations never revealed its true contents, some sort of tobacco was suspected. One thing was certain, though. The odor thrown off by a burning Italian cigar was guaranteed to clear a room of all human occupants and its ancillary use as an insect repellent was never fully explored.

English cigars were made of American tobacco but looked shiny and wooden, rather unlike a natural leaf product. Cigars imported from Cuba before the days of steam often spent five or six weeks at sea in the unventilated holds of sailing ships before they reached English shores. Having been made in a humid climate and packed while fresh, the cigars fermented during the voyage. This generated a growth of fungus on the cigars,

making them taste bitter when smoked and utterly destroying their value.

The French cigar was in the same poor class as the German variety, but since the government controlled the industry, the citizenry was obliged to smoke them or pay exorbitant prices for imported Havana goods. The latter were not sold individually but were repackaged in bond in small glazed-lead boxes containing four or six cigars, and sold only at official government outlets.

How Cigars Came to America

The cigar first arrived here before we were known as the United States and quite by accident. This is how it happened:

During the 1700s, England was involved in a long, drawn-out war with France over colonial possessions in the New World. Eventually Spain, a nation seeking to regain control of Western territories also lost to the British, gladly sided with the French. This did not set well with King George III of England who, in March 1762, ordered a naval expedition to set sail for Havana, Cuba, a city occupied by the Spanish, and take it.

In those years, long before the Revolutionary War, colonists in America were required to raise armies to assist England in military operations. It so happened that, joining the British as reinforcements in the subsequent siege of Havana, was a contingent of Connecticut provincials, one thousand strong. They were led by a charismatic colonel named Israel Putnam, a 44-year-old local boy, former Indian fighter, and swashbuckling soldier of fortune.

Putnam (called "Old Put" by his men) fought valiantly and aided materially in the capture of Havana for the crown of England. During the next six months of occupation, Putnam and the other uninvited foreign guests became acquainted with, and acquired a taste for, one of the island's premier products, cigars.

Presently, Colonel Putnam sailed home to Connecticut and brought with him some of these exceptionally fine Cuban smoking articles. In so doing, he was the first to introduce cigars into American society. True, it took another century for the habit to really catch on, but what started out as a souvenir of war ended up as a popular, permanent, and respectable vice in male circles.

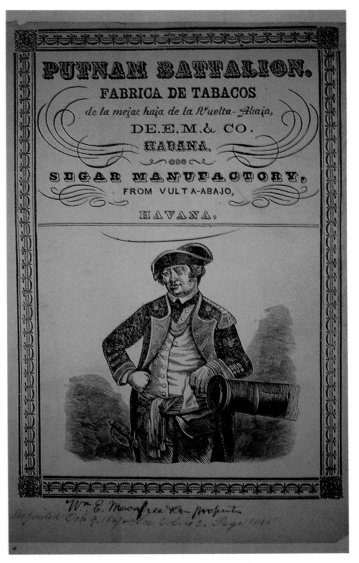

Homage was paid to Colonel Putnam *and his famous battalion with this label issued in 1867. Putnam later became a general during the Revolutionary War and led the minutemen at the Battle of Noddles in 1777.*

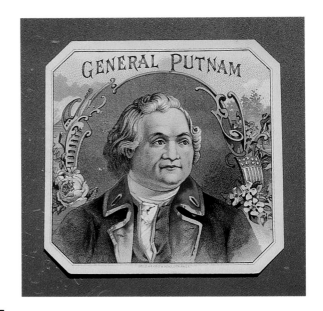

Cigars in Ante-bellum America

Until the 1800s, cigar making in the United States was virtually unknown. Cuba was the premier cigar-producing nation in the world with the Philippines and Puerto Rico running second and third, respectively. The few cigars consumed in the United States at that time were imported, almost exclusively, from Havana.

However, during the half-century between 1810 and 1860, a fledgling cigar making industry developed in America using domestic leaf tobacco grown in Connecticut, Pennsylvania, Ohio, and Wisconsin.

By 1860, cigar making in America had taken on the rudiments of a national industry, though a small one, as an estimated five-thousand craftsmen were turning out around 200 million cigars yearly. By later standards, this was admittedly a paltry figure but it merely reflected the fact that cigar smoking had not yet achieved widespread popularity in this country.

However, one aspect of the American cigar profession had undergone permanent change. No longer was domestic production controlled by family-run (so-called "buckeye") operations that grew their own tobacco, rolled their own cigars, and bartered them to local or regional shopkeepers who, in turn, sold or traded them to wholesalers. From there, the newly arrived smoking articles were distributed up and down the eastern seaboard. Instead, with rare exception, the making of cigars became centered in small shops employing less than five cigar makers.

As such, cigar making qualified as one of the nation's first cottage industries. This peculiar but distinctive trade feature set the manufacture of cigars apart from all other forms of tobacco and, with maddening unpredictability and devastating consequences, would forever prove a

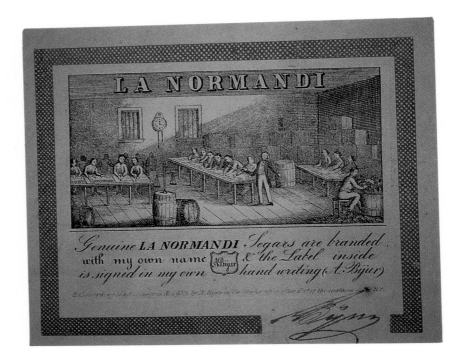

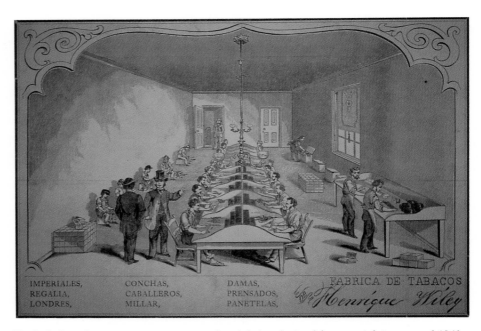

Typical cigar factory scenes *as portrayed on labels submitted for copyrighting around 1860.*

blessing or a blight to all those engaged in the cigar business.

On the eve of the Civil War, cigar making had become a full-time profession for a small but growing number of immigrant Europeans who utilized their rolling skills to establish factories in such places as Baltimore, St. Louis, Cincinnati, Detroit, and Chicago, as well as upstate New York and a few locations in New England.

At this time, cigars in America fell into two broad trade classes: imported (made in Havana and wholly of Cuban tobacco) and domestic (made in this country of native-grown tobacco).

New York City's Cigar Business

By the early 1870s, cigar smoking had become a well established habit in the nation's largest city but the quality of cigars on the market varied widely.

The cheapest cigars in New York City were those dispensed by Chinese vendors from little wooden stands on street corners and in neighborhood markets, and had the dubious distinction of being, in the words of a New York journalist, "the vilest cigars made anywhere in the world." Next came the common domestic cigar, which sold for a nickel, or six for a quarter. They found a ready market at refreshment stands and in saloons and skid row grogshops.

A better grade of domestic cigar was available and sold well all over the city. It was rolled with selected leaf tobacco and cost ten to fifteen cents per cigar. The best class of domestic cigar, running fifteen cents, was fashioned with clear Havana filler and Connecticut wrapper. Many in this category were often palmed off on unsuspecting customers as genuine imported Havana cigars.

Cigars made in America entirely of imported Cuban tobacco were of excellent smoking quality and compared very favorably with many imported brands. Their cost ranged from fifteen to fifty cents each. Lastly, the genuine, imported Havana cigar was the *creme de la creme* of cigar connoisseurs everywhere and was generally in limited supply. While some could be found for as little as fifteen cents, twenty or twenty-five cents to a dollar each was the rule.

It was common in the United States for cigar manufacturers to create the impression that their products were

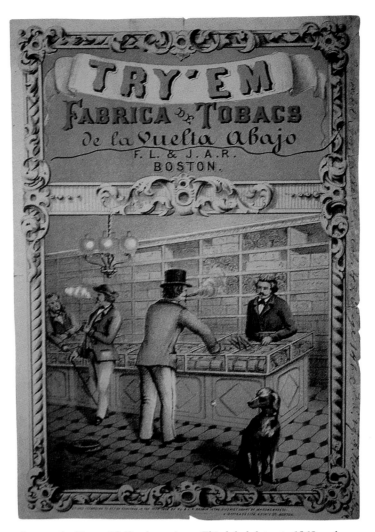

A scene inside an 1860s cigar store. *This label dates to 1868 and was printed for the Raddin Bros. of Boston. It shows that the interior layout of stores (glass counters filled with boxes, spares lining the shelves, and high visibility of all goods) changed very little over the years.*

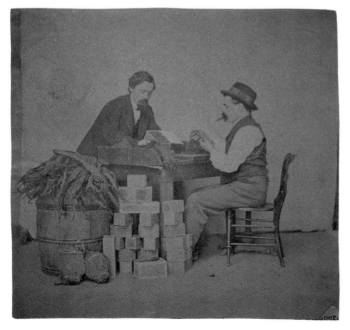

A pair of cigar rollers in 1869.
—Courtesy Prints & Photograph Division, Library of Congress.

imported. This was accomplished by putting up cigars in imitation Cuban boxes and giving them authentic-sounding Cuban brand names.

This subterfuge, however, rarely fooled anybody since all boxes of cigars were required by law to bear the name and location of the manufacturer, the identification number of the manufactory, and, in the case of real imported cigars, the U. S. inspector's seal. Before tobacco tax laws were passed, however, and duties on tobacco were low, this scheme was often worked at considerable profit to dealers.

In 1860, an unofficial report claimed that residents of New York City were spending $12,000 a day for cigars and $10,000 for bread. No one knows if the figures were accurate (they probably weren't), but the fact that an article of smoking could outsell a food staple was not ridiculous. Within a few short years, America would enter the greatest cigar-smoking and tobacco-consuming era in its history.

Branding Cigars

The earliest labeling of cigar boxes, traceable to the 1840s, was accomplished through an unusual form of commercial artwork known as top brand dies. These were heavy blocks of brass or hardwood engraved with simple (later ornate) designs on one side which were literally branded into the wooden surfaces of cigar boxes. The latter, by the way, were in existence during this very early period.

The imprints left on wood by top brand dies, however, were crude and not esthetically pleasing. The ink, forced under pressure, tended to bleed into the grain of the wood, leaving smudged, unclear prints and a definite need for improvement, especially with more elaborate and intricate label designs.

Top brand dies maintained their popularity in the cigar industry until improved printing techniques came along and then the dies fell into rapid disuse. In their place came paper labels.

A New Means of Labeling

Basic to the introduction of paper cigar box labels was the growing business practice of assigning brand names to tobacco products, including cigars. Believe it or not, this was a bold, new merchandising concept around 1860.

It must be remembered that in those times it was customary for smokers to step into a country store, dry goods emporium, stationer's shop, or liquor store and simply ask for "a good cigar," since, with rare exception, the articles were typically sold from wrapped but unnamed bundles.

In the late 1850s, copyrights were granted by the federal government for the first cigar box labels in the United States. Not only were these eye-catching trademarks useful in identifying the contents, namely, private brands of cigars, but they dressed up the otherwise plain, bare-wood appearance of the boxes. The use of brand labels was also shared (or perhaps preceded) by manufacturers of plug tobacco in Virginia who were applying large colored labels to wooden buckets, caddies, and other bulk shipping containers.

In the beginning, cigar box labels were crude in design, drab in color, and relatively expensive to produce. Yet, slowly but surely, these miniaturized versions of chewing tobacco labels, as a means of product identification, proved a boon to business and became a tradition in the profession. However, giving cigars names and composing the layout of labels required skills far beyond the capabilities of most men in the cigar trade

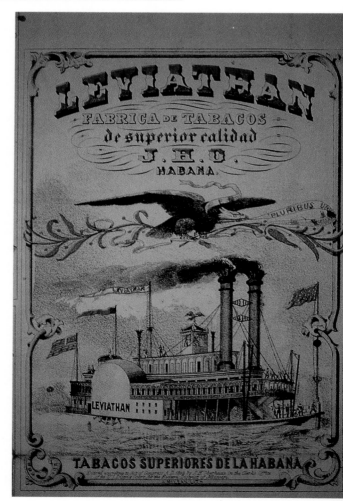

Designing a cigar label in these formative years was not an exact science. Both printer and merchant were inexperienced in this new and exciting area of advertising. Lithographic firms were either too busy, too naive, or unconcerned with making up sample books (as was done later) for cigar men to conveniently leaf through at their leisure and make selections.

Likewise, most tobacconists calling for labels ran small operations and very few employed, or could afford to employ, marketing personnel. This was not the era of such refined sales expertise. As a result, the design of such things as cigar labels generally ended up being a collaborative effort between the shop owner and the lithographer.

Paper Treasures of the Library of Congress

Stored in the custody of the Prints and Photographs Division, Library of Congress, in Washington, D. C., is a large collection of tobacco labels that cover a period of time from the late 1850s to the mid-1880s. Approximately three- to four-hundred of them are devoted to cigars.

The reason for their existence there is due to copyright laws in effect at the time. Part of the official regulations governing the registration of brand names and trademarks required that an original copy of whatever was to copyrighted be submitted directly to the Library of Congress, or a copy filed in any state branch of a federal court.

All the labels eventually ended up in the archives of the Library of Congress where they have been maintained on permanent file for the last 150 years. Individually mounted on large sheets of paper, they are in the public domain and, as such, are made available upon request to anyone wishing to view them.

It is safe to say that, virtually without exception, these government-held labels for cigars and manufactured tobacco are one-of-a-kind specimens.

The Oldest Known Label

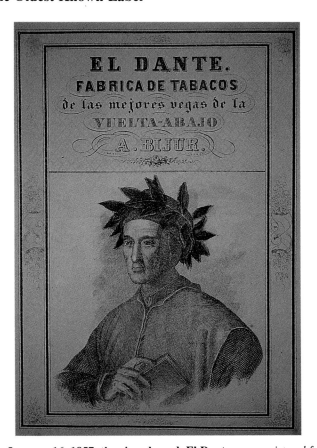

On January 16, 1857, the cigar brand, El Dante, *was registered for copyright purposes at the federal clerk's office in southern New York State. It was submitted by tobacconist A. Bijur, presumably of New York City, and as such has the honor of being the earliest dated American cigar label known. The lithographer of this inaugural piece was not identified. The brand celebrated Dante Alighieri (1265-1321), the famous Italian poet.*

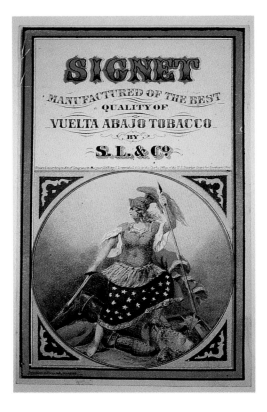

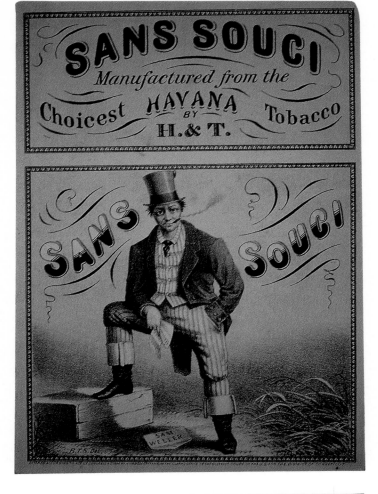

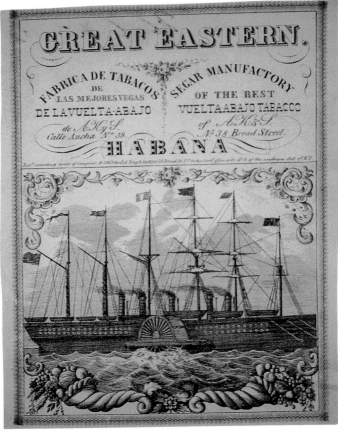

Giving Cigars Names: An Art Unto Itself

The first step, selecting a brand name, was not as easy or simple as it may have looked. The decision was critically important.

Years ago, a good name for a cigar was worth thousands of dollars per letter. There was no other trade on earth that used, or possibly could use, so many titles for its wares. The countless numbers of wonderful (and not so wonderful) names given to cigars showed that cigar manufacturers and lithographers were a very appreciative lot, and were quite as much, if not more, advanced in the philosophy and poetry of life than any other class of business. They truly stretched imagination to the limits.

A glance at the vast list of cigar labels verifies this simple fact. Every category of American advertising theme was literally ransacked for suitable subjects for cigar box labels. There was scarcely a name in history, romance, or song that did not grace the lid of a cigar box in bright, gilded letters at one time or another.

A story was told at the turn of the century about a young man who had a bright idea and submitted one hundred new brand names for cigars to the trade organ, Tobacco Leaf. He was astonished to learn that all but four of his "new" names had already been used.

It took no deep thinker to figure out what kind of labels would be the most advantageous to cigar manufacturers. Before cigarettes came along, the use of tobacco was strictly a male social pastime and cigar labels were accordingly designed to appeal to a man's senses, pure and simple. It may have been chauvinistic, but that's the way it was.

The range of themes depicted on the first generation of cigar labels was not extensive, but it was diverse enough to establish trends that would be copied and expanded upon over the years. The themes used, by the way, were not unique to the cigar industry. Those used in the labeling of snuff, smoking, and chewing tobacco, for instance, were no different than those used for cigars.

The purpose of cigar box labels during this primitive era of tobacco advertising was not to give hints of the wondrous contents inside the box, extol their smoking pleasures, or even brag that they were "the best cigars made" (marketing finesse like this would be added much later). Instead, the aim was merely to capture the attention of the male eye and firmly imprint the brand name in his mind or, in the case of those who could not read, a pretty picture. Brand names were the simplest and one of the most effective sales devices ever invented.

Peculiarities arose during this early phase of American commercial advertising. Predictably, the subject matter depicted on cigar box labels had little or nothing to do with cigars or even smoking. This is still true today, but was particularly so with practically all products advertised and sold in the United States in the late nineteenth century.

Early Labels

In examining the first generation of cigar box labels, several conclusions can be drawn.

First, the commercial use of cigar labels during the 1857-1880 period was extremely sparse. The status of the tobacco industry and especially that of cigars was such that, until the 1880s, sole proprietors and small-time operators comprised the vast majority of the profession. Their market areas were understandably limited, usually extending to the city limits or county line at the most.

This dictated a limited need for labels in the first place and although exact figures are not known, printing runs of the early labels were undoubtedly of a very low order, perhaps several hundred or so (admittedly a wild guess on the author's part).

Secondly, both cigar merchant and printer were usually identified on the same label (albeit in fine print), a situation that would reverse itself when label-making became big business and competition stiffened in the printing industry.

Then salesmen from lithographic companies, sample books in hand, appeared at the doorsteps of cigar shop owners and enticed them with page after page of gorgeous labels identified only by the lithographer, not the cigar merchant.

One other distinguishing characteristic came to light during this early period. Cigar box labels were typically produced by local printing establishments. It makes sense that a businessman would turn to a printing facility in the same city for his needs. It was cheaper for one thing and certainly handier than having to go out of town. Besides, no lithographic house in America enjoyed a wide enough reputation at that time when it came to cigar box labels to attract out-of-state trade.

One tobacco caddy label in the Library of Congress's collection was produced in a stationer's shop, pointing out that any business with a printing press was a potential source of cigar labels in those days.

Thirdly, it is interesting to note that most of these early labels advertised what later came to be called in the trade as "clear Havana cigars," meaning they were made in Cuba and entirely of Cuban tobacco.

Needless to say, it became standard practice to announce this fact on cigar box labels. Consequently, dominating the field of the label was a declaration typically rendered in Spanish and in large flowing letters which ran something like this, *Fabrica de Tabacos Superiores de la Vuelta Abajo, Habana,*" or words to that effect.

Translated, it meant that the cigars inside the box were indeed "the best" and made in Havana factories with cigar leaf grown in the Vuelta Abajo district. For added effect, some tobacconists translated street names in Boston and Philadelphia (or wherever their shop was) into Spanish, too.

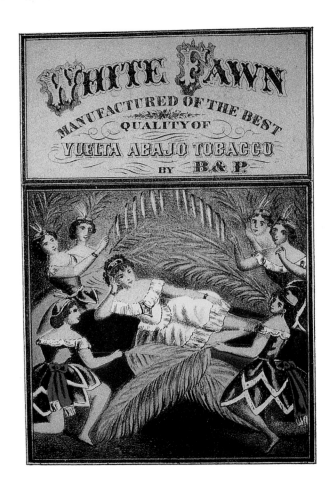

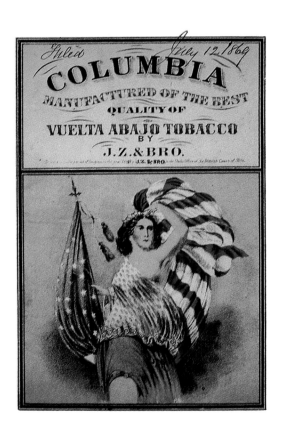

The most important words mentioned here, of course, were "Vuelta Abajo." They worked like magic. Any cigar enthusiast worth his salt knew instinctively that the world's finest cigar leaf tobacco was grown in the inexhaustibly fertile soil of this valley in the southeast corner of the island.

But all the superlatives and fancy words in Spanish were mostly wasted. Most people didn't know what they meant, anyway, but they looked and sounded good. They were put on labels solely to attract the eyes of the consumer and assure him that he was buying the genuine article, as advertised.

After all, if you were going to sell a cigar imported from Cuba, it was important that the label state this clearly. The American cigar industry and tobacco advertising in general may well have been in the Dark Ages then, but tobacco men weren't stupid.

Outers Only

The upright or vertical orientation that characterizes early labels came about for reasons known only to those cigar men who had them made nearly a century and a half ago. All were used as "outers," that is, applied to the outside of the cigar box and usually draped over an end so that the label would be torn upon its opening. Tradesmen referred to them as "outs." "Inners," or labels lining the inside of the lid probably did not exist then.

In small print on most every label from this period was the standard copyright notice to the effect that it had been entered in the Library of Congress along with the name of the applicant. Sometimes the printer was identified, also in barely discernible print and generally located at the base of the graphic illustration.

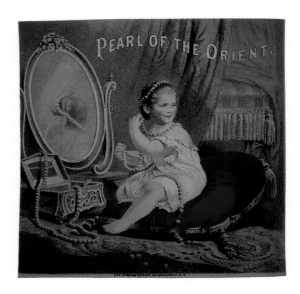

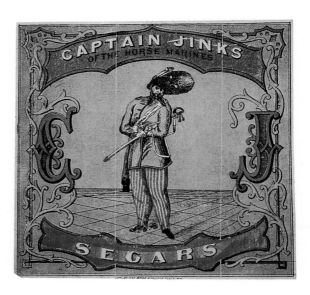

Frontmarks

While categorically all cigars looked more or less alike, a number of subtle variations in cigar construction evolved over time, due as much to the changing demands of those who smoked cigars as the inclinations of those who made them.

Out of a centuries-old tradition that began in Cuba, a dictionary of terms arose that came to define the many different shapes, lengths, and sizes of manufactured cigars. They were called frontmarks (or vitolas, in Spanish).

The terms were typically rendered in Spanish. Among those indicating shape were: Londres, Conchas, Reina Victorias, Panatelos, Embajadores, Especiales, Imperiales, Brevos, Prensados, Cilindrados, and Regalias. Words referring to both size and shape included Infantes (tiny cigars), Princesses, and Elegantes. Combinations of size and shape gave rise to such dual terms as Conchas Finas, Conchas Speciales, Regalia de Londres, and Londres Grandes.

The Damos, as the name suggested, were meant for ladies and were the smallest made. The Cazadores (huntsmen) were the longest and the Trabucos (blunderbusses) the fattest.

Since these descriptive Spanish labels were printed boldly in black on the fronts of cigar boxes, neophyte cigar smokers and indeed the entire nonsmoking public often confused them with brand names, leading to amusing scenes in tobacco shops.

Back in 1902, Joseph Loeser, a young man who later became the owner of a large retail cigar firm in Chicago, was standing behind the cigar counter in the Rudd House, Owensboro, Kentucky, when Pat O'Meara, a cigar salesman, walked in.

"Have you got a panetela cigar?" inquired Mr. O'Meara.

"Sorry, I don't have that brand," replied Mr. Loeser, innocently enough.

After a pause, the bewildered salesman asked: "How long have you been in this business?"

"About fifteen minutes," came Loeser's honest answer.

Cigar: From Whence Comes the Name?

Many years ago, smokers were led to believe that the term "cigar" came from the Spanish word "cigarrel," meaning orchard, and that the smoking article was so named because the tobacco was originally grown in private gardens by Spanish grandees.

There is some truth in this statement. When tobacco first arrived in Spain, dons planted small quantities around their homes for personal consumption. To be able to grow your own tobacco and roll it up into something to smoke was a rare and esteemed privilege.

It was thus the mark of the true aristocrat who, upon entertaining a friend and offering him a cigar, was able to say with great pride, "Es de mi cigarrel," which means "It is from my orchard."

Foreign guests, hearing this familiar phrase, naturally came to believe that "cigarrel" referred to the long roll of tobacco and in time began to use it in their countries of origin, shortening the word to "cigarro" in the process. In the case of English, it was abbreviated to "cigar."

Extending the etymological romance of the cigar was another story which maintains that "cigarrel" originally meant grasshopper because this particular insect always chirped the loudest in the orchard, and the latter took the name of the insect which, in turn, came from the grasshopper.

As charming as these legends are, however, it is much more likely that "cigar" is simply derived from the Spanish verb "cigarar," to roll. This theory is supported by the fact that a cigar is defined as a "roll" of tobacco and those who made cigars throughout the ages were traditionally called "rollers."

It does not follow, however, that in the nineteenth century Spanish spoken on the island of Cuba, cigars were known as "tabacos," not "cigarros," as might be expected.

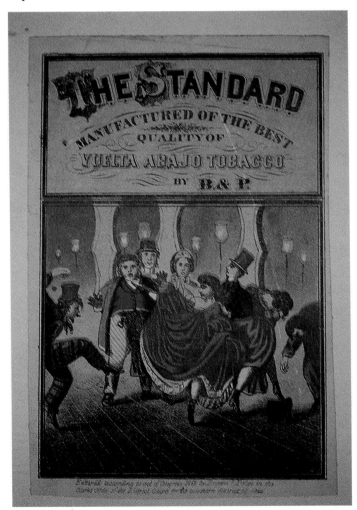

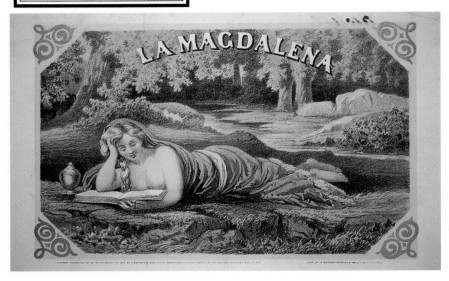

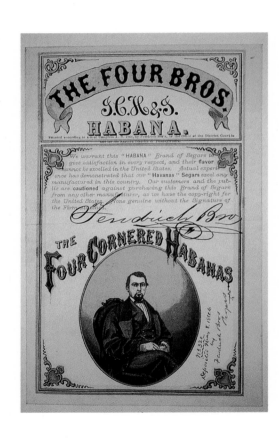

The Way with a Cigar

"It is now time that the reader should be initiated into the art and mystery of choosing a cigar, and this we may now proceed to unravel in the manner following:

"In the first place, it is necessary for our smoker to consult his taste, as to whether he prefers a mild or a full-flavoured cigar. If the former, he chooseth a lighter-coloured roll; if the latter, his digits dive amongst the dark. In selection, do 'your spiriting gently,' not rudely and clumsily subverting the tobacconist's stock, but handling each as though pressure would destroy.

"Select those that are firm, compact, and free from knotty intricacies, which would interfere with the free draught of the air. Remember, also, that the seductive specks are more frequently the result of acid than age, and that the olfactory nerve forms an excellent palate on which to test the superior qualities of what may be proferred....

"After igniting it with a slip of either wood, paper, or German tinder—never commit the absurdity of resorting to gas or any other combustible for a light—just press gently the lighted end of the cigar on the light, and you will leave a clear passage for drawing without difficulty. A good cigar, from a Cuba to a Principe, should burn with a clear steady glow, and leave a firm grey pellet of ashes as it consumes, which forms, by the way, the finest dentrifice that can be used.

"A tube—the best are of porous clay with an amber mouth-piece—may be resorted to for 'using up' the stumps, but no true smoker would from choice inhale a perfect Cigar or Cheroot through this medium, which is infinitely inferior to the rich flavour derived from pressing the fragrant leaf with the lips alone. Held gently between the fore and middle finger, there is but little necessity for leaving the Cigar to more than the occasional embrace of even the lips, but under no circumstances should it be consigned to the harsh imprisonment of the teeth.

"It should recall the recollection of Honest Izaak Walton's worm, and be used 'as though you loved it'; not compelled to endure remorseless puffing, or left to the indignity of self-expiring. A Cigar—once out—is never worth the pains of re-illuming."

—Edward L. Blanchard,
The Cigar and Smoker's Companion (1845)

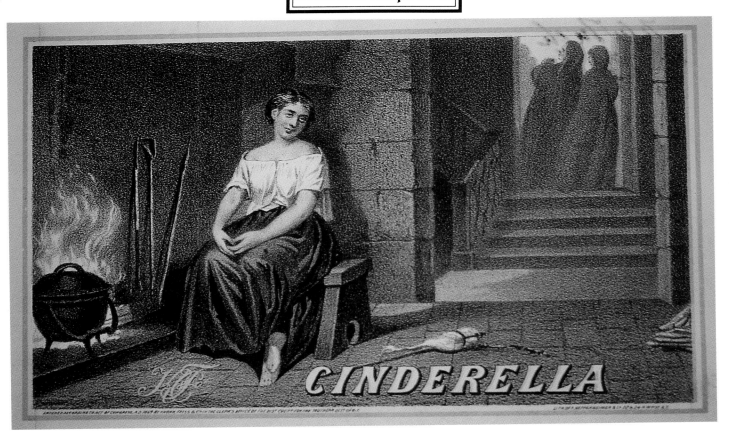

CINDERELLA

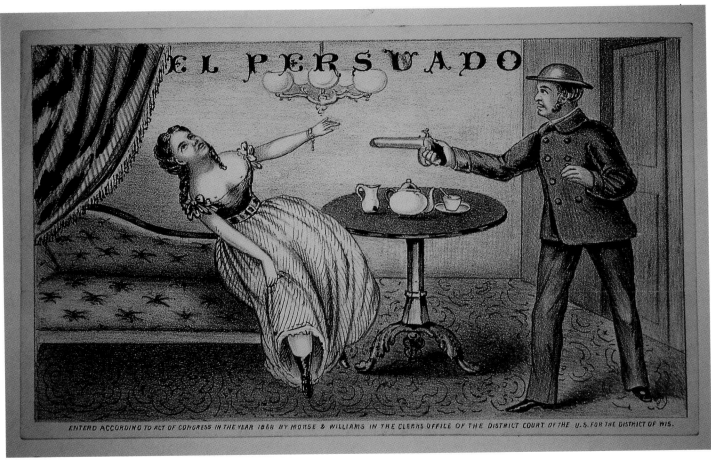

EL PERSVADO

ENTERD ACCORDING TO ACT OF CONGRESS IN THE YEAR 1868 BY MORSE & WILLIAMS IN THE CLERKS OFFICE OF THE DISTRICT COURT OF THE U.S. FOR THE DISTRICT OF WIS.

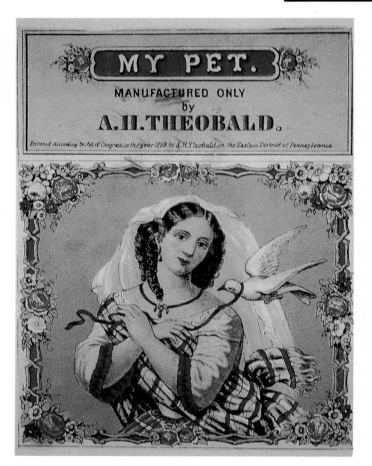

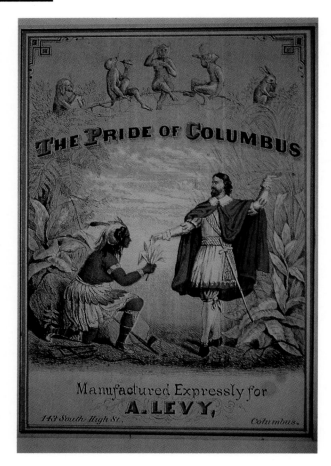

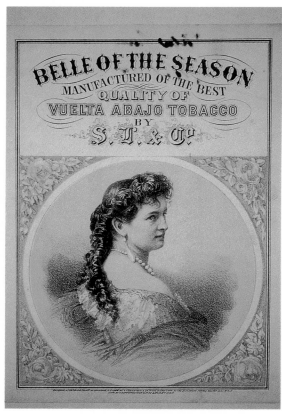

The Image Makers

"Chromo-lithography is in itself an art to reproduce, to imitate, not to create."
—Louis Prang (1866)

It is difficult today to imagine a printing world without color, but it once existed. Americans before the Civil War, for instance, were quite accustomed to seeing all commercial printed matter of the day—broadsides, posters, pamphlets, cards, and stationery—rendered in plain (but thoroughly boring) black and white.

Of course, it was technically possible to produce colored images during the 1850s and 1860s. In fact, printers liked to tease the masses by highlighting pictures with a few dabs of color here and there, applied by hand with a brush, pen, or crayon, but the process was too primitive and time-consuming for general use. These obstacles aside, however, manufacturers of locomotives and patent medicines were among the first to introduce color printing in advertisements in the 1860s.

From the 1850s through the 1880s, wood engraving dominated the printers' art. It held a distinct advantage over its nearest competitor, steel engraving, in that the image could be changed and improved once it was made.

Hardly an illustration appeared in a book, newspaper, or magazine that was not created from a woodcut and, not unexpectedly, some of the original cigar box labels of the 1860s were also wood cuts, some of which were hand-tinted.

But finding a process to transfer images in true color to pieces of paper at a cheap price remained the cherished dream of all printers of the nineteenth century. The color-starved nation was finally rescued from its abysmal existence when chromolithography (literally "colored writing on stone") was developed shortly after the close of the Civil War.

Senefelder and Chromolithography

The groundwork for this momentous achievement was established by Alois Senefelder (1771–1834) of Munich, Germany. In 1796, he invented a printing method, lithography, in which images could be either carved directly into the surface of a flat piece of limestone or incused in a steel or copper plate, and then transferred to paper.

The stone used for lithographic work was a compact sedimentary limestone, yellowish or blue-gray in color, which came from the Solenhofen quarries in Bavaria. It was ground down by moving one stone over another with sand in between and then the surface of the slab was polished with pumice stone.

Designs were made on stones in one of four ways: with a watery ink; with a solid crayon; by transfer from

An engraved block of Bavarian limestone, *the essential foundation of the old-time chromolithograph process.*

an inked design on paper, or by engraving with an etching point.

Some of the cigar box labels of the 1860s and 1870s were created by the crayon method. With this process a design was drawn with a crayon made of soap, wax, or tallow on the surface of a stone roughened with sand. The crayon was handled in the same manner as that of chalk upon rough Whatman paper.

The crayon method, compared to other contemporary techniques, allowed considerable artistic flair and freedom, but the finished image was crude. The roughness of the stone prevented a smooth continuity of lines, whose depth depended directly upon the pressure applied to the crayon as it moved over the raspy surface.

Color was an option with these early lithographed images but its use naturally added cost to an already expensive process. A dry tint was applied, moved around, and buffed up here and there until the desired highlights and contrasts were achieved.

Production of lithographs was severely limited in the first half of the nineteenth century because all printing was done with hand presses. The invention by Robert Hoe of a steam-powered, stop-cylinder press in 1868 revolutionized the printing art.

A printer's output capacity suddenly jumped from several hundred pieces a day into the thousands. The power lithographic press not only lowered the unit cost of prints but also made it possible to create large volumes of work which formerly had to be consigned to type presses with unpredictable results.

Lithography, flexible and adaptable, proved to be a vastly superior printing medium. Not only did it make it possible to faithfully reproduce the work of the engraver, typefounder, and artist, but the transfer process allowed virtually limitless duplication of these same images without degradation in quality. And when it came to detail, lithography outperformed the metal engraver. For certain printing needs such as posters, labels, portraits, maps, and stock certificates, it proved ideal.

Chromolithography was the ultimate in lithographic art. It differed from the ordinary stone printing process, where only one stone was used, in that a number of stones were used, one for each color desired. The end result of combining all the stones was a multi-colored image.

The technique, although it allowed remarkably detailed images in striking color, was still tedious and time-consuming. An original outline drawing was first made by an artist who then duplicated it in exact detail on other stones. Different tints and colors were applied with each stone.

It took a highly skilled artist with a good feel for, and knowledge of, color to know how many stones were needed and in what sequence in order to turn out a quality print.

Needless to say, careful registering was an absolute must so that each color fell precisely into its proper place, preventing off-center or smudged images. The record for the largest number of stones used in a colored image was held by Louis Prang. His famous chromo, "Family Scene in Pompeii," required forty-three stones.

The real story of how color was delivered into practically every household in America lies in the handful of enterprising printers who mass-marketed colored pictures at inexpensive prices. Foremost among them was a lithographer, Nathaniel Currier, who teamed up in 1857 with a self-taught artist, James Merrit Ives.

Their printing firm, Currier & Ives, lived up to its slogan as the "printmaker to the American nation," churning out an average of three or four hand-painted parlor prints every week for fifty consecutive years until it closed in 1907.

The most heroic figure in this groundbreaking epoch, though, was Louis Prang, a printer from Roxbury, Massachusetts who perfected a color lithographic technique in 1875 which he called chromolithography. It was the same

A piece of original art *before it was engraved on a stone.*

as Senefelder's except that Prang used multiple stones, a separate one for each color impressed.

Sometimes it took as many as thirty separate stones in order to reproduce a wide range of shades and tones and, by altering the texture of the fabric on which the final stone was impressed, the "chromo," as Prang called it, actually achieved the same appearance as an original oil painting. Truly remarkable, Prang's achievement was to set the standard for color printing the world over until the end of the nineteenth century.

The essential feature of Prang's method was a drawing made by a greasy red crayon on the surface of a semi-porous slab of limestone which, when covered by a film of water before printing, repelled the printers' ink. Only the greasy ink was retained on the surface covered by the drawing and a paper impression was taken from it.

The end result was a chromolithograph, a perfect replica of the original drawing on stone. With this technique, the ability to reproduce popular pictorial art was enormously expanded.

Through the last half of the nineteenth century, Louis Prang issued forth from his print shop tons of ephemera in vivid colors that flooded the nation—trade cards, awards of merit, bookmarks, Christmas, New Year, and other holiday greeting cards, Sunday school texts, motto cards, calendars, decals, rebus cards, framed mottoes, die-cut scrap, and other paper mementos. All of it found its way into the hearts of millions of Americans, young and old, who eagerly pasted up printed images on the bulging pages of parlor scrapbooks and albums.

Among the many job orders that swamped lithographic houses around the country were those for cigar box labels.

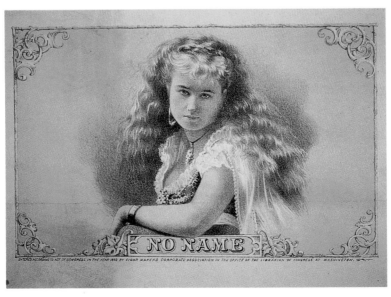

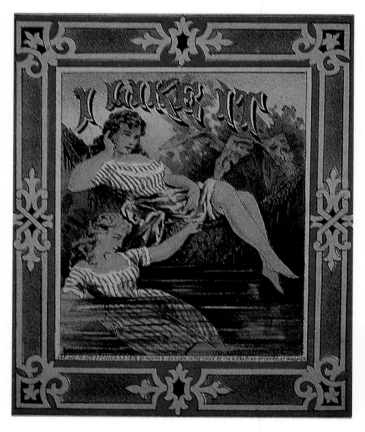

The "I Like It" label *(left)*
was a five-color lithograph.
This was pretty good for 1872.

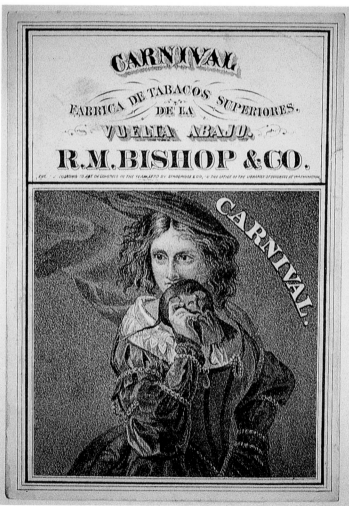

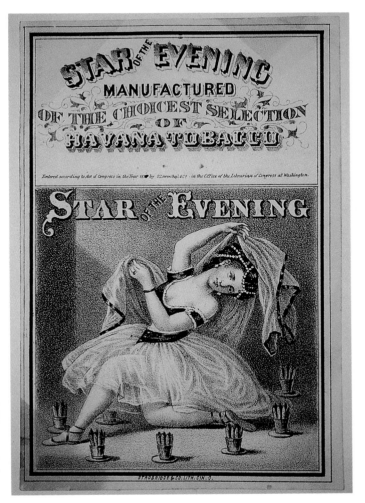

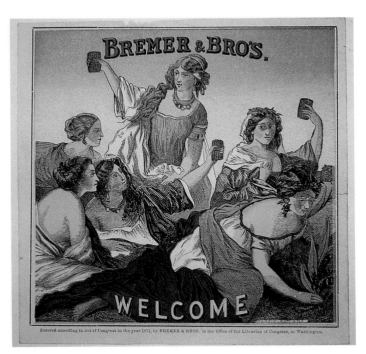

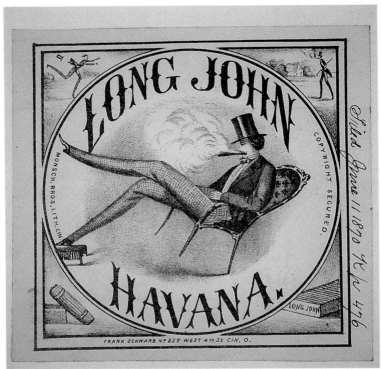

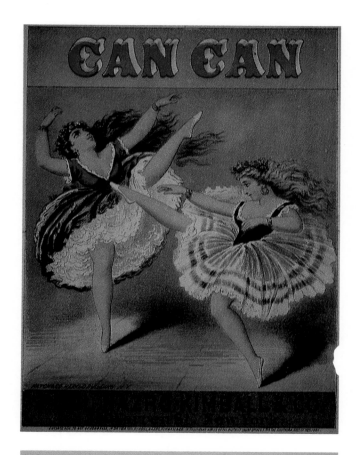

A search through the list of early lithographic firms (above) will turn up only two that went on to achieve widespread acclaim during the golden age of cigar box label production—Schumacher & Ettlinger, and Heppenheimer & Co., both located in New York City. (The latter firm underwent two partnership changes by the 1890s.)

Of the rest, several, such as Strobridge & Co. of Cincinnati and Major & Knapp of New York City, were well-known color printing houses whose services were sometimes utilized for labels by hometown tobacco manufacturers, far more for chewing tobacco brands than for cigars. Both companies remained steady producers of a wide variety of printed advertising ephemera (especially trade cards) up to the turn of the century.

The remaining printers, particularly in the 1860s, were obscure, small-time commercial printers which, after turning out a run of labels or two, were used no more and their names become incidental postscripts on the list of lithographers in America who once made cigar box labels.

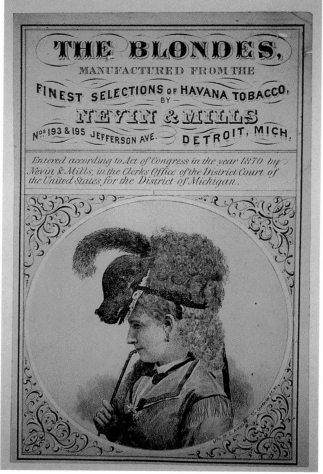

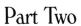

Part Two

Pomp and Glitter:
The Great Gilded Age of Stone Lithography
(1880-1910)

FERN PINKS

DESIGN COPYRIGHTED 1901 SCHMIDT & CO. NEW YORK

FROM SCHMIDT & CO.,
New Chambers Cor. William St., New York.
35 & 37 Randolph St., Chicago.

No.1349 INSIDE, $1.80 per 100
No.1350 OUTS., $.80 "

ALSO BLANK.

SMOKE FERN PINKS CIGARS

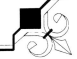

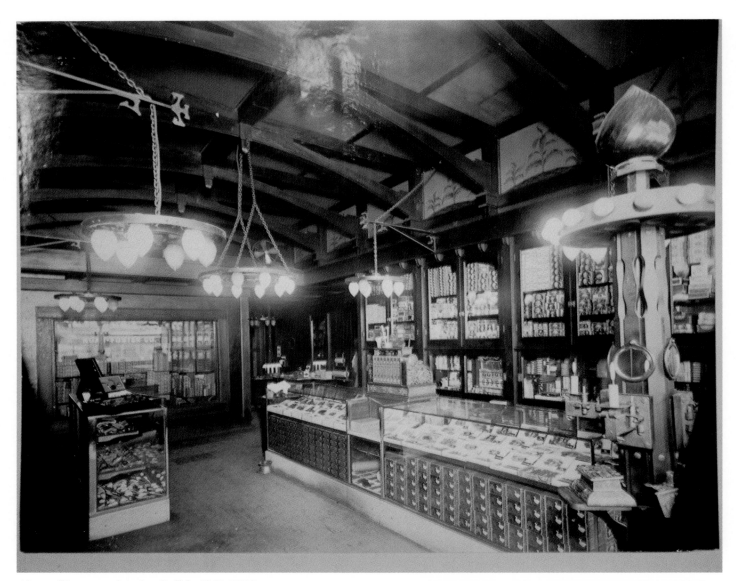

Above: **Cigar store interior,** *Buffalo, N.Y. (1911)*

"Life imitates art," Oscar Wilde once wrote. However, had the distinguished Irish author and playwright ever feasted his eyes upon a few American cigar box labels of the 1890s, true visual pastries, he might have changed his mind and declared that "art imitates life" because this is exactly what cigar box labels of this era did.

It was a unique and remarkable period, 1880–1910, one that would never flash across the American advertising scene again. In terms of artistic beauty, technical achievement, and business application, cigar label art reached its highest level, its finest hour, during this era. The magic of stone lithography and the extra pizzazz of embossing and heavily gilded ornamentation transformed the artist's handiwork into exquisitely detailed and brilliantly colored images on paper.

Right: **The lithographic factory** *of Wm. Steiner & Sons, New York City. (circa 1900)*

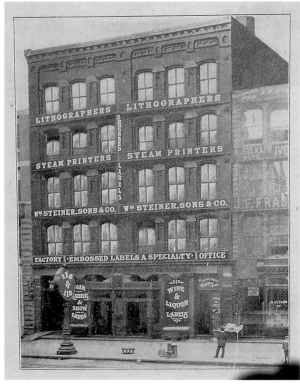

The 1880s: Label Art Comes of Age

The decade of the '80s represented a pivotal point in the history of cigar box labels. Improved color printing techniques, expanding numbers of lithographic houses specializing in commercial advertising, and competition among cigar manufacturers dealing with a sudden spurt in public demand for their products led to, by decade's end, a major break from art trends inherited from the 1870s.

By the early 1880s, the production of labels shifted permanently from small, hometown printers to large lithographic firms in major cities well staffed with artists and engravers. New York City was already home to a cadre of master lithographers who formed the nucleus of a busy cigar-box label industry catering to the needs of the city's rapidly growing cigar making trade.

Among these pioneering print firms were Heppenheimer & Maurer, Schumacher & Ettlinger, Heffron & Phelps, Louis E. Neuman & Co., and O. L. Schwencke. Two others, Johns & Co., located in Cleveland, and Geo. S. Harris & Son of Philadelphia, rounded out the list of pre-eminent leaders in this new area of advertising.

From the standpoint of design, color, and themes, cigar box labels of the early 1880s differed little from those of the previous decade. Following popular formats established in the 1860s, primarily by the New York printing firm of Heppenheimer & Co. (renamed Heppenheimer & Maurer in 1874), themes largely remained stereotyped.

If luminaries from history, fable, and song were not shown, then it was one of a long series of repetitious landscape panoramas or the overly sweet and sentimental depiction of demure young maidens and rosy-cheeked children. Also overdone to the point of tedium was portraiture of cuddly puppies, pampered kittens, dancing frogs, and other household and barnyard pets.

The trade's earliest labels also lacked eye appeal. While the artwork of the 1870s showed a high degree of engraved detail enclosed in lined or fancy borders, overall tones were subdued due to the liberal use of weak pastel colors, monochromes, and sepia tones.

This was not done deliberately but merely reflected the fact that printing houses did not possess—or chose not to invest in—capabilities for full-color lithography at the time. Admirers of fancy Victorian scrollwork, though, found plenty of examples in title letters, borders, corner pieces, and other decorative fretwork lavished on these images.

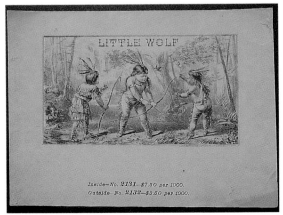

It must be pointed out, however, that while these rather dull ponderous images of the 1870s were quite the rage with the general public and critics alike, ten and fifteen years later they would be vilified by the same critics who now labeled all of it as "mawkishly sentimen-

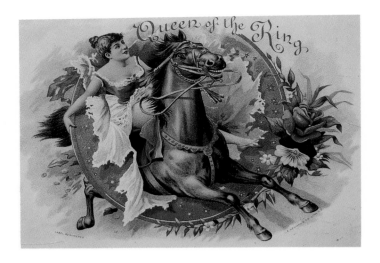

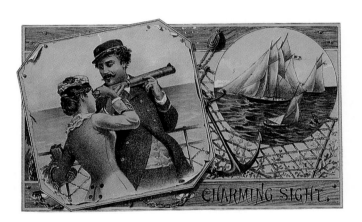

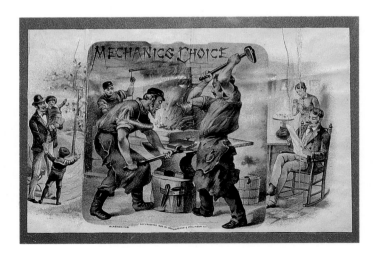

tal," proving that taste in art, like the weather, changed unpredictably.

In the 1880s, time-worn genres favored by artists of an earlier age underwent a long-needed overhaul. Out went stuffy, sentimental images; in came fresh, light, and airy themes rendered with a delicate touch of charm, poignancy, and wit, sometimes a bit roguish or bizarre, but never vulgar, insulting or disrespectful.

Lithographic artists, no longer restrained by the rigid rules of classic portraiture of former days, were encouraged to let their imaginations run wild as the demand for cigar box labels increased. They became philosophers on life and churned out a seemingly endless flow of art for the masses.

The focus was now on human beings, but no longer painted in stiff formal poses as if before a camera lens. Instead, everyday people were captured by the artist's pen, interacting with each other in a variety of real-life situations that provoked a laugh or thoughts of love, nostalgia, sadness, or compassion.

Some labels delivered a subtle—or not so subtle—message, at times silly, naughty, or suggestive, or one that had a moral. Others, with a composite of smaller scenes, told a brief story. Cigar box labels, in effect, were baring the heart and soul of Victorian America.

As a footnote, stone lithography was the preferred method of printing cigar box labels, but it still remained an expensive and laborious process. For a large lithographic firm to create a new cigar box label, for example, it often required the combined efforts of a dozen or so highly skilled artisans, a month or more in time, and as much as $6,000. It was serious business with little margin for error.

Inners

Sometime in the late 1870s or early 1880s, cigar brand labels, in addition to "outers" decorating the exterior surfaces of cigar boxes, were pasted on the inside of the lids. They were called "ins" in the trade or, much later by collectors, "inners." As a rule, inners were applied by cigar box manufacturers, outers by the cigar makers. While using inners seems such a simple and obvious step business-wise, it took a while for cigar men to tumble on to this idea.

Some remarkable promotional advantages were offered by inners and they quickly became a permanent fixture in the trade. Safely protected by the lids, they were kept bright, fresh, and ready to dazzle the eyes of the smoker every time he opened the box to remove a cigar.

More importantly, though, inners displayed well in a cigar shop. Cigar boxes were lined up side by side, in or on top of glass cabinets, with their lids erect, proudly showing off the colorful labels. It was an impressive sight, one to which many photographs of Victorian cigar store interiors will proudly attest.

Cigar box labels produced between 1880 and 1900, with the exception of proofs and untitled artwork, commonly carried the name of the lithographic firm in fine print at the bottom of the image, a feature which allows historians to approximate the date of production.

By the turn of the century, however, the lithographer's identification was replaced by that of the cigar manufacturer or dealer, plus an occasional copyright date of the brand. This date, by the way, represents nothing more than the year the brand was copyrighted, not when the label was printed which, in most instances, was a good ten or twenty years later.

The Business Side

In the 1880s, cigar manufacturers were quite willing to pay exorbitant prices for a cigar box label done in six colors, but the quality turned out in those days was far inferior to those produced later in the 1890s. In spite of this, the commonest labels cost between $65-75 per thousand and the emphasis was strictly on eye appeal, not art.

By the turn of the century, however, it was not unusual for larger-sized cigar manufactories to have 100-150 different brands on the market, giving rise to an even greater commercial need for labels. In the meantime, keen competition among printing houses had resulted in labels displaying an exceptionally high degree of artwork, interestingly at production costs formerly charged for common prints. In the world of cigar box labels, it was clearly a buyer's market.

While many cigar men continued to judge a label by the number of colors in it, this really had little to do with its artistic appeal, hence commercial value. Sometimes a six-color cigar label cost more than one with ten or more colors. The bottom line was the artist's creative ability. An expert could often design a better label with four colors than an inexperienced one with six.

A good example could be found in sepia-tinted labels which became quite popular around 1900. The only color used in them was brown, but when six shades of it were harmoniously combined, they formed a striking visual effect.

It made no sense at all, but if these lithographed images were anything but cigar box labels, many could have been framed and hung on parlor walls as prized works of art, equal in beauty to the best of Louis Prang's chromos going for 25 or 50 cents apiece. Yet beautifully crafted cigar box labels went begging for years at two or three cents each with many cigar men, particularly those operating on a shoestring, bellyaching about the "high cost."

Selecting the design of cigar labels continued to be a bothersome and demanding chore because customers' tastes varied widely and were totally unpredictable. For every cigar manufacturer who flew into a lithographer's office and demanded, "Show me something with the figure of a woman in it," there was one who was not enraptured by the female form at all.

Sometimes the unexpected happened. The most commonplace of images—a dog, for example—would trigger a customer into sheer ecstasy. It wasn't long before lithographers became experienced at sizing up clients.

For those cigar makers who were fond of the turf, a label featuring a horse on the run fit the bill nicely. Likewise, the athletic type reveled in Hercules throwing a spear as big as a thirteen-inch gun, and the devotee of the prize ring wanted the latest champion pugilist portrayed on his label. And then there were the vainglorious cigar men who settled on nothing less than their own names and portraits rendered in heavily gilded ornamentation.

Oddly, for many years in the trade, the most popular cigar label was the figure of an American female beauty representing the state of Connecticut holding hands with a Cuban maiden. The majority of cigar men, though, had no idea what they wanted; this made sample books not only handy but an absolute necessity, worth their weight in gold many times over.

It comes as a surprise but humorous subject matter on labels never became popular among cigar manufacturers, at least those of the last century. Outside of cheap dives and waterfront saloons, lithographers had trouble selling ready-made labels in this category. Portraiture of box labels, it seems, like the smoking of cigars, retained an air of propriety, dignity, and seriousness with smoker and manufacturer alike. It was not to be meddled with.

At times lithographic artists were required to design custom images to fit cigar makers' brand mottoes. This was the true test of creative ability and ingenuity. Consider the unfortunate artisan who was asked one day to come up with an illustration to match the phrase, "Until Death Do Us Part." After days of deep contemplative thought and experimental doodling, the artist finally solved the problem by drawing a poor miserable wretch holding on to a bad cigar.

The variety of designs used on cigar labels far exceeded that of any other branch of the engraving art. In 1900, a New York lithographer (German, no doubt) stated in a newspaper article: "There is an ever changing demand for cigar labels, and it is something new, something new, every hour of the day. And better art is wanted. The Americans buy an article on its looks."

Of course, labels rolling off mechanical presses never quite matched the artistic quality, beauty, and excellence of the proofs which were made by hand. Being primarily a chemical process, lithography was largely affected by weather conditions. On warm, sunny days, for instance, a color pass would dry within a day, but in cold, humid, or rainy weather, it might take a week.

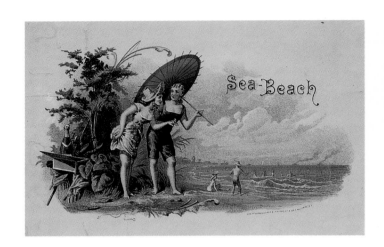

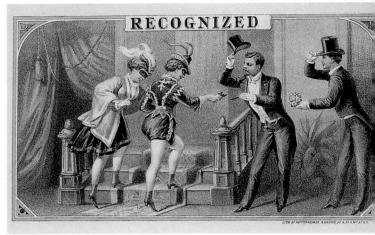

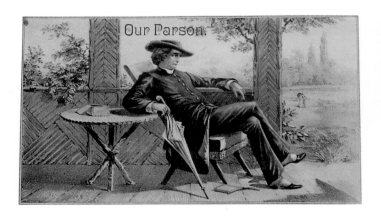

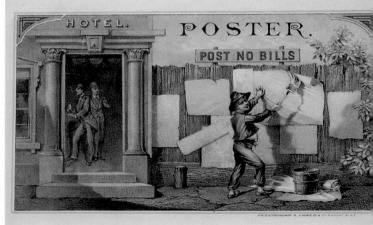

Heppenheimer & Maurer:
Master Portrait Makers

Before cigar box labels were mass-produced *in vivid colors, this New York City lithographic firm left a priceless legacy for future generations in a unique set of samples issued around 1880. The images shared a distinctive format—formal framed borders, detailed engravings, and simple one- or two-color combinations. They were not the most colorful labels ever made, but the themes captured much of the real essence and flavor of Victorian life in America.*

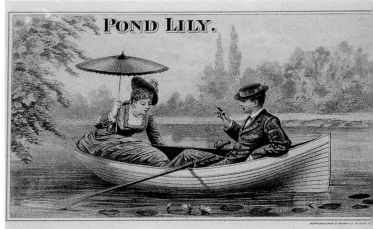

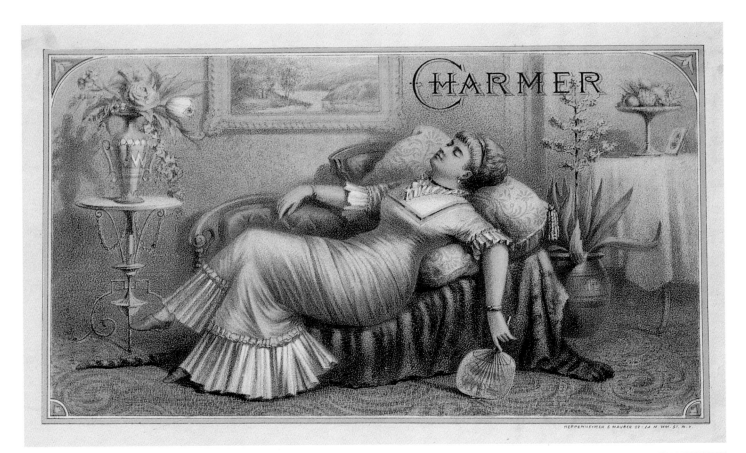

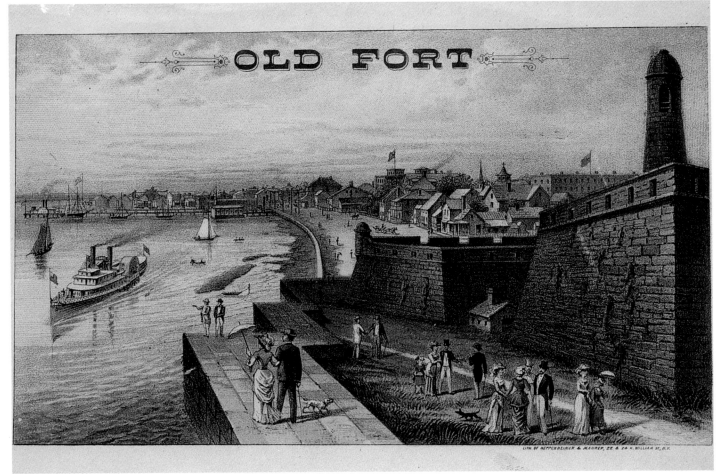

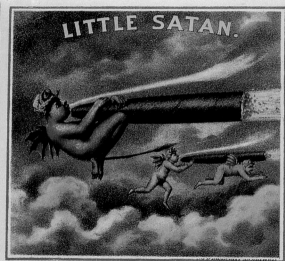

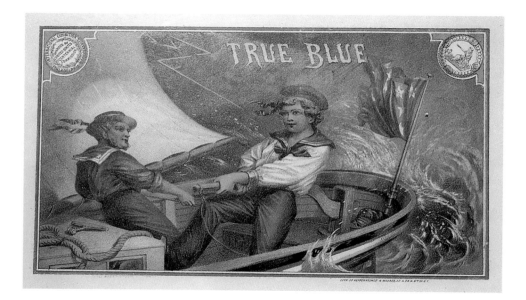

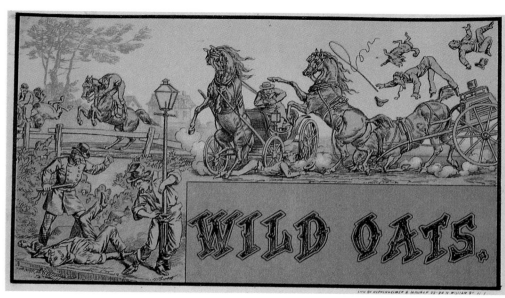

A Blaze of Color

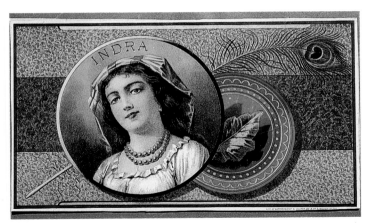

The move to brilliantly colored images *in the 1880s was celebrated with great passion and exuberance by such lithographic firms as Witsch & Schmitt and George Harris. The following works of art reveal something of the depth, intensity, and richness of color that could be imparted into something as ordinary as paper advertising labels.*

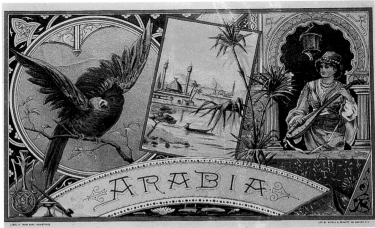

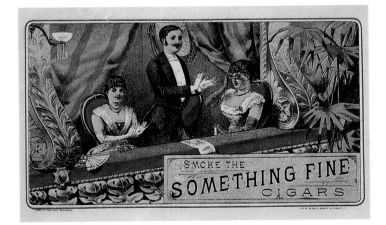

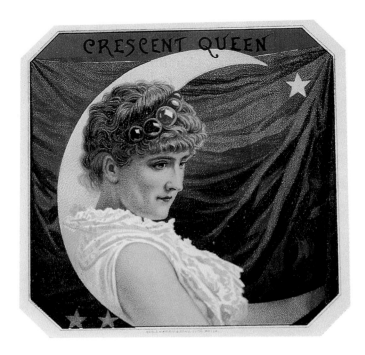

Brunswick

LITH. WITSON & SCHMITT, NEW YORK.

NEW BRICKS

LITH. WITSON & SCHMITT, NEW YORK.

The Label Artists

As with engravers of stock certificates, bonds, and bank notes, the highly skilled artisans who hand-designed cigar labels comprised a well-respected profession, but not necessarily a well-paid one. In the 1880s, for instance, they considered themselves lucky to be earning $25 a week. By the 1890s, however, when demand for cigar labels hit its peak, it was hard to find a first-class litho artist working for less than $60 weekly. The best ones took home as much as $75 and felt underpaid at that.

This specialized type of work never was an exclusively male profession. Although they dominated, men frequently worked side by side with female artists also engaged in the tedious, day-to-day output of cigar label illustrations.

As individuals, practically nothing is known of the talented and industrious corps of nameless, faceless professionals whose unsigned works constitute the field of cigar label art today. Such was—and is—the nature of the advertising business. Their job was to turn out images for commercial use, not to enter them in contests.

They never thought for an instant that future generations would consider their work with so much fascination and awe. It was only when artists reached national prominence, such as Winslow Homer, that we learn they started their careers as lowly assembly-line illustrators in lithographic houses.

We do know something, however, of contemporary artists employed in allied fields. Those who created artwork for Louis Prang in the late 1800s, for instance, have been identified and written about, and from this body of information certain generalizations regarding cigar label artists can be cautiously extended.

While most owners of lithographic companies were German immigrants who arrived on our shores with the first mass migrations from Europe in the 1870s, their staffs of artists were mostly native-born Americans. Virtually all were educated in art schools in the United States. It was also very common (expected, really) for novices to expand their training and add a crowning touch to their resumes by traveling to London, Berlin, Paris, and other capitals of Europe to receive instruction there from esteemed artists of the day. It was extremely rare, but some artists were self-taught, like W. Hamilton Gibson of Sandy Hook, Connecticut, who worked for Prang for many years.

Almost all artists were members of national professional associations such as the National Academy of Design, the Society of American Artists, the American Water Color Society (founded in 1866), the Art Students' League, the Society of Painters in Pastel, and the Woman's Art Club, as well as local organizations such as the New York Etching Club, the Boston Art Club, and the New York Water Color Club. A few instructed at local art schools such as the School of Artist-Artisans in New York City, or, like Homer, produced sketches for national magazines such as Harper's Weekly and Leslie's Illustrated Weekly.

While some craftsmen possessed added expertise at etching or engraving, they all had mastered one or more of the basic art techniques—oil, pencil, or watercolor. Some proved particularly adept at certain artistic genres such as landscape scenes, flowers, children, or portraiture, and applied their distinctive hand to these specialized subjects for cigar labels.

As a matter of fact, to the highly discerning eye today, the work of a particular artist can be seen in cigar labels issued from different lithographic houses, proving the simple fact that some of them, like any other kind of employee, moved around, professionally speaking.

Major Cigar Box Label Lithographers and Dates of Business Operation

American Lithographic Company, New York City (1892–1930)

Boyd & Co., New York City (1880–1890)

Calvert Lithographic Co., Detroit (1861–1970)

Cole Lithographing Co., Chicago (1903–1922)

Guenther & Mueller Co., St. Louis (1898–1902)

Harris, Geo. S., Chicago (1847–1872)

Harris, Geo. S. & Sons, Philadelphia (1873–1892)–sold to Amer. Litho. Co. in 1892

Heffron & Phelps, New York City (1880–1890)

Heppenheimer & Co., New York City (1849–1874)

Heppenheimer & Maurer, New York City (1874–1885)

Heppenheimer's (F.) Sons, New York City (1885–1892) (merged with Amer. Litho. Co. in 1892)

Howell & Co., Elmira, New York (1897–to present)

Johns & Co., Cleveland (1879–1902) (became Otis Litho in 1902)

Krueger & Braun, New York City (1884–1904)

Mensing & Stecher, Rochester, N. Y. (1880–1885)

Moehle Lithographic Co., New York City (1900–1930) (bought out by O. L. Schwencke in 1900)

Neuman, Louis E. & Co., New York City (1870–1898)

Schlegel, Geo. Litho. Co., New York City (1845–1934)

Schmidt & Co., New York City (1874–1916)

Schumacher & Ettlinger, New York City (1883–1892) (became part of Amer. Litho. Co. in 1892)

Schwencke, O. L., New York City (1870–1880)

Schwencke, O. L. & Co., New York City (1884–1900) (became part of Moehle Litho. Co. in 1900)

Schwencke & Pfitzmayer, New York City (1875–1884)

Steiner, Wm. & Sons & Co., New York City (1890–1926)

Wagner, Louis, New York City (1895–1915)

Witsch & Schmitt, New York City (1880–1892) (sold to Amer. Litho. Co. in 1892)

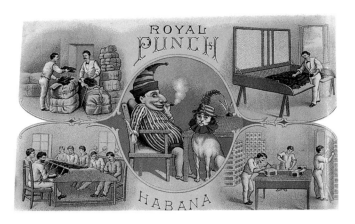

IDOL

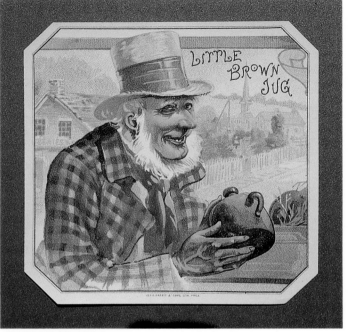

LITTLE BROWN JUG

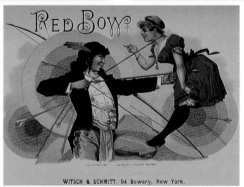

RED BOY

WITSCH & SCHMITT, 94 Bowery, New York.

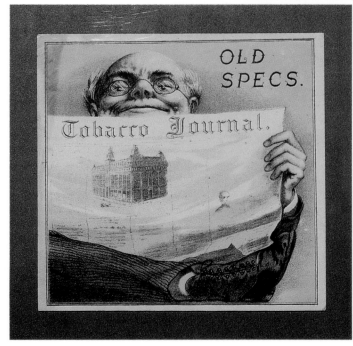

OLD SPECS.

Tobacco Journal.

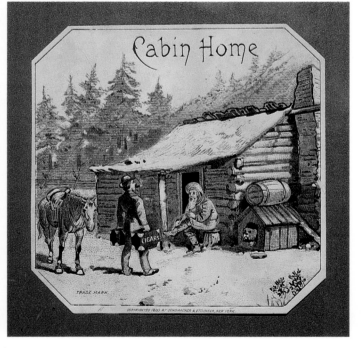

Cabin Home

TRADE MARK.

The Golden Rule

"Lastly (and this is, perhaps, the golden rule), no woman should marry a teetotaller, or a man who does not smoke. It is not for nothing that this 'ignoble tabagie,' as Michelet calls it, spreads over all the world. Michelet rails against it because it renders you happy apart from thought or work; to provident women this will seem no evil influence in married life. Whatever keeps a man in the front garden, whatever checks wandering fancy and all inordinate ambition, whatever makes for lounging and contentment, makes just so surely for domestic happiness."

—Robert Louis Stevenson,
Virginibus Puerisque (1881)

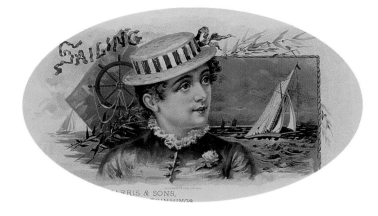

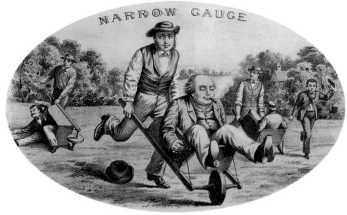

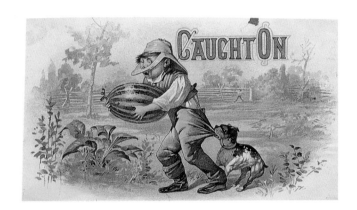

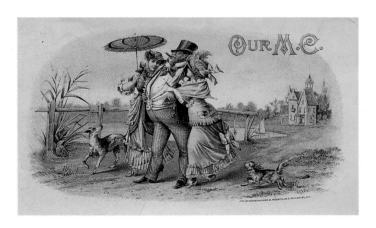

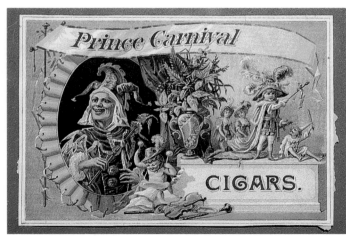

The Cuban Connection

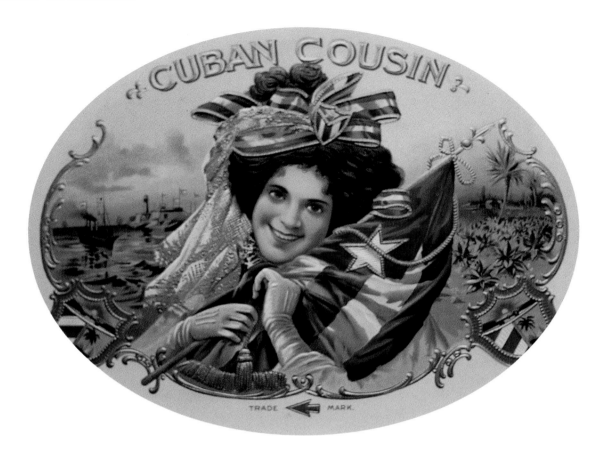

Ever since Spain claimed Cuba as a colonial possession, Spanish galleons carried back to the mother country a domestic product that was almost as precious as the gold and silver plundered from Indian civilizations of Central and South America—cigars. Spain developed a taste for these New World rolls of tobacco and, following Napoleon's invasion of Spain in 1803, the cigar's popularity spread like wildfire throughout Europe.

Spain was initially protective of this special island export. In the early 1800s, cigars were sold to the Cuban public in wrapped bundles of twenty; total production was on the order of four- to five-hundred thousand per year.

Finally, in 1818, Spain passed laws liberalizing the international trade of Cuban cigars and tobacco and sales spurted dramatically, increasing each year until 1826 when they topped two million. It was about this time that demand for Cuban cigars, already acclaimed the best in the world, really picked up and, by 1848, the number sold reached three-and-a-half million. Exportation of cigars continued to rise. In 1866, the amount sold by the Don Francisco Cabaños factory in Havana, for instance, exceeded sixteen million.

It was about 1810 when the first imported cigars from Havana trickled onto the United States market. The American craze for Cuban cigars began in earnest around 1860 and since then the Cuban cigar industry has been inextricably linked with our own. For close to two centuries now, Havana cigars have been, by common agreement, the finest in the world and have become the yardstick of quality by which all others are measured.

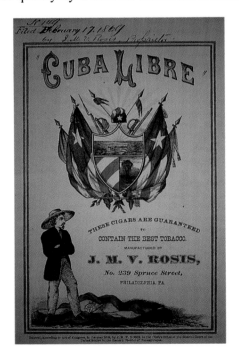

The Finest Cigar Tobacco in the World

The main reason for the exquisite smoking qualities of Havana cigars can be traced precisely to the western end of Cuba in the province of Pinar Del Rio. There, in a narrow, eighty-mile-long, sun-drenched valley known as Vuelta Abajo, the soil and climatic conditions allowed the cultivation of a superior quality of leaf tobacco. From the early 1880s, the words "Vuelta Abajo" became forever synonymous with the world's finest cigar tobacco.

To the eye, Vuelta Abajo tobacco leaf was unsightly in appearance–oily, dull, and covered with fine hairs-but when rolled into a cigar it offered the smoker a flavor as rich as it was rare. The leaf burned evenly with a clear steady fire and threw off a delightful and distinctive fragrance that never lost its zest and aroma, even when the cigar was allowed to go out, become cold, and then re-lit.

It was like a priceless, vintage brandy. Once a man tasted Vuelta Abajo tobacco on his lips, he never forgot it and never mistook it for anything else. Such was its exceptional mark of quality.

Not all tobacco grown on the island of Cuba was of the finest quality. Yara, for example, was a good grade of Cuban tobacco, but its smoking qualities were judged coarser than that of Vuelta Abajo. Nonetheless, Yara leaf was still far superior to any cigar tobacco grown in the United States and imparted "tone" to Connecticut tobacco with which it was commonly mixed to produce what was known in the American trade as the "seed and Havana cigar." A century ago, most Yara cigars were exported to Europe (London in particular) where smokers developed a taste for them.

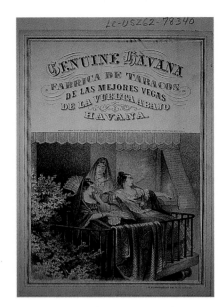

There was no sex discrimination *in Havana last century when it came to smoking. Cigars were a common pastime with many señoritas who were not ashamed to take their habit out of doors.*

Good grades of leaf tobacco were grown in other districts in Cuba, to be sure, such as the more attractive but less fragrant Partidos, the large, four-foot-leaved Remedios used mainly in "seed and Havana" cigars, or any of a half dozen other varieties, but the best was still that grown in the Vuelta Abajo.

A typical Cuban tobacco yield in the 1880s, cultivated on approximately 67,000 acres, averaged between 400,000-500,000 quintals annually (20,000-25,000 tons). The tobacco was shipped to Havana where it was bought by local cigar manufactories to be made into cigars for export. The rest of the leaf was packed into bales and shipped abroad.

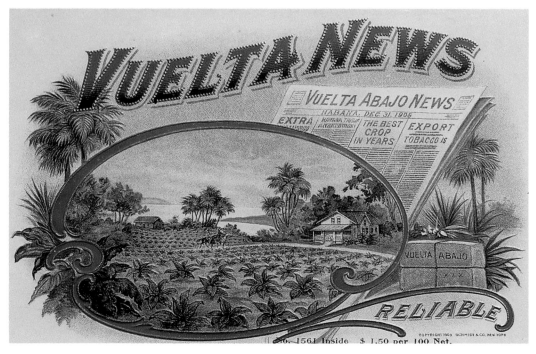

Making Cigars in Cuba

Cigar factories in Havana in the early 1870s numbered more than one-hundred-and-twenty-five and ranged in size from small shops opening on the street employing three or four hands to immense *fabricas* (factories) erected specially for cigar production where five- to six-hundred workmen rolled cigars.

By 1885, the Havana cigar industry employed about seventeen-thousand people and those who rolled cigars were the most prized employees by factory owners. As much as forty dollars in gold was paid to these skilled workers for making a thousand cigars. One of the largest factories in Havana was the Bock firm supplying the Henry Clay brand, which turned out eighty- to one-hundred-and-twenty thousand cigars each day.

Of foreign businessmen in Havana in 1887, most were German and the majority of them were engaged in the tobacco trade. At that time, there were twelve to fifteen large, wholesale tobacco houses exporting about $15 million worth of Havana cigars and tobacco annually to all points on the globe.

Anyone wishing to become a cigar manufacturer in Havana in 1885 obtained a license from the government

and was then permitted to apply for and receive as many trademarks as he wished. Small manufacturers who had no brands or trademarks usually contracted their services to larger companies.

New brands were generally introduced on the market at dirt-cheap prices, but if they sold well, prices were hiked accordingly. Enormous profits could be made by owners of popular brands and many a proprietor provided well for his retirement by selling off trademarks.

Since the beginning, the center of the Cuban cigar industry was always in Havana, the capital city. Manufacturers were typically Spanish or Creole (later in the 1890s German immigrants entered the field). Workers were a mixture of all classes—Creoles, Orientals, Spaniards, mulattos, and blacks. Most of the latter group were slaves, but they tended to be poor investments and brought little profit to their owners. The going price for a good slave cigar-roller during last century ran from $700 to $1,000. But they had to be fed, clothed, and housed and, in the end, had the annoying habit of running away.

As a group, Havana cigar makers were a most unpredictable and frustrating lot to deal with. Their work ethic was directly tied to the tobacco crop. In flush times when the harvest was good and work plentiful, they generally proved unmanageable, demanding, and difficult to please. If the tobacco crop was bad, however, they became tractable only out of necessity. Manufacturers then had their pick of the labor force and those owners who offered the largest advances of wages secured the best workers.

This system of advancing money was fraught with problems. Cigar makers who could not—or would not—repay what essentially constituted a loan were thrown into prison. Sometimes the number of deadbeat workers ending up in jail caused significant shortages in skilled

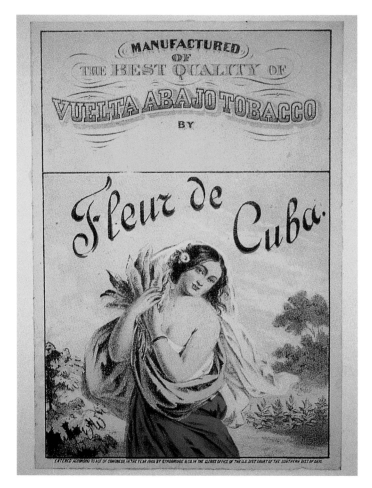

labor. Another nuisance was the long-established habit of paying factory hands three times a day—at breakfast, lunch, and supper.

The manner in which Havana cigars were made varied somewhat from that in the United States. Cuban manufacturers, for one thing, made their cigars smaller. Cigar makers faced a wooden model of the cigar to be rolled and also had a flat piece of wood with a hole in it through which the cigar was drawn.

In making a cigar, rollers took two or three pieces of leaf tobacco and placed them flat in their left hand. Then, taking as many smaller pieces as were needed, they rolled them all together into the shape of a cigar and applied the wrapper last. The mark of the expert roller was to cover the veins in the tobacco leaf or to place them all on one side.

The heads of Havana cigars were not held together by gum or any other sticky substance, unlike those turned out in America, but with wheat bread which the workmen carried with them. Its taste could not be detected when the cigars were smoked. In contrast, the ends of expensive cigars were shaped and secured not by wheat bread but through a series of tight twistings and turnings of tobacco leaves that only deft hands could accomplish.

The typical workday ran twelve hours, winter and summer, and the finished cigars were bound up in bundles of fifty. Using time-honored guiles of merchandising, the best-looking specimens were placed on the outside and those with sides showing veins were turned to the inside. An efficient roller could turn out two-hundred to two-hundred-and-fifty cigars daily.

Working conditions in the average Havana cigar factory were far from tidy and clean; some were downright appalling. As a matter of fact, if any smoker could have seen how often the tobacco came in contact with spittle and the naked feet of the workmen, he would have lost his appetite for Cuban cigars forever.

Cuban cigar makers were traditionally allowed to smoke as many cigars on the job as they wished. In the evening, they took at least six more cigars home with them. They considered this a privilege, not stealing, but large-scale theft of cigars by hired help was always an ever-present danger.

Police rarely interfered in instances of employee theft. If the proprietor lodged a formal complaint, it was only to rid himself of the dishonest employee. The factory owner was certain to mention to the police that he did not expect return of the stolen goods—for good reason. If they were recovered, the payment to the police far exceeded the cigars' commercial value.

It was interesting to see skilled tobacco artists at work in the prominent cigar factories of Havana long ago, rolling truly expensive cigars for the European market. The number of men qualified to do this kind of work was small and most men worked only a few hours at a time.

They earned top wages and could afford to take things easy since demand for their skills was always far greater than supply. A newspaper reporter once watched one of these artists fashion a difficult shape for one of the European courts.

After he finished applying the wrapper on the cigar, he held it up before him, admiring it much as a painter admiring his work of art after applying the final brush strokes to the canvas. The cigars this man made cost $1,500 for a thousand wholesale (a tidy sum even today, and more so in 1900) and were packed neatly in expensive, inlaid wooden cabinets.

The value of Cuban cigars was not determined by size. Manufacturing costs escalated rapidly, for example, if difficulties arose in procuring good wrappers. The following story illustrates this point:

One time in Havana, a manufacturer received an order for a thousand cigars intended for the Queen of Spain's husband, Don Francisco de Asis, which the manufacturer agreed to do for $1,000. The cigars were made in due time and then packed in an elaborately decorated cedar chest.

They were magnificent Cazadores, all the same color and all so smooth they they looked like they had been lathed from hardwood, not rolled from tobacco. The cigars were placed on exhibit for a few days in Havana before they were shipped to Spain. A gentleman of means happened to see them and asked the manufacturer to make him the same number for the same price.

To the gentleman's surprise, he was refused. The manufacturer explained that he could not do it again for that kind of money. It was not the cost of the tobacco that was the problem, it was the time and the trouble. It meant the cigar maker had to pick over thousands of bales of tobacco in order to find enough leaves of the proper length, color, and fineness suitable for wrappers.

For many years in Cuba, enormous pride and honor surrounded the making of cigars by the old pioneering families. Thus it came as no surprise when, in the late 1880s, Pedro Murias, head of the great Murias cigar factory in Havana, closed his factory for an entire year because the current crop of tobacco was so poor in quality that he refused to risk damage to his reputation by making cigars with it. Such drastic and unselfish actions were not rare in those days.

Cigars made in Havana for the export market were first packed at the factory in small wooden boxes containing fifty or one hundred cigars and then loaded on steamships in large pine crates holding two hundred of the former or one hundred of the latter.

And speaking of Cuba's famous exported cigars, the finest brands were invariably shipped to Europe to satisfy the esthetic demands of royal and aristocratic houses.

A good example was a cigar called a Napoleon, a very large model that was originally made for the French emperor. Napoleon's death, however, did not stop the popularity of the namesake cigar, which continued to be exported abroad. They cost one dollar each, American money.

Every one of these expensive Napoleones was made with the best grade of tobacco available in Cuba and hand-crafted with great skill. No gum, for instance, was used to turn and form the ends of the cigars. This challenging feat was accomplished instead through delicate and intricate workmanship.

The Reader: An Old Spanish Custom

A unique feature of most Cuban cigar factories was the professional reader. Each room of the factory featured a bench or wooden pulpit attached high on the wall. On or in it sat a man, selected for his voice quality and ability to read, who was employed by the workers to talk for hours to the army of rollers. He read from daily newspapers, recited poetry, and told stories, or talked about anything the workers wanted to hear. The pay for this tedious job was good, though—$10 a day, in gold.

The purpose (and value) of the reader depended on

the point of view. From that of the employees, it was for entertainment and to make time pass faster. From that of the factory owner, it was to keep the workers busy making cigars.

Why the reader became necessary at all was due to the Cuban's typically excitable nature. While working, the average Cuban felt uncontrollably compelled to talk, but at the same time was equally compelled to gesticulate wildly with the hands and arms. Simply put, it was hard for Cubans to talk and work at the same time.

This was not conducive to the rolling of cigars. To meet this peculiarity of temperament and to prevent workers from talking with their hands as well as their mouths, readers came into the factory scene as a blessing to the factory owner—most of the time, that is. Readers proved a two-edged sword to management; most worked out well but some were natural-born agitators and caused serious problems, namely, strikes.

Exporting Havana Leaf

Havana leaf tobacco was always hard to get in the United States during the last century and, when available, commanded high prices. This was due to the peculiarities of the cigar industry in Cuba.

In the 1880s and thereafter, Cuban leaf tobacco that was exported to the United States and called "Havana" more often times than not came from the Vuelta Arriba area, not Vuelta Abajo. Tobacco grown in the famed Vuelta Abajo district was almost completely absorbed by manufactories in Havana to make cigars for the export market.

Factory owners contracted for future tobacco crops with the best plantations in Vuelta Abajo, which caused the growers to remain mortgaged (and therefore obligated) for years to come, just as had been the case with cotton plantations in the South before the Civil War. As a result, very little true Havana leaf was available for export.

Pictorial Homage to Cuba

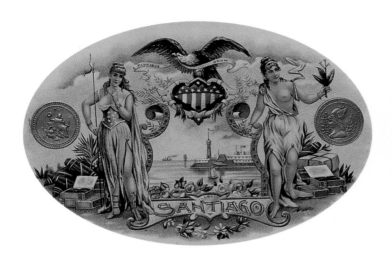

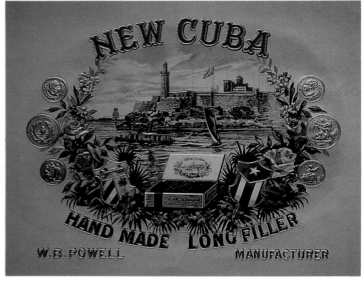

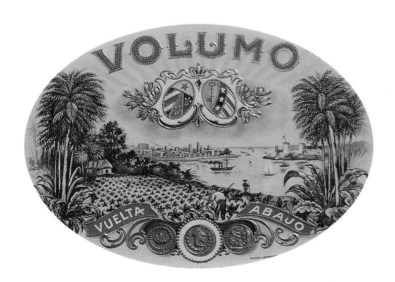

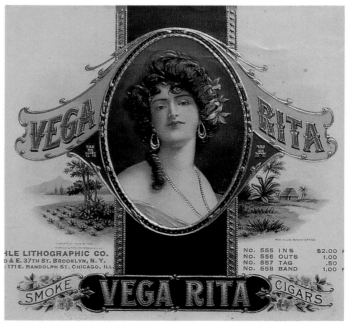

The depiction of Cuban themes *and use of Cuban place names on cigar labels was a common advertising ploy indulged in by manufacturers, especially after the turn of the century. The cigar men took advantage of the long-standing association of quality goods with the island empire.*

Key West Cigars

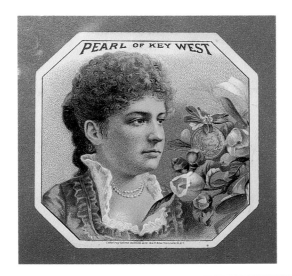

Following civil unrest in Cuba in the 1870s, thousands of Spanish and Cuban cigar makers fled the island and made their way across the channel to Florida, bringing with them a centuries-old tradition and skill in hand-rolling cigars. The émigrés settled initially in Key West and erected large factories there. It wasn't long before their products made significant inroads in the cigar market.

Later, the Key West industry spread to Tampa and, because of better shipping facilities there, Tampa went on to dwarf the original cigar making colonies in Key West. By this time, forward-thinking cigar manufacturers in New York City began to import Havana tobacco and combine it with domestic leaf to create, in a sense, a hybrid cigar that was still a darned good smoke and priced very competitively.

By 1880, the list of available choices had expanded. When cigar smokers entered a tobacco shop and asked for an imported cigar, they got one made in Havana. If they asked for a Key Wester, they were sold a cigar that in every respect was as good as an imported one except that it was made in Florida, not Cuba. If customers asked for a domestic cigar, they were handed, in exchange for a nickel, a cigar made entirely of domestic tobacco, or one filled with Havana scraps. For a dime, they received a cigar made with Havana filler and a wrapper of genuine Connecticut leaf.

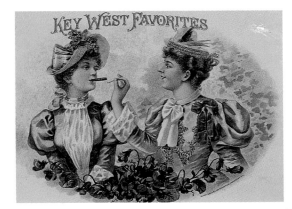

Regardless of where they were bought or what label they were sold under, these three distinct classes—imported, Key West, and domestic—comprised all cigars sold on the market in the United States in the 1880s.

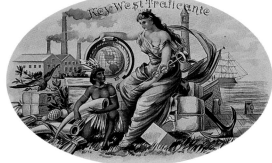

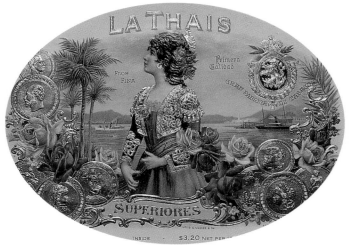

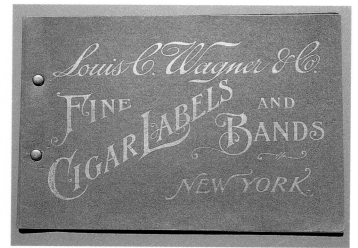

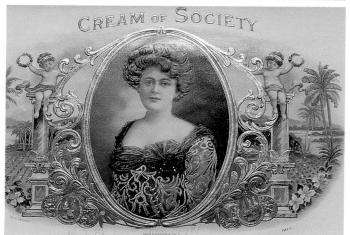

Sample Books: A Taste of Elegance

Sample books, first issued in the early 1880s, *were a great boon to the cigar label business. The bound volumes of stock images made it easy and convenient for cigar manufacturers to not only select a brand name but a beautiful illustration to go along with it as well. Oddly, sample books were quite deceiving at first glance. This was so because the covers, virtually without exception, looked dull, plain, and uninviting. But once inside, browsers found page after page of some of the most gorgeous paper images they had ever seen.*

Good for Your Health

Smoking cigars, as late as the 1850s, was still considered by certain physicians to possess important therapeutic properties, at least in Europe. A London newspaper article of 1852, for example, stated that the incorporation of volatile organic and inorganic chemicals (Raspail's camphor, corrosive sublimate, stramonium, and cicuta) into nicotineless tobacco and smoked in cigars was used in treating "some forms of ulcerated throat."

Similar feats of medical magic were performed by the inventor, Dr. Landerer, who moistened tobacco leaves with "tincture of iodine, a solution of mercury in sulfuric ether, or a solution of potassium iodide" before rolling them into cigars. The well-meaning but misdirected doctor also experimented with tobacco soaked in a solution of creosote, spirit of wine, and ether, and found cigars made of this tobacco quite effective in treating "scorbutic ulceration of the gums," as well as ordinary toothaches.

Cigars containing a dilute form of arsenic, made by steeping tobacco leaves in Fowler's solution (well known today as a carcinogen) also showed great promise in fighting disease, all of which proved that if the ailment didn't kill you straight-away, then the treatment eventually would.

Smoking and Spitting in the 1870s

Spitting has always been considered a drawback to the pleasures of smoking and over a century ago was a decidedly obnoxious social nuisance.

To complicate matters, prevailing medical opinion of the 1870s caused smokers to be caught on the horns of a dilemma—excessive spitting exhausted the salivary glands and this, it was believed, predisposed tobacco users to disease.

On the other hand, not spitting caused an even greater peril: Swallowing the juices of the weed altered fluids present in the stomach and interfered with proper digestion which, although not specifically identified, implied ghastly consequences, scaring the consumer.

Fortunately, there was good news for smokers and spitters. Enjoying a good Havana cigar, it was claimed, as long as it was not smoked down to the very tip, led to little saliva production and was therefore considered the safest, most healthful way to use tobacco.

By the 1880s, the virtues of tobacco as a medical cure-all were still held in high esteem by vast numbers of people, both lay and professional. For reasons of convenience, if not conviction, these beliefs also served as ready excuses for those who had no intention of abandoning the use of tobacco.

Medically speaking, while the tobacco habit at this time in history was largely considered an innocuous

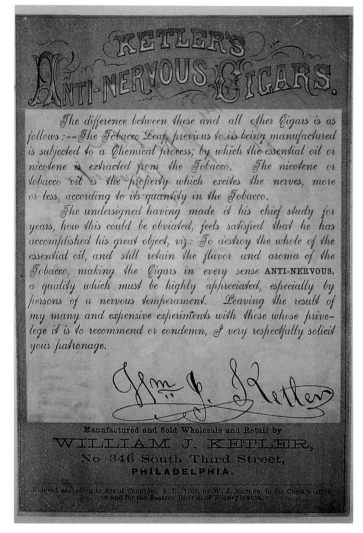

The belief that smoking relieves nervous tension *has been around since Elizabethan days. In 1867, an enterprising cigar maker, William J. Ketler of Philadelphia, capitalized on the notion by aptly naming his cigars, "Anti-Nervous." This particular claim was widely used in the trade until the 1920s when the Federal Trade Commission finally ordered its halt.*

pastime, its abuse was blamed, depending on the authority, for either a short or a rather long list of maladies. The common sense advice proffered addicts of Lady Nicotine by experts was: if you experience bad effects, give it up.

Tobacco, as a disinfectant, had few equals. Its use as a sheep and cattle dip was quite popular during the last century. Tobacco smoke (and especially snuff) was regarded as a good preservative of the teeth and constant use of tobacco was felt to give them a protective coating or "varnish." The coating was really nothing more than staining of the enamel by tobacco tars and oils and, while some people did not mind the appearance, it looked horrible.

Brushing with tooth powder two or three times a week helped keep the "ivories" looking uniformly bright. Not surprisingly, a mixture of cigar ashes and powdered cuttlefish (squid) or orris root, plus a few drops of oil of

cloves, was highly recommended in Victorian times as an effective dentrifice.

Freud and Cigars

Sigmund Freud, the father of psychoanalysis, was addicted to cigars. The psychological reasons for smoking obsessed him and the subject was once brought up as a topic of discussion at the Wednesday Society, the name given to an informal weekly gathering of fellow analysts in Freud's waiting room.

If anyone could have explained why men smoked cigars, it was the famous Viennese physician. Freud believed that cigars were "brain food" and smoking them enabled him to think better and clearer, a common opinion shared by many intellectuals in other fields besides medicine. Freud also thought that holding and savoring something in the mouth satisfied an inner instinctive need for love and nurturing.

Unfortunately, the great analyst's habit proved fatal. As happened with General Grant, Freud developed oral cancer from smoking and the disease progressed relentlessly despite a series of mutilating operations.

His painful suffering was finally brought to an end when, in 1939, his daughter mercifully administered a fatal dose of morphine, bringing relief in death to one of the world's most illustrious probers of the mind.

The medical endorsement *of the safety of cigar smoking was implied on these labels of the 1880s.*

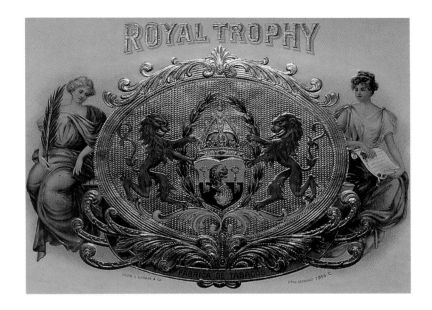

Gold Embossing

The most significant and dramatic printing innovation of this era was metallic embossing which first came into vogue in the early 1890s. While lustrous gold and bronze tones had already been incorporated into labels of the previous decade by such lithographers as Heppenheimer & Maurer, its effect was strictly two-dimensional.

This changed when special precision-made dies and thirty-ton mechanical presses were used to emboss the lithographic paper before color was added. A sizing agent was first applied to the raised portions of the die before it was dusted with bronze powder. Then the surface of the die was hand-polished to a high gloss with a leather

Bronze embossing plate.

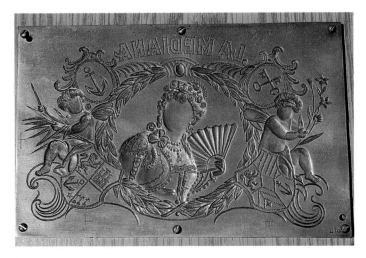

Brass embossing plate.

buffer.

European lithographers, on the other hand, tended to spring for the real article, mixing 24-carat gold dust with bronze powder to make an even shinier gold.

With either process, though, the visual effect was stunning—a three-dimensional, lifelike quality was suddenly imparted to images already ablaze with living color. Coins, medals, jewelry, and other ornamental doodads literally jumped off the paper and bedazzled the viewer's eyes. Almost single-handedly, embossing elevated cigar box label art to a new and exalted level of achievement and visual appeal.

And quite by chance, the advent of embossing led to another significant improvement in label making. Cigar box labels, up to this point in time, were printed on inexpensive, short-fiber paper that was composed mostly of wood cellulose. While the material was economical, it had the annoying habit of becoming brittle and discolored with the passage of time, ruining precious investments of time and money. But, worse yet, the paper was simply not strong enough to withstand the force of tons of steam pressure placed on it in the embossing die without tearing or breaking down.

There was little choice but to find a better quality lithographic paper. After experimentation, paper manufacturers developed a superior (and expensive) grade of paper made of cellulose processed from long fiber, acid-free, linen- or cotton-rag stock. No wood pulp or lignin was present in this special paper.

The finished product, similar to that used in banknote manufacture, not only proved extremely durable but refused to shrink or expand when placed in contact with water- and grease-based inks, even after being passed through as many as thirteen stones in the chromolitho-

through as many as thirteen stones in the chromolithograph process.

Lithographic paper was also coated with clay which offered several distinct advantages, both mechanical and esthetic. The clay prevented solvent-based inks from bleeding through the paper and the "ghosting" or lifting of images from the top of one sheet to the underside of another.

Fine examples *of the gold embossing art.*

This special coating also imparted a bright, glossy finish to the paper which enhanced appearance and, more importantly, facilitated the accepting of inks during printing. The clay also acted to preserve the paper by preventing discoloration and decomposition which explains why practically all of these age-old images look so fresh and clean today.

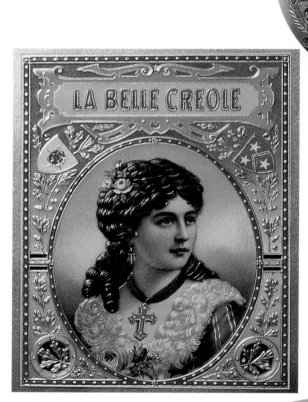

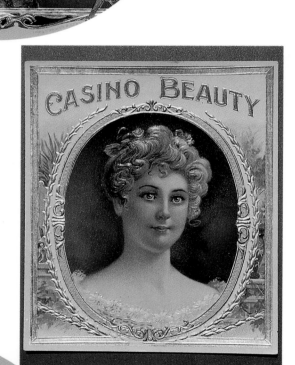

The Glint of Silver

Silver tones, as with gold, first appeared on cigar box labels of the early 1880s by lithographers such as Heppenheimer & Maurer. The change was another printing innovation designed to add a special dash and flair for appearance's sake.

The silver touch was resurrected during the 1890s and for a short time after the turn of the century. This time the silver effect was enhanced greatly through embossing. And for those cigar makers who did not think silver alone imparted enough visual dazzle and shine, printers were happy to add gold embossing to the same image to create even greater eye appeal.

Lithographers did not use real silver for embossing, of course. This was accomplished through the use of aluminum powder, which bestowed a silvery appearance.

But real dangers attended the industrial use of aluminum powder. Tremendous pressures exerted by heavy presses during the embossing process generated enough heat to ignite the fine powder and cause it to suddenly burn, even explode.

Accidents occurred and the threat of flash fires, it was said, made silver embossing a risky business, so risky that it brought an eventual halt to its use in lithographed paper labels.

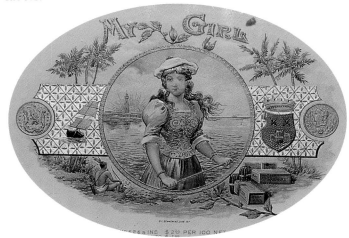

Artistic Trimmings

The Look of Linen

In an attempt to outdo competition, *some labels were lithographed on special paper to enhance visual effect. The Heppenheimer company, for example, produced labels in the 1880s on paper that had the texture, appearance, and feel of real linen. This extra touch, however, added appreciable cost, which was probably enough to make the "linen look" a short-lived fad.*

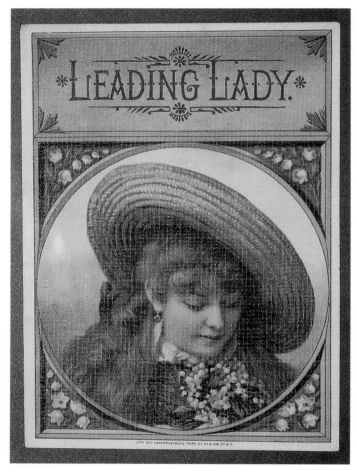

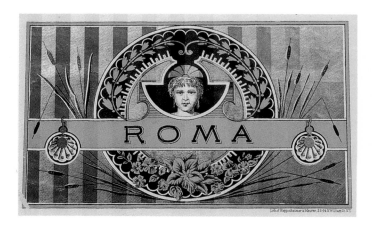

Stripes

For a period of time in the 1880s, *some cigar box labels were made which had parallel bands casting alternating shadows running vertically through the image. The visual impact was generally subtle; the label had to be viewed from an angle in order to appreciate the striped effect. With others, it was bold enough to be seen head-on. This herringbone pattern was produced with special paper. Again, printing frills like this were strictly experimental and this particular technique didn't survive the decade.*

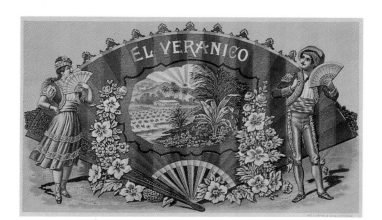

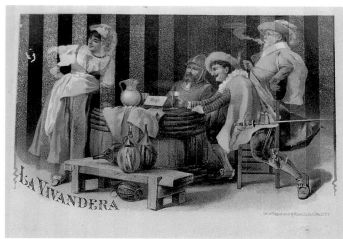

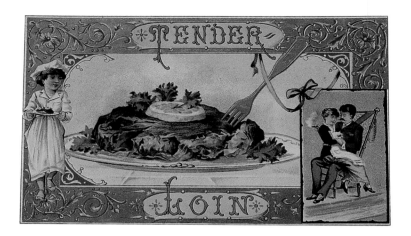

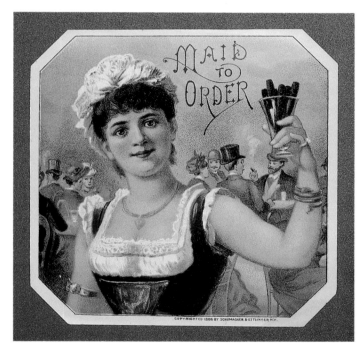

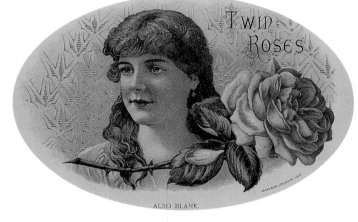

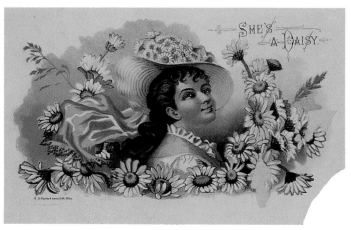

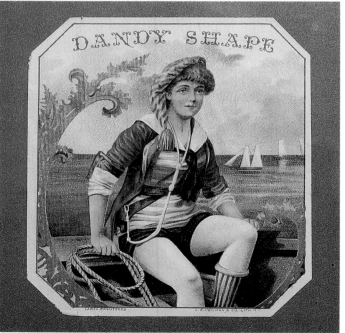

The use of double meanings *in naming brands of cigars was a not an uncommon feature in the old days. The most popular subject, naturally, was the fair sex and was typically rendered in a benign and complimentary way. Sometimes, though, implications were a tad racy, at least by Victorian standards.*

Cigars Become King

As America recovered from the Civil War, a nineteenth century industrial revolution dawned, one marked by unprecedented technological advancement and the formation of giant industrial and banking empires. In those halcyon days, long before income tax became a hard fact of life, men of means, as well as their imitators, sought and found in the cigar a more manly and emblematic means to fit their worthy images. It was not hard to understand how or why this particular form of tobacco achieved such widespread use.

Snuff was passé. The powdered and scented tobacco, once the rage of European kings and their courts (plus a Pope or two on the sly), barely survived the colonial period and its use was primarily confined to old judges in satin waistcoats and gouty Old World aristocrats in powdered wigs, as well as a certain breed of earthy women in rural America who dipped it on a stick.

Chewing tobacco offered no better persona. With few exceptions, notably down South, it was still regarded by most people as a vile, vulgar, and repulsive social habit that, even with the passage of time, never shed its disreputable image. Worse, it typically branded the user as a commoner and one unmistakably (and regrettably) "in the trades," marked by their lumpy jaws and amber-colored stains on their whiskers and shirt fronts.

The pipe was the official badge of the thinker and marked the man who had too much time on his hands, and a convenient bucket of shag at his elbow. But pipe smoking was an impractical and untidy habit for important men on the move. They couldn't afford the precious time to stop what they were doing, load up their hand-carved meerschaums, ignite a load of tobacco, and keep it lit.

Pipes had the dreadful and annoying habit of going out. Furthermore, they periodically ejected red-hot embers which burned ugly holes in the smoker's velvet smoking jacket, favorite upholstered armchair, and expensive Oriental carpet. This type of smoking ritual simply did not fit the busy business schedule or fastidious personal habitude of a true connoisseur of the weed.

And there was no real competition from cigarettes—not yet, at least. Domestic production of these newfangled smoking articles was still in its infancy. Besides, cigarettes were strictly big-city items. Typically perfumed, they catered primarily to adventuresome young damsels who lit up in the privacy and sanctity of their parlors, and prissy dudes and dandies of high society.

While other types of cigarettes could be readily found on the market, they were hardly designed for the delicate palate. Imported from Cuba, wrapped in dingy, yellow paper, and filled with harsh-smoking tobacco, they found steady patronage in lower classes of society. Cigarettes of

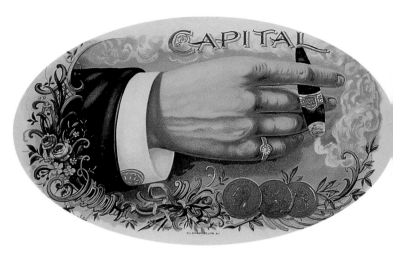

the 1870s and the 1880s were clearly not a cultured man's smoke.

And so it was that the cigar established a strong foothold in the smoking preferences of the American male that would last through the turn of the century.

A Change in Composition

By the 1880s, after the Tampa-based cigar industry divided honors with Key West, new types of cigars began appearing on the market that were different from the strictly Cuban type. A small amount of domestic tobacco from the North was worked into the cigar. The end result was that the terms, Key West and Tampa, no longer retained their individual characteristics, although they still represented a fine quality product. From the transition came a new term, "clear Havana," which was used to designate a cigar made entirely of Havana tobacco, wherever it was made and no longer just in Cuba.

About the same time, on the island of Sumatra, a Dutch possession in the East Indies, a new kind of tobacco leaf was discovered that showed great promise as a wrapper. Enthusiastic cigar manufacturers in the United States began importing this product to replace the coarser domestic wrappers currently in vogue. Its attractive color, silky and elastic texture, marvelous thinness, and free-burning qualities made it very desirable. In spite of a heavy duty—$2 a pound—American cigar makers imported tremendous quantities of Sumatran leaf.

The popularity of Sumatran tobacco paid off in another way—it inspired the improved cultivation of domestic tobacco in New England, Florida, and Georgia. Soon a new variety of leaf tobacco emerged, called the shade-grown wrapper. Aptly named, this tobacco was

grown under artificial shade (tents of cheesecloth), which enabled the tobacco to ripen slowly into large, thin leaves of fine grain, extremely well suited for use as a wrapper.

The cigars of Puerto Rico and the Philippines, with the exception of the old-fashioned black Manila cheroot, fell into virtual business extinction, that is, until after the Spanish-American War when leaf tobacco of Puerto Rico and Philippine cigars staged a mild market comeback.

By 1900, the number of cigars, cheroots, and stogies made and smoked in the United States was a trifle less than seven billion, the highest point of consumption ever. But old-time smokers had become confused at times over what appeared to be changes in marketplace cigars. Nearly half of those being consumed were different in character from those made thirty years before.

These changes did not affect the genuine imported Havana much at all. The smoker who was partial to imported brands had merely to ask his dealer for the same, and to look for the U. S. customs stamp on the box of cigars. This guaranteed their authenticity.

The cigar previously known as the Key Wester was now going by the name "hand-made clear Havana." Every dealer carried at least one brand of such cigars, usually in various sizes. For the dubious smoker who had reason to doubt the genuineness of this brand, all he had to do was demand a *bonded* clear Havana. U. S. customs inspectors in Key West and Tampa factories, by affixing bonded stamps on the boxes, ensured that cigars therein were made entirely of Havana tobacco and by the traditional Spanish hand-method.

The greatest change in composition, however, came with domestic cigars. Here true confusion reigned. A wide variety of tobaccos used as fillers, binders, and wrappers kept undergoing periodic manufacturing favor. Connecticut shade-grown, Florida shade-grown, and Java wrapper varieties were added to the standard Sumatran and Connecticut wrappers.

Old-time aficionados accustomed to domestic cigars were now tempting their smoking palates with products made in Puerto Rico, of which 156 million were being consumed annually, or with Manila cigars, a quarter of a billion going up in smoke every year.

If a smoker hankered for the five-center of his younger days, he had to call for a cigar with a Sumatran or Connecticut wrapper and a long filler of Ohio tobacco or Havana scraps, or a combination of both. If his taste ran to the old ten-center, he demanded one with the same wrapper but with a long Havana filler. It no longer sold for a dime, however; it ran fifteen or twenty cents.

A major reason shade-grown Connecticut wrapper was coming into vogue was that the leaf was light in color. Nature intended that tobacco leaves, when cured, take on a rich nut-brown hue, but it was also the habit of nature to produce some lighter-shaded varieties, such as the Connecticut shade-grown one.

Changing consumer demands happened to fit into this scenario like a hand in a glove and the timing proved fortuitous (and profitable) for cigar manufacturers. Smokers were becoming more health-conscious now and were led to believe that light-colored cigars were milder in taste, hence healthier, than the long black cigar preferred exclusively in grandfather's day, a false notion fostered in advertising copy by manufacturers who just happened to make light-colored cigars.

Smokers were now insisting upon cigars with an outer wrapper that was both very thin in texture and light in color. This demand spawned the birth of growing tobacco in Connecticut and Florida under tents of cheesecloth, a costly process.

A proud cigar leaf dealer *poses with his goods in hand, and in mouth.*

The Nickel Cigar

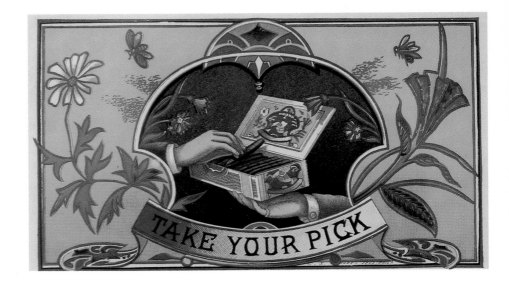

For five cents in the 1890s, you could buy a loaf of bread, a quart of milk, a bottle of beer (with a free lunch and floor show thrown in for free), or a good cigar. This was the era of the famed nickel cigar, the most successful cigar ever marketed in history.

Opinions about the nickel cigar of Victorian times ranged widely, even among smokers, dealers, and manufacturers. This was a predictable situation which was probably due more to individual differences in smoking tastes than to real qualities of the tobacco.

Some experts considered the nickel cigar almost as good as an imported Havana and a true bargain at the price. This was hard to believe since nickel cigars were made entirely of domestic tobacco. Because of this, many cigar fanciers looked down their noses at nickel goods and called them "cheap cigars."

The meaning of the famous whispered remark made on the Senate floor by Vice President Marshall in 1905 during a debate, "What this country really needs is a good five-cent cigar," can be taken two ways.

On the one hand, smoking qualities of the nickel cigar had already hit the skids and Marshall may have only been expressing genuine dismay over this fact and truly yearning for a good, inexpensive smoke of days long past.

The remark can also be construed as pure sarcasm. There was not a single cigar maker in the United States who did not honestly believe that his product was the "best in the world," and, in truth, this phrase became the most overworked and cliché-ridden advertising claim ever made in the history of the cigar industry.

The Spanish-American War

The Spanish-American War had severe repercussions on the cigar trade in the United States. In May, 1896, as war grew imminent, Spain dispatched the infamous Captain General Weyler to Cuba to quell the gathering insurrection. In addition to inflicting a host of atrocities on the civilian population, Weyler issued an official order forbidding the exportation of tobacco leaf from Cuba.

The news stunned cigar makers in the United States. Manufacturers of Havana cigars, especially small operators, shuddered in horror at the thought of running out of the precious leaf and not being able to buy more Cuban wrapper at any price. Many factories across the country fully expected to shut down operations within three months as they used up their last remaining supplies.

Large and well-heeled tobacco importers, on the other hand, planned to ride out what they hoped was a temporary situation (with an eye to quick profits, too). They quietly invested all their spare cash in Havana tobacco, fully anticipating such a situation to develop. The sudden demand led to a thirty percent surge in prices for imported leaf.

Some importers and cigar manufacturers like Eugene Vallens of Chicago spoke up in defiance of the Spanish embargo, suggesting that the United States retaliate by increasing duties on imported Cuban cigars and forcing the American public into consuming more domestic cigars. In Tampa, news of Weyler's order led to consternation among members of the local cigar industry who forwarded immediate protests to Madrid.

Weyler's edict was a punitive one, designed solely to close up American cigar manufactories dependent on Cuban tobacco. The Spanish general knew most of the factory workers in the U. S. were Cuban expatriates who regularly sent part of their pay checks home to fund the cause of Cuban insurgency. But the embargo also threatened the economic future of Havana's cigar industry as factories faced a sudden loss of business, adding greatly to the threat of riot and insurrection in Cuba.

All this boiled down to the simple fact that American smokers with a fancy for imported Cuban cigars could expect to dig deeper into their pockets to indulge their already expensive habits. Sure enough, in April, 1898, as war finally broke out, fears turned to reality as Havana tobacco became an extremely scarce commodity in the United States.

Prices for Cuban cigars soared nearly twenty-five percent. The man who previously paid fifty cents for three clear Havanas now had to fork over twenty cents apiece, and "two-for-a-quarter" brands sold for fifteen cents each. The common "three-fers" (for a quarter) now became "two-fers." The cost of imported Cuban wrapper leaf also took a shot upwards, increasing from $2.50 a pound to $4.50 and $5, and the likelihood of $6-a-pound tobacco by the summer was not unreasonable.

Today these price increases, measured by a few pennies or a nickel, seem insignificant, but compared to the buying power of a dollar bill a century ago, they were astronomical. Many small companies were forced out of business and the smoking preferences of many cigar smokers were changed forever.

McKinley and Cigars

President William McKinley, by 1899, had developed a voracious cigar-smoking appetite and the excessive consumption was blamed for a nervous disorder afflicting the chief executive.

McKinley smoked cigars incessantly, from the time he arrived at the Executive Office at 9 in the morning until he retired around midnight. Official visitors always found him in the company of a fine Havana and when the door of the Cabinet Room was thrown open, a huge blue haze of cigar smoke billowed out, a good bit of it due to the President's cigars.

Winning the Spanish-American War unfortunately led to a worsening of McKinley's smoking habit. Following the American occupation of the former Spanish possessions, admirers of the President holding commissions in the army and the navy sent him presents of cigars. First to arrive were those from Manila, long, strong, black ones, typical products of the city.

Almost every returning officer from Cuba and Puerto Rico was sure to bring along a box or two of fine cigars for his commander-in-chief. They were rolled especially for McKinley from the best tobacco leaf grown on the islands.

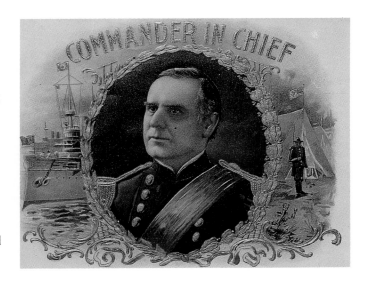

Besides, for those concerned with image, it had to look downright foolish for a man dressed up in a tux and top hat to strike a cigar against a hard surface like an ordinary kitchen match in order to fire up a smoke.

Smokers understandably had health concerns about self-lighting cigars. Might inhaling the fumes of the combustible chemicals be harmful to the lungs in some way or be bad for health in general?

Scores of patents were issued to inventors obsessed with perfecting a self-lighting cigar. Essential to all designs was the impregnation of the business end with a mixture of adhesive, a combustible chemical, and a frictional igniter.

Upon striking the end, the cigar burst into instant flame amid a low hissing noise, a cloud of smoke, and a strong chemical smell approaching that of gunpowder.

All models proved flops. Cigar smokers simply insisted upon matches or lighters of one sort or another to do the job. When it came to smoking, some things just would not change.

Self-lighting Cigars

The cigar that lit itself was a novelty smoking item that turned up on the market around the turn of the century. Like low-nicotine cigars, however, they never caught on with the smoking public.

This was partly due to the fact that the traditional ritual of "lighting up" with a friction match was too well ingrained with the average smoker to be abandoned. The sudden flash of flame, the familiar and not unpleasant smell of burning phosphorus, and inhalation of the first wisps of smoke from the cigar were sensory delights that satisfied deep and inexplicable needs of the smoker.

The Old Shop

"There's a great deal of philosophy in cigar-buying. I know men who have changed their residence a dozen times in as many dozen months; they have changed their tailors, their dining places, their daily papers, but they buy their cigars in just the same place as they did when I first knew them, and out of the same box, often. We choose our cigars and force our tastes as we do flowers in hot beds, rather than 'fly to others that we know not of.'"

—A. B. Tucker, *Bath Robes and Bachelors* (1897)

Cigar Boxes

It all started with a rectangular wooden box, squared all around and fitted with a lid. If this specialized means of putting up cigars had never been invented, there would be no cigar box labels today.

Up to the time of the Civil War, virtually all cigars offered on the market were unlabeled, including imported ones from Havana, and most were sold by the piece or in bunches, or "wheels," of twenty-five, fifty, or one hundred, tied up with pretty red or yellow silk ribbons. Sometimes, if smokers were lucky, a brand name, or more often the Spanish word indicating the size of the cigar (called a frontmark), was imprinted in black on the ribbon.

It must be remembered that consumers in these early days of commerce were not accustomed to (nor did they expect) everyday utilitarian staples to be labeled. Cigar manufacturers and dealers were not being lazy, they were just following established custom.

People were in the habit of simply asking for "a good smoke," nothing more, nothing less. It came as no great surprise, either, that cigars shipped in bulk in large wooden crates and barrels in the holds of clipper ships were also unlabeled.

Knowing that the first cigar box labels were registered for trademark in the late 1850s, it stands to reason that this was when cigar boxes also made their first commercial appearance. Their design was probably influenced by large wooden caddies used by chewing tobacco manufacturers in Virginia to ship their fine cut in bulk to overseas markets.

The cigar box as we know it today did not really become regularly established in the trade until 1862. This was the year the federal government levied the first excise tax on cigars and made matters worse by requiring that tax revenue stamps be affixed to cigar containers. Manufacturers were thus forced into adopting boxes.

It was just as well. They had already learned that cigars dried out quickly after rolling and that cigar boxes helped keep the rolled goods moist and fresh, at least for

A. Kauffman & Bro.

YORK, PA.

Manufacturers of CIGAR BOXES

Choice Variety of Ribbons

Gold and Silver Embossing on Wood and Paper

We Carry a Large Stock of Labels
from the Most Expensive to the Cheapest

a while. Individual wrappers—tubes and other devices (cellophane was not even a wild dream then) —were a Sybaritic luxury, if they were around at all. When they became available, they were strictly reserved for those who could afford them—emperors, kings, czars, and the royal courts of Europe. Like them or not, cigar boxes, in the end, proved a blessing in the trade, not a burden.

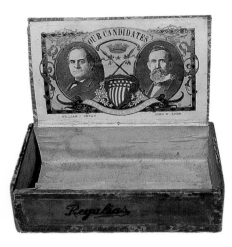

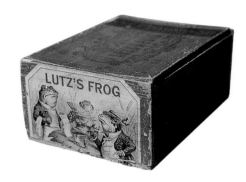

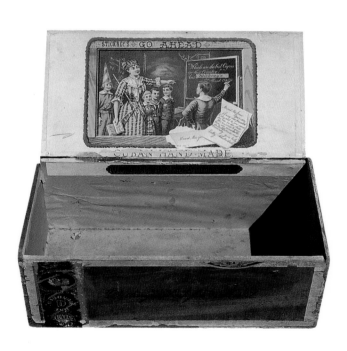

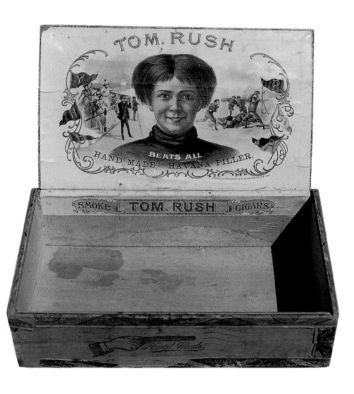

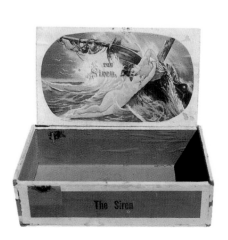

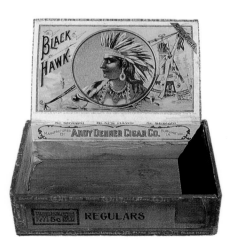

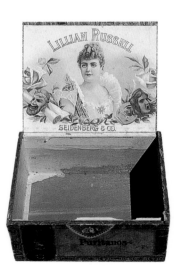

Cigar Ribbons

The use of silk ribbons to bundle cigars originated in Cuba. The ribbons, manufactured in Barcelona and exported to the Caribbean island, were initially plain and carried no printing.

Patriotism to Spain called for the flag colors of the mother country, red and yellow, and these two colors, separate or in combination, remained the standard for many years. Color selections consisted of crimson-scarlets, called Figaros, vivid yellows named Cabañas or Partagas, and red and yellow combinations termed Españolas.

In the late 1860s, a cigar manufacturer in the United States produced a customized ribbon with the name and shape of his cigar imprinted on the silk ribbon. This was rendered initially in black, then in colors, and eventually in silver and gold with fancy embossing and coats of arms.

A final touch of elegance was attained when the brand name was woven into the ribbon instead of being printed upon it. The woven ribbon proved especially valuable as a trademark since it was impossible to counterfeit in small quantities.

The first American cigar ribbon factory was established in 1868 in New York City by a man named Wicke and operated by two Swiss employees.

Originally, domestic ribbons were made of pale yellow cotton with a brown stripe running down the center. The cotton was replaced by silk shortly thereafter. In the beginning, only two widths of what was called a Londres ribbon were produced by the American factory, but as demand for ribbons increased and the business became profitable, a four-loom factory was established in 1870.

The raw silk for cigar ribbons was imported directly from Japan and China. By the 1880s, cigar ribbons had become an industry staple. More than ninety-four styles of ribbons were on the market, varying in width from one-eighth of an inch to one and one-half inches.

Cigar ribbons were attractive items and became popular with the general public. Many ribbons were sold by cigar dealers to women who turned them into shelf valances, scarves, and sofa cushions. The heyday of the cigar ribbon eventually faded by the turn of the century as, by then, bulk packaging of ribbonless cigars in bundles of 25 or 50 in large wooden boxes had taken over.

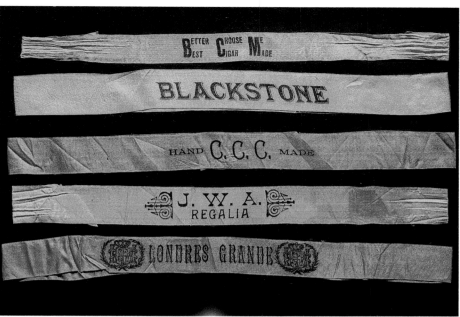

Cigar Bands

The origin of cigar bands, those intriguing bits of paper caressing the compact bodies of cigars, goes back well over a hundred years. Who invented them, however, remains entrenched in controversy. The Germans and the English have stepped forward from time to time to claim the honor for their respective countries, but their proof is thready and subject to great doubt.

The consensus of scholarly opinion favors the Cubans. Historians in that country credit Gustave Bock, a German immigrant and well-known Havana manufacturer, with being the first to slip a paper ring bearing his signature around cigars bound for export.

This took place in the 1830s and the national archives go on to show that by 1855 practically all Cuban cigar makers were banding their products and recommending that their customers insist upon banded cigars as a mark of genuineness and hence quality.

Cigar bands became commercially adopted in this country last century and they were pretty things, especially when embossing enhanced their appearance. It wasn't long before they became a collecting rage. Previously, little attention had been given to the habit of Victorian-era grandfathers who spent long hours making intricate artistic patterns with bands accumulated after years of smoking.

The hobby became so popular that a club was formed in New York City, the Cigar Progress Board, which established a trading marketplace for collectors. Through this medium of exchange, those interested in doing appliqué work with the colorful rings of embossed paper

on ash trays, the inside of vases, and on stone pedestals could reach fellow collectors and arrange trades, both of bands and handiwork.

Around the turn of the century, the hobby reached its peak. This was when no home was considered complete without a few art objects decorated with cigar bands resting on fireplace mantels and end tables. Some artists conducted a lively business selling sewing boxes, pincushions, ashtrays, and vases adorned with hundreds of appliquéd bands.

It took steady hands, infinite patience, and some degree of skill to work with cigar bands. Metal tweezers were standard tools for handling the fragile articles and a good grade of transparent glue was necessary to make the bands lay flat and not curl up. One collector claimed to have decorated an old glass fruit bowl with more than a thousand cigar bands.

Until American cigar manufacturers began to produce a better quality of bands, collectors favored those imported from Germany which, for many years, led the world in this specialized area of printing.

Imaginations were taxed to the limit among enthusiasts of this unique hobby. A man in New York City worked for years on a village of houses composed of cigar-box wood glued together and trimmed inside and

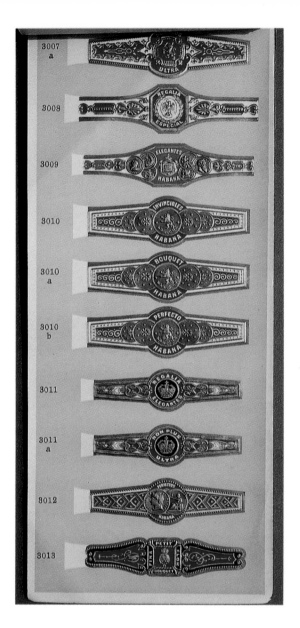

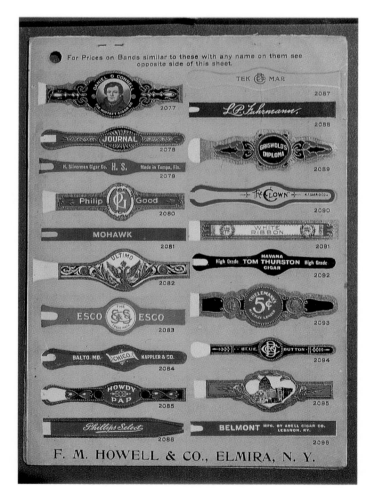

out with cigar bands of many different colors. Interiors of the wooden houses were likewise constructed with meticulous care and detail. Miniature tables, chairs, and a refrigerator were fashioned of wood and also decorated with cigar bands.

Lamp shades were often embellished with bands by patient workers and picture frames were also fair game for decoration. Old wine decanters, with their narrow necks, wide bases, and lots of clear glass, represented an especially challenging work project. True and careful craftsmanship was needed to line the bottle inside its neck and place the bands evenly so that the bright colors and pattern showed to their utmost.

Contests were held to select the most skilled cigar-band artists, who applied their talents to such varied objects as shoe trees and toothpick holders. One hobbyist decorated a miniature ocean liner from stem to stern with many different bands, leaving the funnels black and unadorned.

When a Woman Buys Cigars

In Victorian days, the occasion of a woman buying cigars for her husband or boyfriend often led to amusing scenes in cigar shops. Many of these experiences ended up in the exaggerated story-telling repertoire of male audiences, forming a class of jokes that achieved wide-spread popularity many years ago.

"She was a plump little matron of some thirty summers and when the showcase loungers in the corner cigar emporium sighted her steel-grey paddock in the doorway, they all edged away from the counter and appeared to be suddenly interested in the Oriental hieroglyphics that come with the Egyptian cigarettes.

" *'I would like to look at some cigars,' she announced as she placed her shopping bag on the glass case. "I want to make a little present to my husband."*

" *'Yes, Ma'am,' responded the young clerk with a low bow. "What—er—is his favorite smoke?"*

" *'How is that?'*

" *'I mean does your husband prefer a mild, medium, or strong cigar?'*

" *'I think he likes strong ones. Some of those he smokes after supper are so strong that the neighbors ask if we are burning leaves in the back yard."*

" *'Hmm! They must be strong. How would these suit him?'*

"The clerk drew a box from the showcase and displayed a row of handsome cigars, each bundle embellished with a yellow ribbon.

" *'I like the pretty ribbon,' said the fair customer, slowly examining the cigars with her gloved finger, "but I don't like the color of the tobacco. Besides, there are horrid yellow specks on them.*

"The clerk suppressed a smile. "My dear lady," he hastened, "don't you know that those little spots are just what connoisseurs look for?"

" *'No, never heard of such a thing. I believe the cigars have been damaged. Show me another box.*

"The obliging clerk reached for another brand and opened the box on the showcase.

" *'Here is something fine,' he began, but the prospective purchaser shook her head.*

" *'It is no use to show me those. I don't like the picture on the inside of the cover."*

"The clerk smiled and reached for another box.

" *'Well, how about this make? Surely the picture pleases you this time. It represents an old Cuban fort by sunset. You can take it off with warm water and use it to decorate a screen."*

"There is a remote possibility that the fastidious customer may have decided on the old "Cuban fort"

brand had she not glanced at the end of the box. But she did glance and all the suave cigar clerks in town could not have made her purchase those cigars.

" *'It is no use,' she said firmly. "I see it with my own eyes."*

" *'See what, Ma'am?' asked the mystified clerk.*

" *'Why, the word 'Colorado.' You know that Havana cigars should not be made in Colorado. I suppose you think women are green at buying cigars."*

" *'But, Madam ...'*

" *'It is no use of trying to convince me that those cigars were not made in Colorado. Why, isn't there the stamp on the box? Why don't you try to sell me some that were packed up in Connecticut and then claim that they are imported from Porto Rico. Oh, it takes you men to try and goldbrick a woman when she enters a cigar store."*

" *'The clerk sighed. He collected the open boxes and placed them back in the glass case.*

" *'I am sorry,' he said in pepperish tones, "that we don't seem to have any cigars suitable for your husband. He must, indeed, be a fastidious smoker."*

"The over particular patron did not reply to this hidden thrust. She swept up and down in front of the long glass cases and minutely examined every box of cigars on display. Suddenly she pointed her slender finger toward a long box with an expression of triumph.

" *'There is what I want,' she exclaimed. Those real long cigars. I know they are just the kind that Henry smokes. He will be tickled to death if I present him with a box of those."*

"The clerk followed the direction of her finger and then laughed so loud that the yellow cat asleep on the snuff jar awoke with a start.

" *'What is so laughable?' demanded the woman in the gray coat, rather sharply*

" *'Nothing in particular, Madam,' hastened the clerk. "I was just thinking about a good joke I heard at the theatre the other night about a woman selecting cigars for her husband. Do you really want those?"*

" *'I certainly do. Don't think that I don't know good cigars when I see them. I know Henry will compliment my judgment as soon as he smokes the first one. Wrap them up, please."*

"The smiling clerk drew forth the long box and quickly wrapped it up in pink paper and tied it with a blue cord.

" *'One dollar ninety-nine, Ma'am,' he said. "That's right. Thank you."*

"She gave him a two-dollar note and he returned her a copper in change.

" *'And now you admit that I know something about selecting cigars?' she said with a winning little smile.*

" *'I do, indeed, Ma'am,' assured the clerk. "Very few would have selected the brand of smokes that you did."*

"She placed the box under her arm and the next moment her steel-gray paddock had vanished in the

crowded street. Then the chronic loungers turned away from the Oriental cigarette hieroglyphics.

" 'What kind did she select?" they asked in unison.

" 'Stogies!" roared the clerk. "Upon my word, she selected a box of Pittsburg stogies. Preferred their looks to Havanas and Porto Ricos. Maybe it was the bargain counter price of one dollar that attracted her. Say, I'd like to be around when the old man opens that box!"

"And the clerk grinned and threw a ball of tinfoil at the yellow cat on the snuff box.

—New York Times (1906)

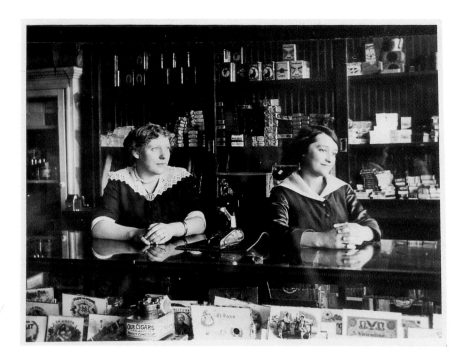

On the Equality of Tobacco

It was commonly held years ago that tobacco was one of the greatest known levelers of social rank, and still is. There is little to equal it. Tobacco has become the common ground upon which the field marshal and the foot soldier, the prime minister and the office clerk, the millionaire and the rag picker meet, even if they don't shake hands.

Through the use of tobacco they live the same life, follow the same instincts and obey the same laws of smoking etiquette. The man who smokes is equal to the other man who smokes. These solemn truths allow no contradiction.

Smoking is the universal freemasonry and, as the humblest apprentice in masonry can "give the sign" to his royal Grand Master, the Prince of Wales, for example, so can there be no doubt that if the Prince of Wales were in want of a light for his cigar, he would not hesitate for an instant to stop the humblest of brother smokers with that familiar and formal request, "A light, sir, if you please."

For some reason this brotherhood of smoking equality was most conspicuous in Spain, perhaps because in Spain there were few aristocrats. Every Spaniard was equal to any other Spaniard, and it was through tobacco that social amenities were worked out.

The lowest peon was allowed to approach the highest grandee of countless generations, cigar in mouth, and boldly ask, "Fire! (in Spanish, of course), to which the nobleman replied without a shiver of affront, "Take a light," also in Spanish.

No greater arena of social equality among men existed than in that sacred temple of tobacco, the neighborhood cigar shop. There the rich and the poor, the lawyer and the lackey, the prince and the subject, rubbed elbows in mutual respect, decorum, and enjoyment.

From this same business establishment, the poor man took leave with his ounce of rough shag, the rich man with his box of pure Havana cigars, both carrying off an equivalent source of solace and pleasure.

Tobacco is no hypocrite and one of those rare things that promotes universal equality and brotherhood, and as such is highly recommended to all people of the world.

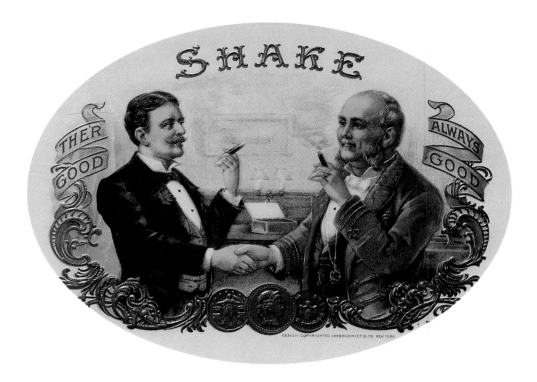

Proper Cigar Smoking Etiquette

1. Give your last cigar away occasionally. It will make you feel better.

2. Don't light a cigar in the presence of a respected friend or acquaintance unless you give him one. This does not apply to employees, fellow boarders, or anyone with whom you come in contact with daily.

3. Never refuse a light to any smoker. If you haven't a match to give him, let him borrow some of your fire, even if it spoils your cigar.

4. Remember that all smokers are equal—when smoking, that is.

5. Do the "nice thing" once in a while. If you have more than one cigar and notice a man looking sadly out of the smoking car window, proffer him one of your smokes with the understanding that there have been times when you were short on smokes and long on loneliness yourself.

6. Give your friend your best cigar. You'll have lots of fine future smokes coming to you if you do.

7. Remember that you can display more brotherly feeling in the way you proffer a cigar than in a world of nice words or small loans.

8. Never play a joke on a smoker. Don't give the meanest of them a loaded cigar. It's a brutal, dangerous, and stupid thing to do.

9. Don't be a cigar "sponge." It's a low-down habit. You can lose your self-respect and the respect of your friends more in this way than any other.

10. Don't be a strutting, nose-tilting smoker. It's tough.

11. Life is too short for poor food, poor company, poor clothes, and poor cigars.

12. Remember that silence and a good cigar are two of the finest things on earth. Even a hermit can be an angel under these circumstances and a man of the world a man of the other world.

13. Puff your smoke heavenward and pitch your thoughts toward the clouds.

14. Never smoke in the presence of ladies, unless you know it is not offensive. If you don't know, ask them. If they object, don't smoke. In spite of Kipling, any good woman is far finer than any cigar ever dreamed of.
—Newspaper article, circa 1900

The Calvert
Lithographing Company

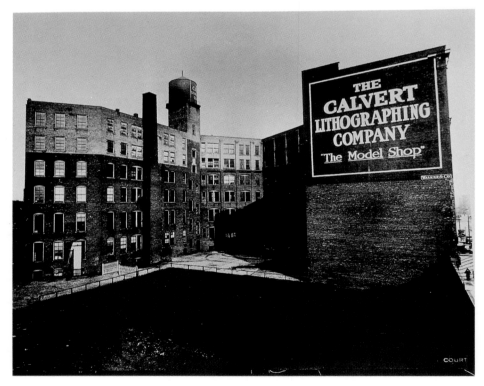

Among the early commercial printing houses that sprang up in nineteenth-century America was the Calvert Lithographing Company of Detroit, founded in 1861 by an English immigrant, Thomas Calvert (1828–1900).

At the time of the firm's beginning, Detroit was a major stepping-off point on the Western frontier and boomed with a population of 46,000 inhabitants. Here Calvert started his business, alone and equipped with only a small hand-printing press. Slowly but surely, however, demand for Calvert's work increased.

The Englishman excelled at chromolithography and built up an enviable reputation over the years in sign, label, and poster making. Calvert's staff of artists and engravers turned out finely detailed and technically perfect images in stunning colors, true works of art in the fine Victorian tradition.

The Calvert firm went on to establish itself as one of the country's premier lithographic houses. It was a major producer of tobacco-related advertising ephemera for Detroit-based companies and even turned out a few cigar box labels after the Civil War.

The company remained in business until 1970 when it was absorbed by a Canadian printing firm.

The following photographs, dating to the 1920s, illustrate the various steps involved in the time-honored tradition of stone chromolithography.

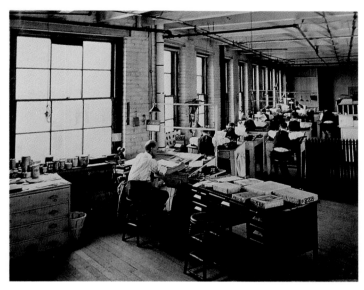

1. **The first step was creating a painted image** *in color. An army of talented artists sat for hours on hard wooden stools performing this vital chore. Note that natural daylight was used as primary illumination.*

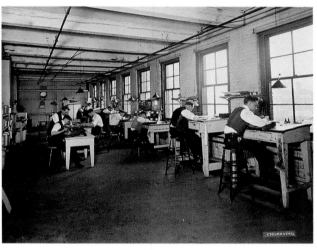

2. **The colored image was then transferred** *onto the surface of a limestone slab by skilled engravers who meticulously carved every minute detail of the print in reverse image onto the stone.*

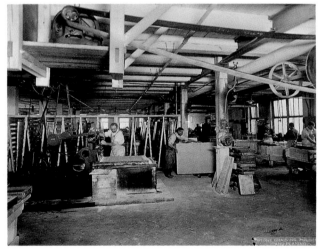

3. **Employees are shown planing** *and polishing limestone slabs, making them ready for the transfer process.*

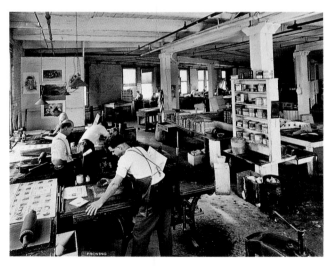

4. **Proving.** *A worker inks a slab of limestone prior to a run through the press.*

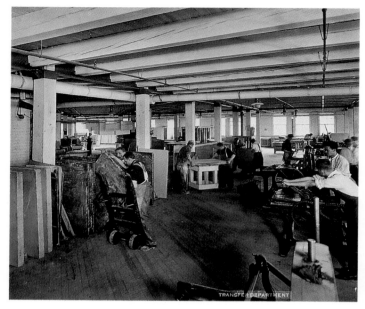

5. **Large stones were stored** *in wooden racks in the transfer room. The photo shows that hand-operated presses were still in use at this time.*

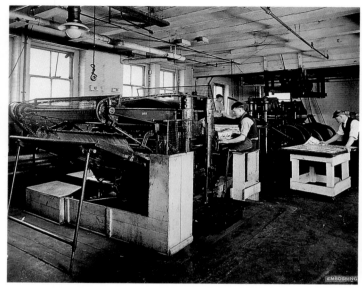

6. **Embossing machines.**

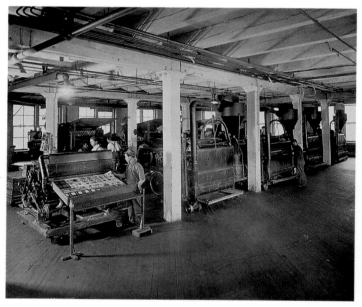

7. **Bronzing machines.**

8. **Curing lithographic paper.**

9. **Stacks of printed labels** *await cutting and trimming.*

10. **Flatbed press room.**

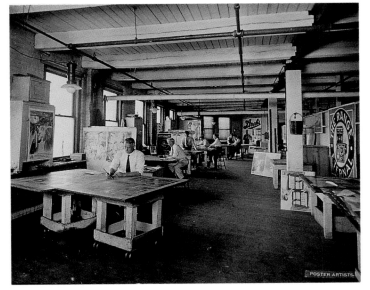

11. **Poster artists at work.**

12. **The stone vault.** *Storage of stones took up considerable space.*

Part Three

Themes of Inducement

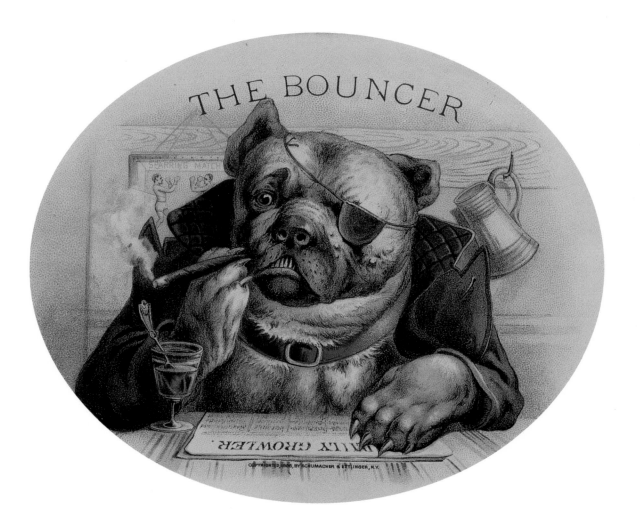

A. The Civil War

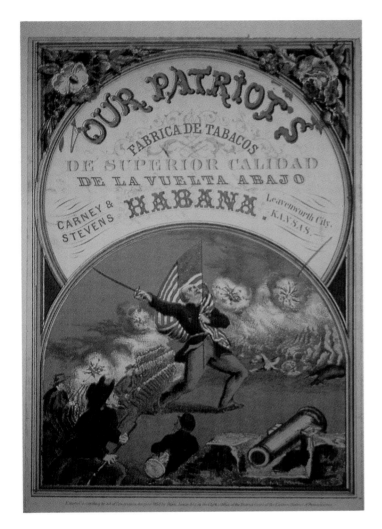

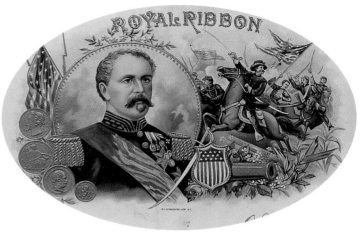

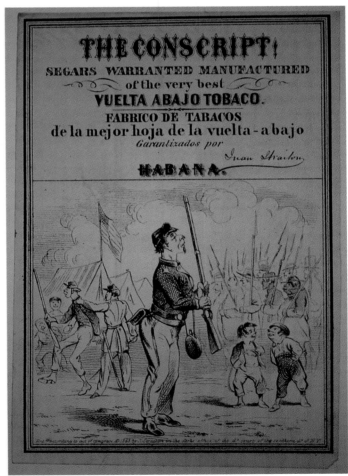

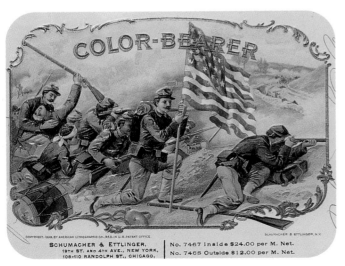

Opposing the draft *(above) is not a modern social issue; its roots go back to the Civil War. This tongue-in-cheek label was issued in 1863, the year conscription in the North was officially established. The law applied to all able-bodied men between the ages of 20 to 45, but there was a built-in escape clause: Reluctant draftees could discharge their obligation by either paying $300 in cash or furnishing a volunteer substitute. Would this work today?*

Tom O'Connor Speaks Out

"In the hottest part of the Wilderness battle on May 6, 1864, while we were lying down under the withering fire of the enemy,' said Corporal John F. Buckley of the Fourteenth New York Heavy Artillery acting as infantry, 'Tom O'Connor, a six-foot brawny Irishman, a member of my company, persisted in jumping to his feet and was only kept in position by the threats and commands of the captain. He would lie down a few minutes and jump up suddenly and unexpectedly, as a jack-in-the-box.

"Many of the boys near him were sleeping under the effects of the terrific but monotonous roll of the musket fire. Its continuous, r-r-r-r-r-r-R-R-R-R-R-R-R-r-r-r-r-r-r-r, as it ascended from the little r's into the awful roar represented by the capital letters, to sink again in low cadence, acted soporifically upon the tired and worn-out battle line which had been in action for seven consecutive hours.

"The Irishman was but a few hours in New York before he had enlisted and scarcely knew which end of his gun to shoot from. The man next to him had fallen asleep with his hand supporting his head. On the little finger of his right hand was a sparkling ring and it was surmised that some tree scout sighted it.

"At all events, the bullet went right through his head so instantaneously that he never moved a muscle. The Irishman heard the well-known 'pink' of the bullet, so different from its 'whiz' when it passes and misses its victim. He turned his head to see who was hit and found his right-hand man dead with the blood oozing slowly from the large and ragged hole made by the minie ball.

"This sight crazed Tom O'Connor and, forgetting time, place, and circumstance, he jumped to his feet with a whoop that must certainly have been heard by the enemy. Throwing down his musket and cartridge belt, he shouted:

"'Och, ye bloody, cowardly murderers, shootin' from behind trees, bad luck to yeez! Here I am, Tom O'Connor, and I will fight the best one among yeez, like a man, with bare fists, if yeez come from cover!'

"The laugh that greeted this sally from along the regimental line was both spontaneous and natural, despite the roar of musketry and the wounds and death being inflicted all around. The captain was forced to rap Tom sharply over the head with his sword to bring him to a realizing sense of 'where he was at.'

"The big Irishman resumed his accouterments and, standing on one foot at a time, kept dodging and bobbing up and down until the poor fellow was finally quieted with a bullet through the jaw from the rebs, and the last we saw of him, he was crawling on all fours toward the stretcher-carrier in the rear."

—The Washington Post (1902)

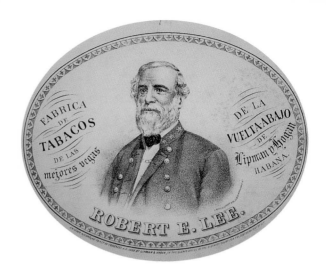

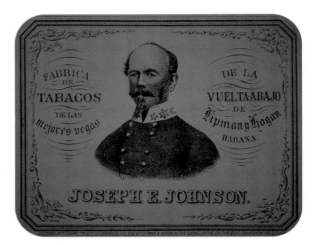

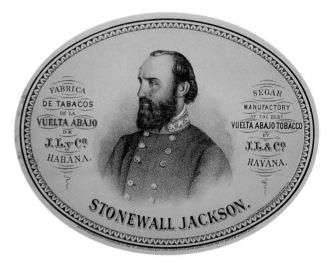

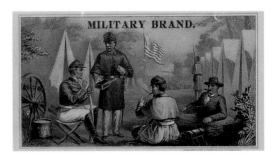

Union Generals and Their Cigars

Ulysses S. Grant was the most highly publicized cigar smoker of his time. Contrary to popular belief, however, Grant was not the chain-smoking demon he was commonly portrayed as, and furthermore did not adopt a serious cigar habit until late in the Civil War.

Grant liked to cut off the end of his cigar with a pocket knife and shove the stump into his mouth. After lighting it, the cigar never left his lips until the fire got close enough to singe his mustache. Then he removed the cigar, impaled it on a toothpick and continued to draw on it until the very last puff of smoke was extracted.

True details of Grant's cigar habit were divulged by his son, General Frederick S. Grant, in an article published in McClure's magazine in 1901:

"My father tried to smoke while at West Point, but only because it was against regulations; and then he didn't succeed very well at it. He really got the habit from smoking light cigars and cigarettes during the Mexican War, but it wasn't a fixed habit. When he left the army and lived in the country, he smoked a pipe—not incessantly. I don't think that he was very fond of tobacco then, and really there was always a popular misconception of the amount of his smoking.

"But he went on as a light smoker, a casual smoker, until the day of the fall of Fort Donelson. Then, the gunboats having been worsted somewhat and Admiral Foote having been wounded, he sent ashore for my father to come and see him. Father went aboard, and the admiral, as is customary, had his cigars passed. My father took one and was smoking it when he went ashore. There he was met by a staff officer who told him that there was a sortie and the right wing had been struck and smashed in. Then my father started for the scenes of operations. He let his cigar go out, naturally, but held it between his fingers.

"He rode hither and yonder, giving orders and directions, still with the cigar stump in his hand. The result of his exertions was that Donelson fell after he sent his message of 'unconditional surrender' and 'I propose to move immediately upon your works.' The message was sent all over the country that Grant was smoking throughout the battle when he only carried this stump from Foote's flagship. But the cigars began to come in from all

THE THREE LEADERS

No. 4871. $18.00 per 1000 net.
ALSO FURNISHED BLANK

over the Union. He had eleven thousand cigars on hand in a very short time.

"He gave away all he could, but he was so surrounded with cigars that he got to smoking them regularly. But he never smoked as much as he seemed to smoke. He would light a cigar after breakfast and let it go out, then light it again, and then let it go out and light it; so that the one cigar would last until lunch-time."

On the other hand, General William Tecumseh Sherman, another inveterate smoker, never talked with a cigar in his mouth. It seemed to bother him. The general always laid the cigar down somewhere whenever he started to speak. Predictably, Sherman forgot where he had placed it when he finished talking, then lit up a fresh one.

As a result, the office desk and furniture at his headquarters in Washington, D. C., were covered with half-consumed cigar carcasses. "Sherman's old soldiers," his staff called them. The general's absent-minded behavior also led directly to an unintentional but amusing breach in smoking etiquette. He was often seen borrowing another man's cigar to get a light and then, in momentary preoccupation, nonchalantly throwing the borrowed cigar away when he was through with it.

General Philip Sheridan was another senior officer who also enjoyed a frequent cigar. The problem was, however, that Sheridan breathed through his nose and unless he paid strict attention to smoking a cigar, it was always going out. Consequently, Sheridan's desk and carpet was littered with half-burned matches. He usually went through an entire box with each cigar he smoked and once admitted, "If I had a dollar for every match I have wasted, I would be as rich as Vanderbilt."

General Benjamin Butler was different with cigars; he was the kind people called a "cold smoker." He never lit cigars but jammed them down his throat, wrong end first, until an inch or so protruded from his mouth. He didn't chew the cigars as many did, but instead rolled his tongue lovingly over the roll of tobacco, enjoying the taste. When Butler dictated letters, he would tip his chair back, put his feet on a table, and shut his eyes, all the while sucking on his beloved Havana as if it were a lollipop.

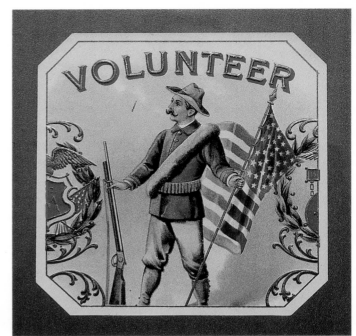

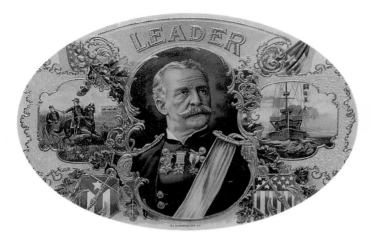

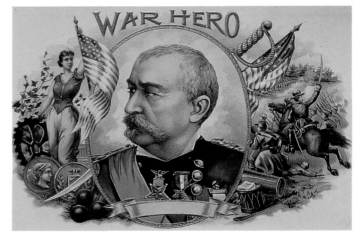

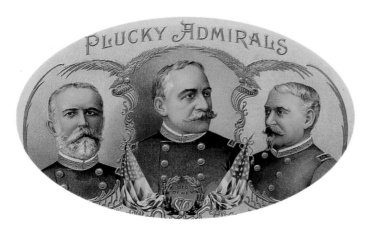

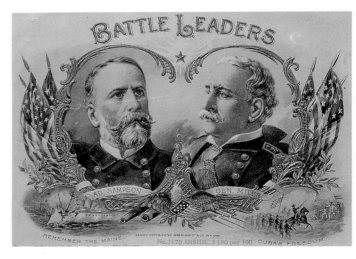

The Battle of Manila Bay

"... At thirty-five minutes past seven o'clock, Admiral Dewey gave orders to cease firing and then, according to popular belief, 'withdrew the squadron for breakfast.'

"Now this breakfast episode is a rather precious item in the story. The words 'I ceased firing and withdrew the squadron for breakfast' are taken from the unrevised version of a letter written by Dewey on May 4, 1898, and received at Washington on June 18. Mr. Joseph L. Stickney, however, in his account of the battle, speaks as though he had invented both phrase and pretext.

"He says that when our squadron hauled off from the fighting line at 7:36, nothing of great importance had occurred to show that we had seriously injured any Spanish vessel while the Olympia's stock of ammunition was so depleted that continuance of the fight for another period of two hours was impossible.

" 'The gloom on the bridge of the Olympia,' he continues, 'was thicker than a London fog in November. Dewey hauled out into the open bay to take stock of ammunition and devise a new plan of attack.'

"According to his own account, Mr. Stickney asked and received permission to declare that the squadron withdrew so that the men could take breakfast. But here again we have come upon a statement which is misleading without being quite untrue. No doubt it did seem necessary, or at least advisable, to take stock of ammunition and find out how the vessels of our squadron had fared.

"But the Admiral says that already the Spanish flag ship had been 'barely able to return to the shelter of the point' and 'the fire started in her by our shells at the time were not extinguished until she sank.'

"In other words, he had taken the enemy's measure and had good reason to be confident of victory. To investigate the report in regard to a shortage of ammunition and, if necessary, to redistribute shells of certain sizes, to make other preparations for delivering a crushing blow, and to take breakfast—was precisely the sort of proposition that would appeal to his good sense and his sense of humor..."

—Harper's Weekly (1899)

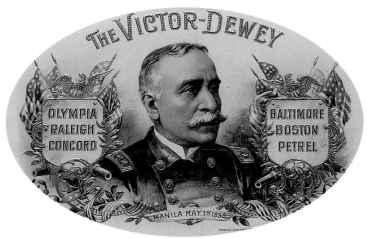

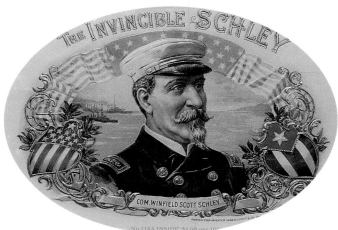

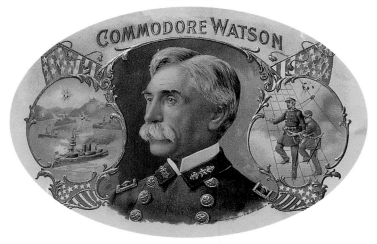

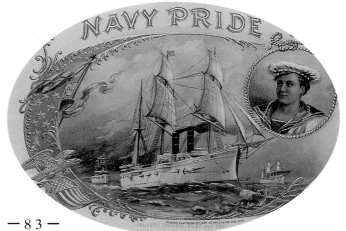

Sergeant Johnson at San Juan Hill: "It Was Ugly Work"

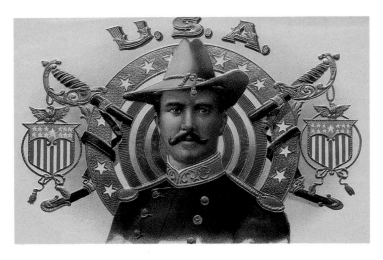

History books recount how Colonel Theodore Roosevelt and the Rough Riders took San Juan Hill near Santiago, Cuba, on July 1, 1898, the most celebrated land battle of the Spanish-American War. But little mention is made of two units of black cavalry without whose heroic actions and heavy casualties on that hot summer day, the battle might have been lost.

Among the army veterans who came home and told their stories was a black soldier, Sergeant George H. Johnson, Troop H, Ninth United States Cavalry. His account was published in a San Francisco newspaper:

"We were lying in front of El Paso and we knew that lively business was ahead, so we were not surprised when, on the morning of the July 1st, we were routed out and given our breakfast at 5 o'clock. Then we knew that the business—business of war—was right upon us. We had barely finished our breakfast when Troop H, under command of Lieutenants McNamee and Hartwick, was ordered forward as part of an advance guard. We had gone but a few hundred yards down the hill when the first gun from Captain Grimes' battery on the heights above El Paso went 'boom' and the battle was fairly on.

"Still we went ahead until we reached what has since been called 'Bloody Bend' on the San Juan River. Here we were in the direct line of the Spanish fire, and many was one of the boys who never crossed the ford but made his long halt right there. On the other side of the ford was the steep bank of the river and at the top of it was a wire fence, or trocha. It had to be cut and the men who cut it were bidding for death.

"While we were at this work, two aides-de-camp rode up and told Colonel Hamilton, who was in command of the advance guard, that he must go no further, as we were a mile in advance of the army and would all be massacred if we went on. Said Colonel Hamilton:

" 'If we stay here, we will be shot to pieces; if we go back, it will be to court death. Boys, we will go ahead!'

"It was one of the last things he said, but I will tell you about that later. Anyway, we cut the wires and went ahead.

"Over and back of us there was an observation balloon with two men in it. I happened to be looking at it when, of a sudden, it flattened and the car and its occupants dropped to the ground. What had happened? Why, a Spanish shell had gone through it. I never heard that the men were killed and I don't think that they were.

"After we got through the trocha, Colonel Hamilton ordered a forward movement. At that time the fire was so heavy that I didn't believe a man of us would live through it. As for answering it, that was impossible for we could not see where the shots came from.

"I didn't see anybody that wasn't scared. We knew the only hope we had was a soldier's hope and that seemed a mighty slim one.

"There wasn't any place to run to and besides we didn't want to run. We let the Spaniards do all of the running. Some of the boys yelled, 'Let's go and chuck some of the d___d Spaniards out of their blockhouse,' but that is the only sort of running we felt like doing.

"About noon, an aide-de-camp came and gave Colonel Hamilton a verbal order. I was told it was an order to fall back. I don't know about that but I heard Colonel Hamilton say to the aide-de-camp, 'I won't obey a verbal order at such a time; bring the order in writing and I'll comply with it, but not otherwise.'

"Then a forward movement was ordered again. It was the hottest time of the day. Soldiers were falling about me everywhere and the lives of men depended upon the turn of the dice of war. Here Colonel Hamilton was killed. A shell struck him and I was ordered by an officer who said the Colonel was wounded, to take two men and carry him back. But as soon as I reached his side, I knew it was useless for his neck was broken and his head hung limp. He never spoke a word after he was hit. Several other officers were killed or wounded at this place.

"Talk about the coolness and bravery of newspaper correspondents! Right there in the thickest of the fight I saw two of them, though how under the sun they got there, I can't imagine, and here is the way they were managing things. One of the them was up in a tree and the other sat on the ground with a notebook in his hand. The one above would call to the other what the troops were doing, and the one below would write about it in his notebook. Nothing seemed to disturb them; they just went ahead with their business while shells crashed above them and bullets cut leaves and grass at their sides. They were a cool pair.

"At the top of the hill, we took the first Spanish post. It was an old sugar house which had been converted into a blockhouse. The Spaniards ran from us as if the very deuce was after them. There was an awful loss of life first, though.

"But the boys had their fighting blood up then. A Rough Rider near me was mortally wounded by a shot in the head. I ordered two men to carry him back and as they started to do so, he whispered, 'You boys take my belt and use the cartridges on the Spanish.' His eyes were glazing at the time but that was the way he felt. We took his cartridges and you can bet that we used them.

"Then we were ordered on to the blockhouse on San Juan Hill and we took that, too, after more loss of life. It

was ugly work. We held this blockhouse until the truce came. The Spaniards tried to re-take it but they failed."

So ended Sergeant Johnson's personal recollection of the Battle of San Juan Hill. Some time afterwards, Captain McGinnis of the Rough Riders, in speaking of the bravery shown by the black troops, released the following dispatch which was printed in the Chicago Chronicle:

" *'The Ninth and Tenth colored cavalry were the first and after that the whole army. And it is no more than justice to say these negroes were the pluckiest men on the field. Twice they saved our lines, and had it not been for them, there would be no Rough Riders to tell the tale. It was a battle wherein the men did the charging and the fighting. They took the matter entirely in their hands and to them is due the credit of that memorable victory. The order was disobeyed and the day won in spite of General Shafter.' "*

—San Francisco Examiner (October 23, 1898)

2. Waving the Flag: Patriotism and Other Symbols of National Pride

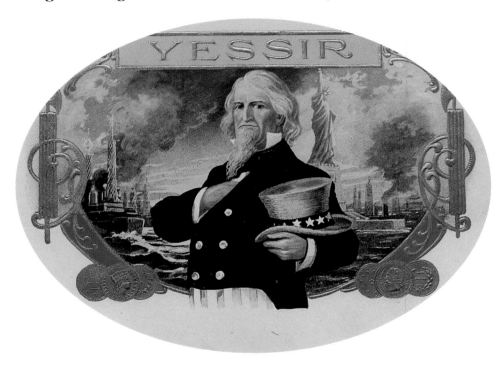

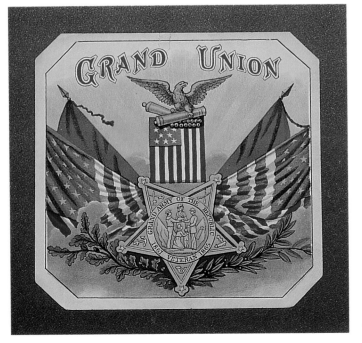

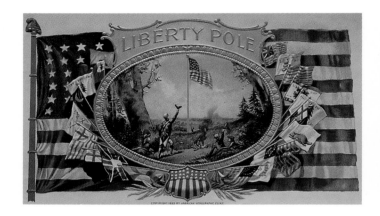

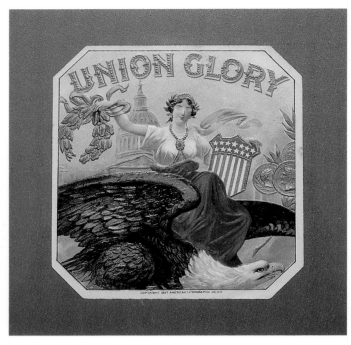

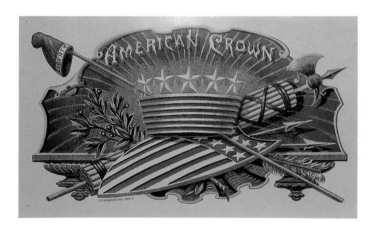

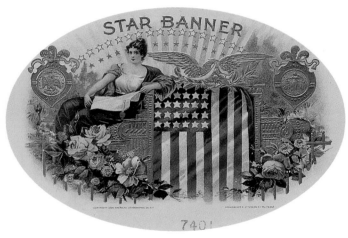

7401

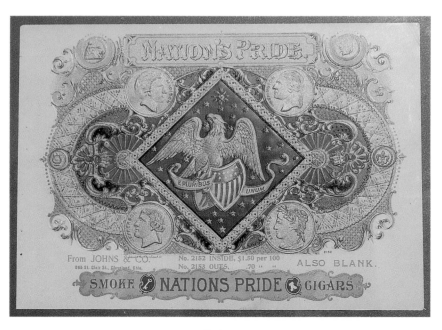

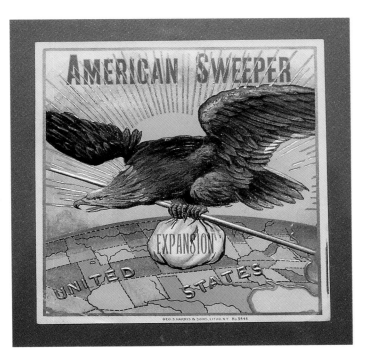

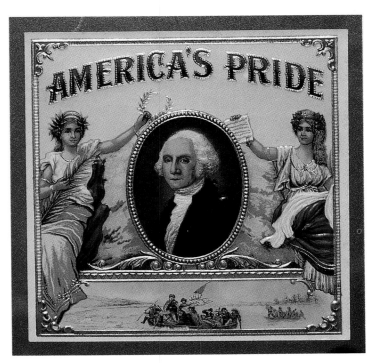

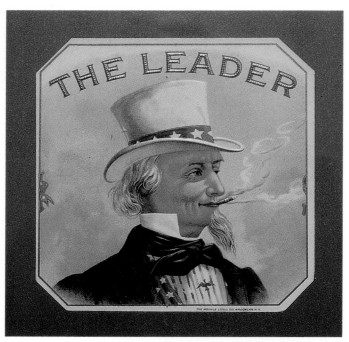

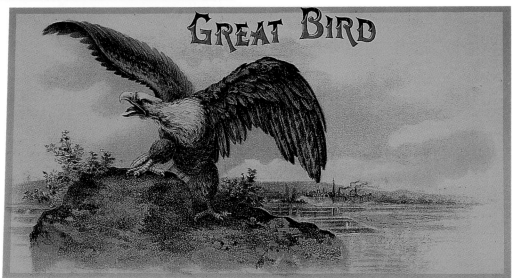

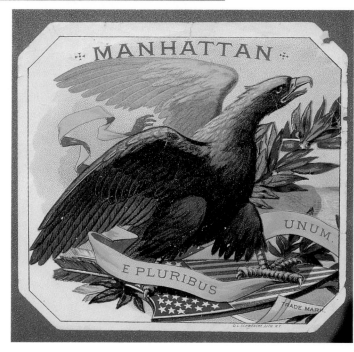

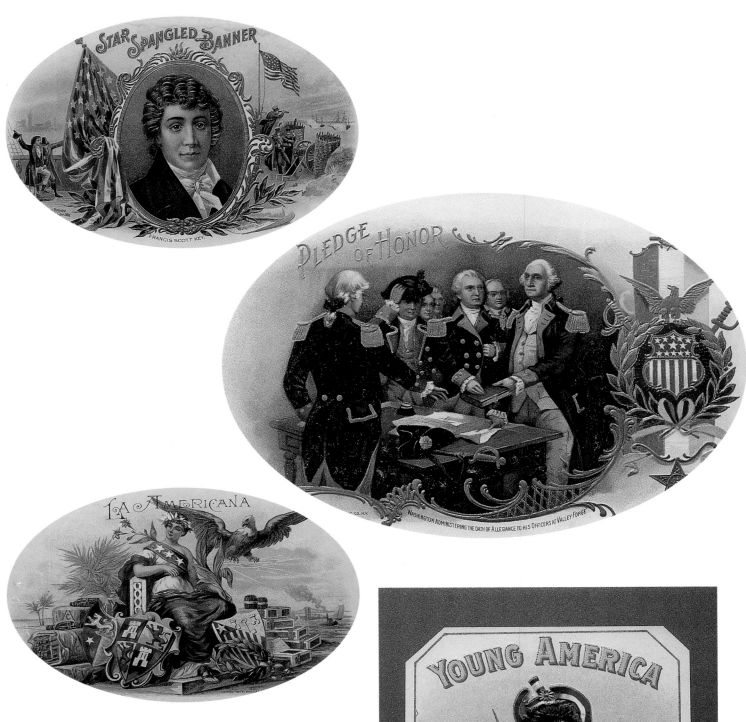

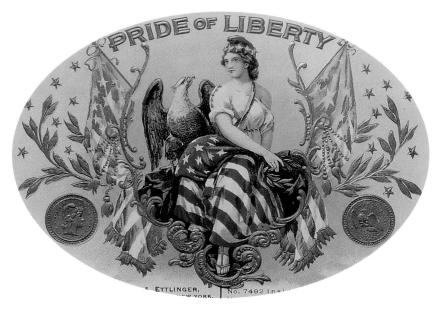

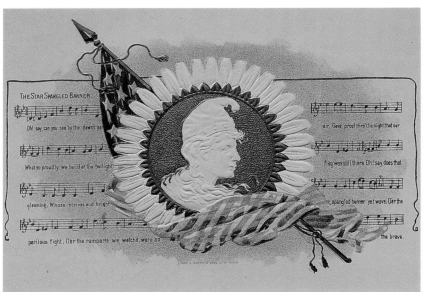

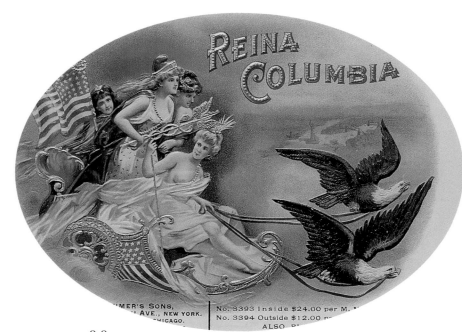

3. Getting Around: Means of Transportation

A. Railroads

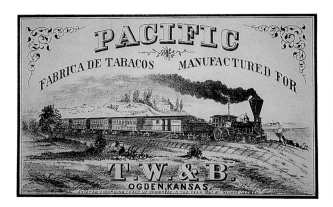

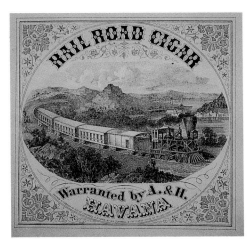

Railroading in the 1870s

"John Dobbs was one of the oldest and best men on the road. It was his boast, and an honest one, that during the sixteen years he had been driving on that road, he had not cost the company a dollar for any negligence or mistake of his. His record was clear. I sat and watched him from the opposite side of the cab.

"He was rather tall, thin, and of a nervous temperament; and although not even the smoke-stack of the engine could be seen for the darkness and the drifting snow, his piercing eye never wavered from its unsubstantial mark. Her machinery quivered with its force; she leaped and reeled on each defective joint, but her iron members held her firm. The fireman never ceased to cast in the fuel, and the fierce flames darted ardently through her brassy veins.

"Suddenly a scream from the whistle, a quick movement on the throttle—the fireman rushed to the other side of the engine—a flash of light! We passed a station and a freight train on the side track. More fuel into the fire, and the Greyhound surged ahead, for now we had a straight piece of track before us.

"The storm abated and the sky cleared. The fireman produced from his pocket a small cutty pipe, loaded it with tobacco, lighted it with a puff or two, and without saying a word, stuck it between John's teeth. John had taken about twenty rapid whiffs when the fireman, as unceremoniously as before, transferred it to himself and with a few firece draws, consumed the load—a very impolite proceeding, but apparently part of the discipline of the engine. Those few draws did both men good. Johnny's grasp tightened on the throttle and the fireman with new energy threw in the wood.

" 'Engine driving is trying work such weather as tonight, Sir,' said Johnny, wiping the perspiration off his face with his sleeve, 'when you can't see your signal lights, nor even your smoke-stack, and you have to run like mad on a bad track to make up time so as not to lose connection. I tell you it makes a man sweat even if he's as cold as a lump of ice. You have to go it blind. You can't see if the switches are right. If trains you are to pass have got into a side track, you can't make out anything till you're right into it. It's trying work on the mind, Sir, is driving an engine. Such as us get very little sleep.' "

—From *A Fast Life on the Modern Highway* (1872)

A Conductor of the 1870s

"*Scarcely less important is the conductor. He is the captain of all but the engine. He must be a good judge of human nature, know how to be quick and yet courteous, firm and yet affable. He must be able to detect the difference between the real unfortunate who has lost his ticket and his purse together, and the railroad swindler who makes a pretense of loss serve him the purpose of getting many a free ride.*

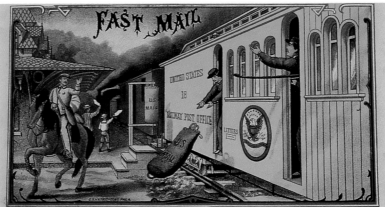

"*He must be equally competent to help out with all her bundles the anxious lady from Pumpkinville who has never ridden in the cars before, and quick to eject the brazen-faced defrauder who has no ticket and no notion of paying for one.*

"*He must take up all tickets, and often must go through a long train twenty or thirty times on each trip to make sure of the tickets of his way-passengers. He must get out at every station, see his passengers all off, and signal the train to proceed, being always on time and never in haste.*

"*In brief, the combined duties of captain, clerk, and steward of a steamship fall upon the conductor of a first-class passenger express. He travels usually from one hundred and fifty to two hundred miles a day, often including the Sabbath, and his compensation reaches the enormous sum of $1,200 per year!*"
—From *A Fast Life on the Modern Highway* (1872)

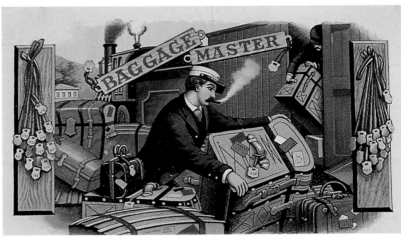

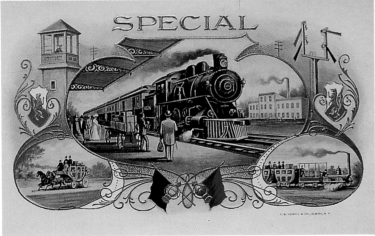

B. Bicycles

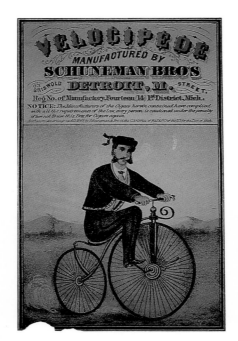

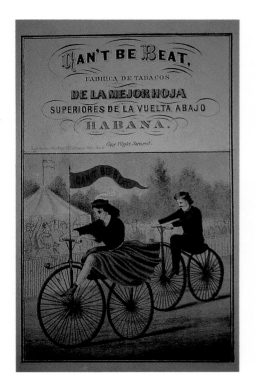

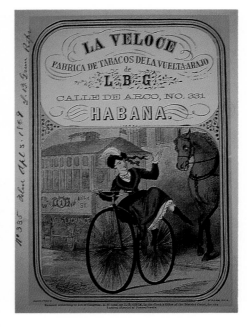

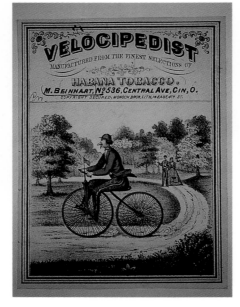

Boneshakers

In 1816, a strange, two-wheeled contraption pushed along with the feet on the ground was exhibited in the Tivoli gardens in Paris. It had vague but unmistakable elements of what we now call a bicycle and was invented by Baron Von Drais of Mannheim, Germany, a landscape gardener.

The concept of the modern-day bicycle originated in France. It was a model that featured three wheels and was propelled by pushing pedals on the front wheel. It was patented in 1865.

The next year, 1866, Pierre Lallement, a French mechanic engaged in the manufacture of baby carriages, came to the United States and in New Haven, Connecticut, built a two-wheeled version made entirely of wood and also operated by pedals on the front wheel. He called it a "veloce."

Lallement popularized his new invention (and the new sport of cycling) by pedaling all the way from Ansonia, Connecticut, to Binghamton, New York, a distance of 150 miles featuring roads far better suited for Sherman tanks than bicycles. It was fate that ordained the plucky Frenchman to make history by becoming the first rider in America to take a header over the handlebars.

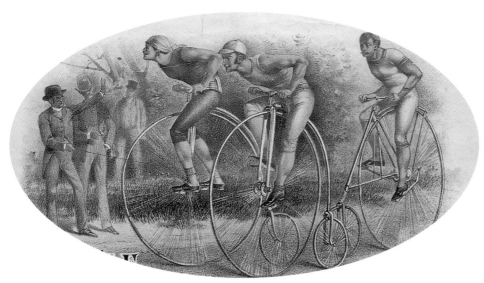

Cigar labels of the 1880s *recorded the decade's favorite, called a "highwheeler" or a "safety." The latter term was a misnomer. Some models elevated riders as high as seven feet off the ground, making the sport a true test of balance as well as nerve. The new models featured rubber tires for the first time, which gave cyclists a much smoother ride than the spine-jolting models of the 1870s.*

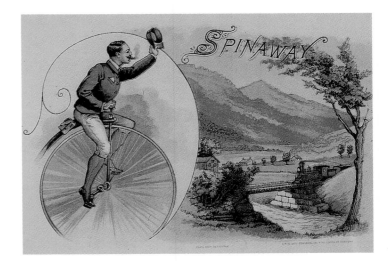

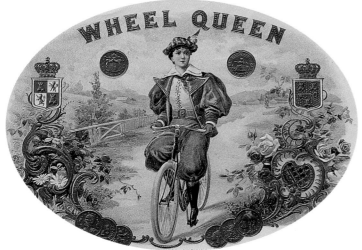

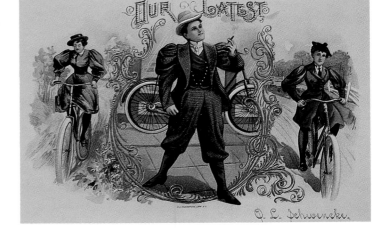

By the 1890s, *the bicycle had taken on a standard form that we all know today. By this time, also, women had become avid enthusiasts of the healthful, open-air sport of cycling. And then came the automobile which brought an abrupt halt to the bicycling pastime.*

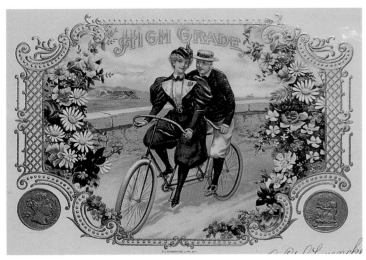

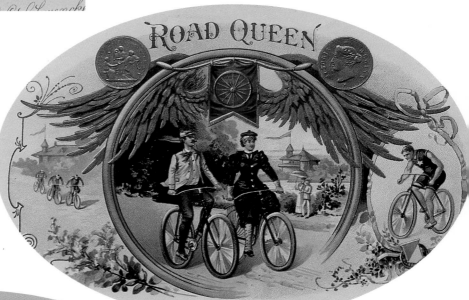

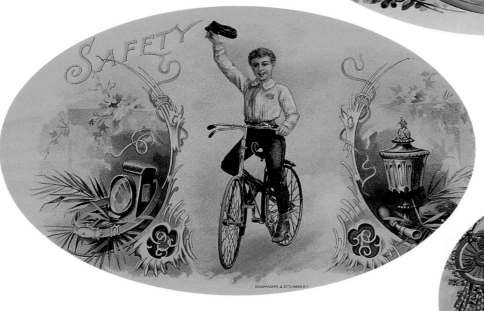

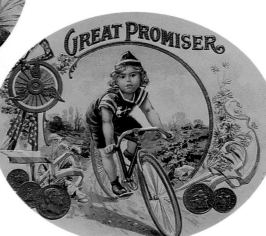

C. Trolleys and Trams

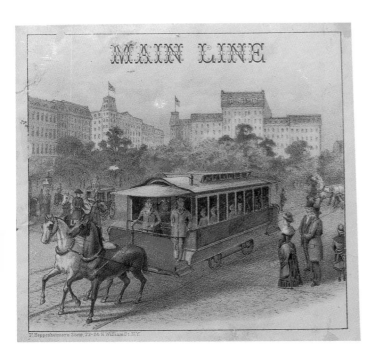

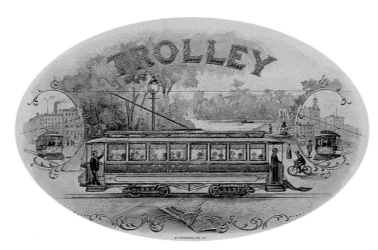

D. Balloons and Aeroplanes

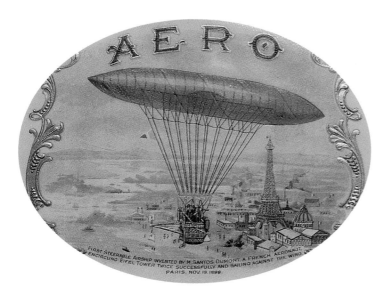

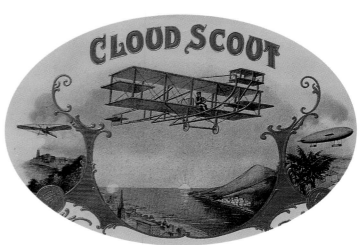

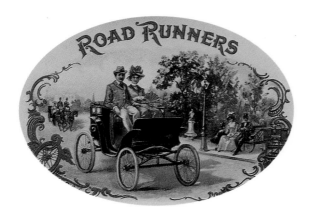

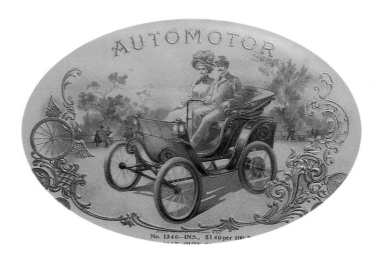

Infected by the Motor Germ

"Have you had the automobile fever yet? Have you noticed your neighbor Bilkins across the street with his nice little red car, and envied him with consuming envy, wondering how he manages to do it on $2,500 a year? Perhaps you have been inoculated, have experienced the realization, and have a first and second mortgage on your home, too.

" 'No, no,' you protest. You abhor the automobile with its noisy horn, its flashy show, the foul trail it leaves floating in the air behind, and, above all, the contemptuous disregard it breeds in the owner for the rights of others in the streets. Every man that runs an automobile faster than a walk and fails to toot his horn every twenty feet ought to be arrested and fined, and put in jail for a year, and have his license revoked and his automobile confiscated, and be hanged and have his body given to the medical colleges.

"You can't understand why every man gets to be a speed maniac as soon as an automobile is delivered into his hands. An evenly balanced man ought to have enough self-control not to be carried away by a little thing like an automobile and have his mind obsessed with the speed mania.

"If you had a car you would drive out into the country with it and jog along easily, so that you and your wife could enjoy the scenery—say ten or twelve miles an hour. That is fast enough for anybody to get any pleasure out of automobiling.

"What fun is there in dashing madly along at a mile-a-minute gait in a swirling cloud of dust with eyes glued on the road ahead and in imminent danger of colliding with a wagon, running down a foot passenger, or upsetting on a turn? You would like to have a machine just to show some of the fellows in town who have gone crazy with the speed mania how a man with a little dignity and equipoise can get a lot of sensible pleasure out of one without becoming a menace to the public and a common law-breaker."

—Harper's Weekly (1909)

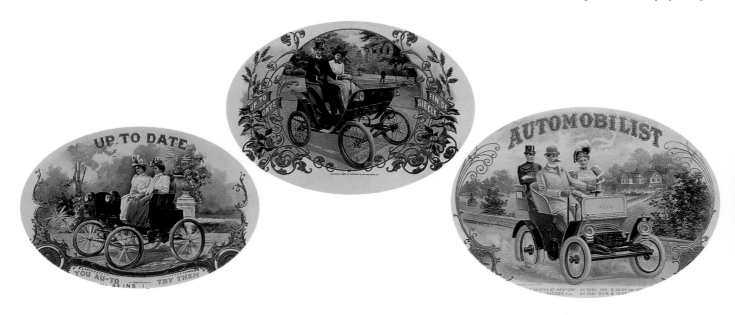

4. Portraits of the Old West

A. The Great American Cowboy

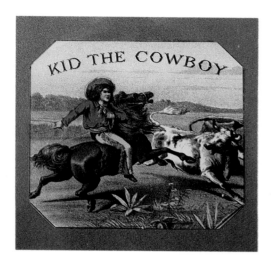

The cowboy was a creature of circumstance. He galloped off the hot, dry, dusty plains of west Texas into the pages of history and the hearts of Americans at home and foreigners abroad. He was a new and picturesque breed of frontiersman, essential to cattle ranching, and went on to become the most familiar, enduring, and legendary symbol of the Old West the world has ever known.

Mounted on a horse, armed to the teeth, booted and spurred, and wearing a distinctive broad-brimmed slouch hat, his casual, almost slovenly appearance and soft-spoken manner belied the kind of man he really was—independent, adventuresome, fearless, skilled with a horse and a rope, and capable of tolerating extremes of physical exposure and endurance. In short, the cowboy was a man of pure rugged strength and courage.

Somewhere around 1870, cowboying emerged as a profession. For various reasons, not the least of which was a never-ending flow of highly romanticized literature (much later, the cinema), urban folks took a shine to the cowboy and fantasized about his thrilling and unique lifestyle, in the process transforming his rough, crude, and uncultured persona into that of the genuine and thoroughly American hero. This image has never faded.

As a breaker of horses, the cowboy was unequaled. While the average cowpuncher was relatively good at it (after all, his profession, by definition, demanded some degree of proficiency), there were others who truly excelled at busting and became professionals, getting $10 a horse on the average.

These busters were so good, in fact, that they could put a playing card on the saddle or a silver dollar under each foot in the stirrup or under both knees and ride a wild bucker to the finish without losing a card or a coin. Generally, the dare-devils in leather chaps did it to pass away slack times or to replenish pokes constantly depleted by too much bad whiskey and even worse poker and stuck to it for lack of an easier job.

As a rule, however, professionals could only stand so much of their work because one day bronco busting was sure to end up busting the buster.

Breaking horses was unarguably a potentially dangerous occupation and one in which physical training and conditioning really didn't count

that much. Sooner or later, the bronco buster was going to get hurt, and when he did, injuries could be serious enough to cripple a man, or kill him outright.

The best bronco busters were heavy men, weighing between 170-180 pounds. Weight in the saddle usually helped accomplish what a lighter man could not, although one of the best-known riders in the 1880s was a skinny, long-legged Texas lad who stuck tenaciously to the horse with his head snapping back and forth like a whip until he actually lost consciousness.

The whole secret of busting was to completely exhaust the animal the first time around; the animal would never buck as vigorously after that. This, of course, was how it was done under real working conditions on a real cattle ranch.

It was different, however, when bronco busting was performed before a paying audience. Buffalo Bill's show ponies, for example, were allowed to throw their riders, or riders judiciously slipped off at the right moment in order to give the cheering crowd its money's worth.

In a wide open work setting, the buster was careful to avoid sheds and timber and to allow plenty of room for the ride. He had to stick to his saddle like a leech, with or without stirrups.

Those who needed stirrups for a hold, though, were looked down upon with contempt by the "sure enough" riders who had plenty of that special and mysterious substance they called "glue." It was all a matter of professional pride.

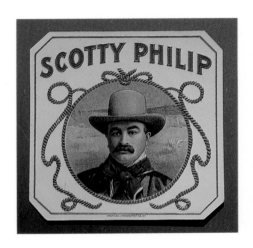

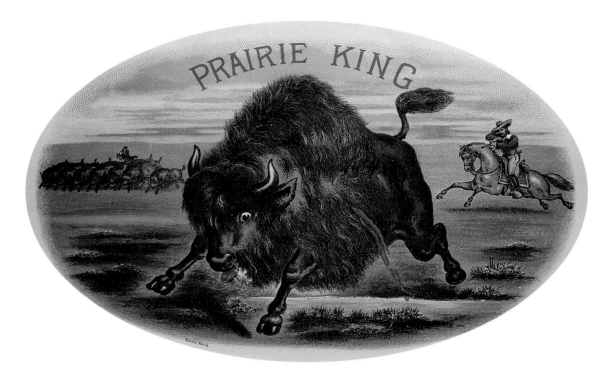

One of the great tragedies accompanying the settling of the West was the white man's systematic destruction of buffalo to the point of virtual extinction.

At one time in history, from South America to the Arctic regions, great herds of bison numbering in the millions once roamed the North American continent. Some were spotted in 1712 within thirty miles of Charleston, South Carolina, and migrating herds even reached the seaboard in Virginia and Pennsylvania.

Existence of the Plains Indians depended heavily on buffalo. The animals were vital sources of food, shelter, and clothing and were hunted solely for these purposes. The natives, armed with lances or bows and arrows, hunted buffalo on horseback. In winter, they did it on foot with snowshoes.

Every scrap of the carcass was salvaged by the Indians; nothing was left to waste. The meat was eaten and the rest preserved as jerky, hides were turned into blankets, robes, and teepees, tendons were used as cords and threads, the dried dung *(bois de vache)* was burned as fuel, and bones were fashioned into tools.

Then came the white man. First there were the explorers and the scouts, then soldiers and finally prospectors, ranchers, settlers, and especially hunters and travelers who soon began killing the animals in enormous numbers. It was done for sport in the beginning but quickly changed to nothing more than relief of boredom and a senseless lust for slaughter. In 1869, a writer for Harper's Monthly laughed at fears expressed by Indians that the buffalo would someday be destroyed.

Within a short period of time, however, these fears became reality. Buffalo, by the mid-1880s, had practically disappeared from the United States. A few small herds, one on the Pecos River in Texas and two or three up north, were all that remained.

The federal government unwittingly encouraged the animals' destruction by furnishing cavalry escorts for foreigners who came to the States expressly to take home some of these magnificent creatures as trophies. As a result, Forts Riley, Kearny, Lyons, Laramie, and Garland and other military outposts became centers of these hunts.

Parties were usually composed of a few English noblemen, a retinue of American hosts, hangers-on, and servants well armed with the latest and deadliest of repeating rifles, a squad of U. S. soldiers, and all the army officers and camp loafers who could find the time or an excuse to join the hunt.

Two or three weeks later the group returned, having killed as many buffalo as they could. While a few tidbits of meat and some hides were taken, most of the carcasses were left on the ground to rot or to be devoured by wolves. Merely for the sake of being able to brag that they had killed so many hundreds of the harmless, peaceable buffalo, these so-called sportsmen cast aside any pretext of fair play and instead acquired the contemptible status of bloodthirsty butchers.

To make matters worse, completion of the transcontinental railroad in 1869 hastened the demise of the animals. Passengers on the Union Pacific railroad, for instance, traveling through the heart of buffalo country in Nebraska, had frequent opportunities to see herds of buffalo from the cars. In a grisly and typically American scene, accommodating engineers slowed the trains to keep pace with the galloping beasts in a macabre race with death as passengers blazed away from every available car window and open platform with rifles, carbines, and revolvers.

In this manner, from the days of the California Gold Rush until the buffalo had been swept from the land, the main routes of travel across the Great Plains were lined for hundreds of miles with their decaying bodies and parched skeletons, grim reminders of their once proud existence and a faded symbol of a uniquely American heritage.

Cattle

In December, 1864, a government trader, making his way to Fort Douglas, Utah Territory, with a wagon train of supplies, was caught in an unusually heavy snowstorm near Laramie. In his haste to find shelter, he was forced to abandon his team of oxen, fully expecting the animals to die from exposure and starvation in the harsh environment. When the trader returned in the spring, he was surprised to not only find the oxen alive, but also fat and healthy from eating an abundance of dried grass exposed when the overlying snow was blown off.

This simple but astounding discovery had far-reaching implications. The fact that cattle could be raised on the open range of the northern states without the need of man to provide food, shelter, and water, was the event that truly "opened the West," far more than the discovery of gold and silver.

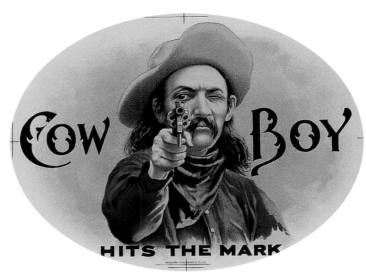

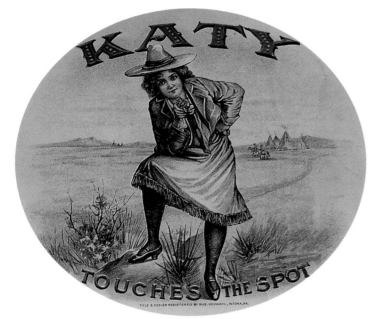

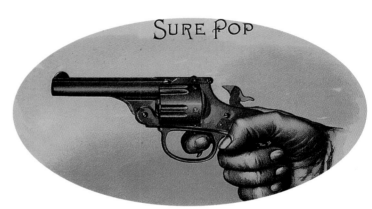

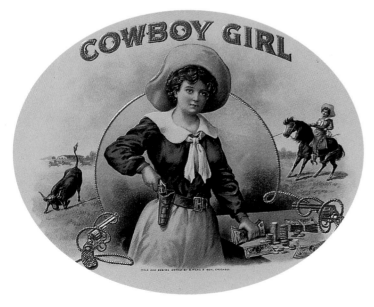

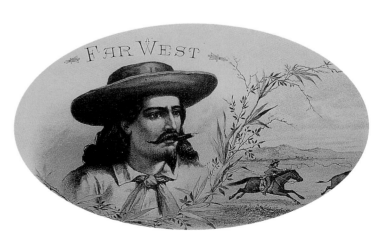

B. Our Native Americans

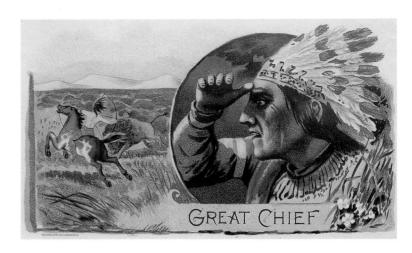

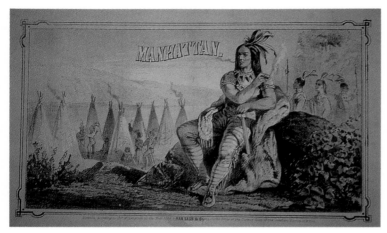

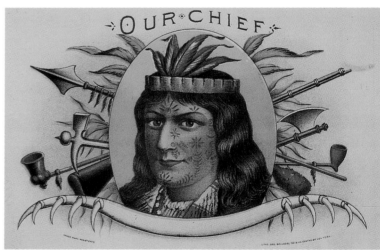

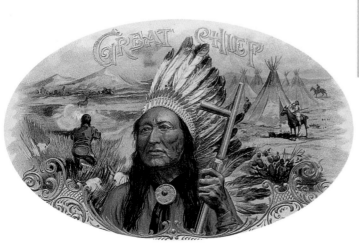

As an advertising theme, Indians *served as an abundant source of brand names for all sorts of products and their striking portraiture fired the imagination of men of all ages. Unlike the contemptuous and inhumane treatment Indians were forced to suffer in real life, the natives were always depicted in respectful and stately poses on cigar box labels.*

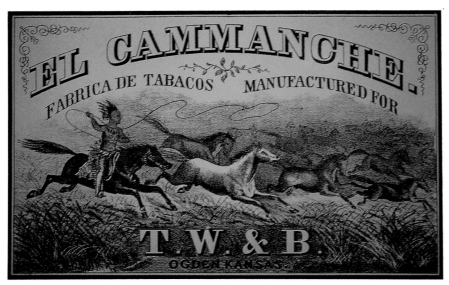

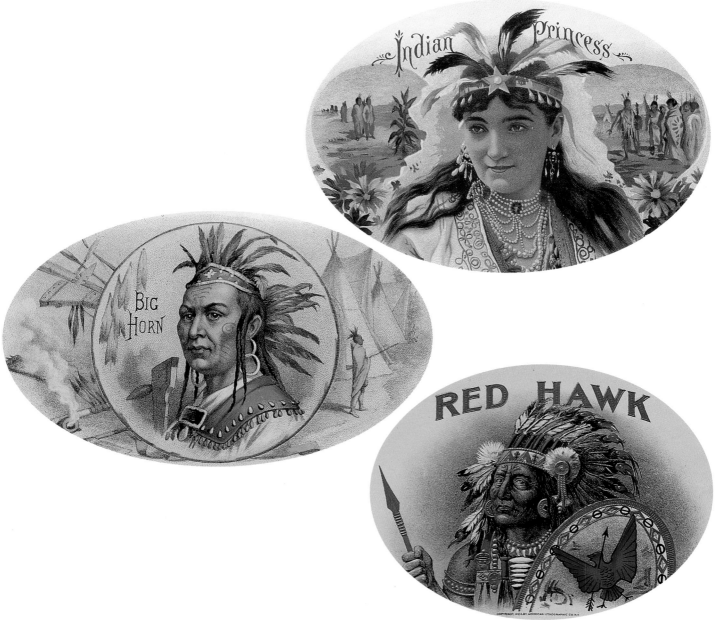

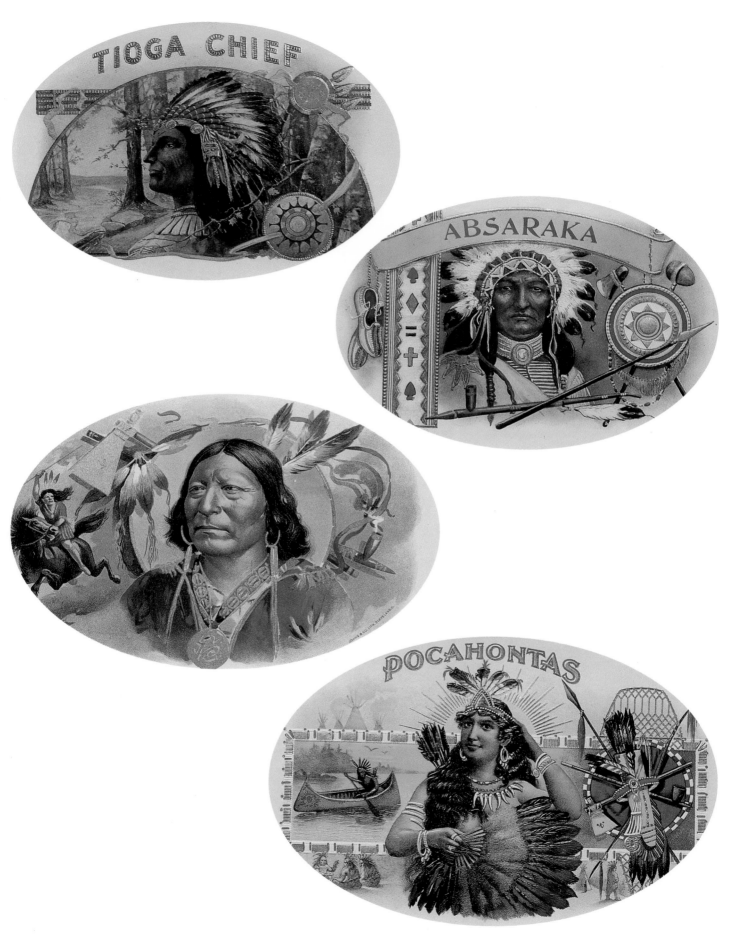

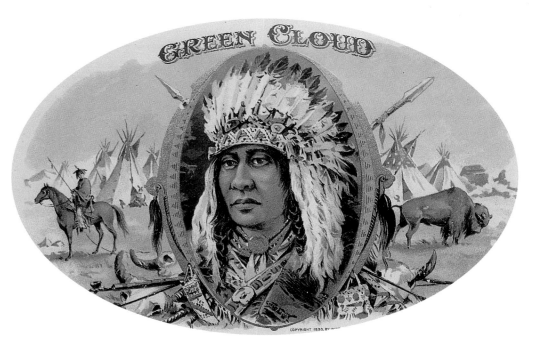

C. Mining

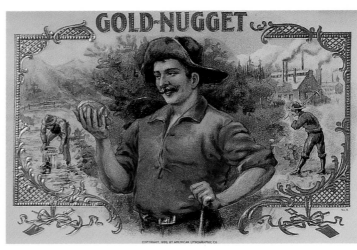

Gold Fever

"When, in 1848, news of the gold discovery by J. W. Marshall at Sutter's Mill became generally known, all the little world of California hastened into the mountains to hunt for gold. Those were indeed the primitive days of mining.

"Machinery had not then been invented, and the materials for constructing the crudest implements were with difficulty obtained. In many instances, baskets or basins of willow twigs were used. The sand or earth supposed to contain gold was agitated in these, and the earth was so rich in many instances that, even with these imperfect appliances, a very short term of labor was certain to reward the adventurer.

"At that time gold was found in the crevices of the rocks, protruding from the banks of the streams, and dazzled the eye here and there in bright nuggets on the surface of the earth, as it reflected the sun's rays. Many gold-seekers used no other instrument than a common sheath-knife, with which to pry out these 'chispas,' and thus, as they averred, saved time and the expense of machinery. Thousands of dollars' worth were thus collected long before the cradle was introduced.

"A volume would be required to perpetuate the fabulous tales still circulated of the former richness of the placers along the banks of this river (Mokelumne)... How the price of a common Irish potato in 1849 was one dollar; a pinch of gold dust paid for a drink of bad whisky; the same for a 'chaw' of tobacco; and a doctor did not look at you for under twenty dollars.

"... A Yankee had set up a small tent among the miners' cabins whence he dispensed whisky, tobacco, physic, raisins, and other groceries. It is related that an Indian came to the tent with a handful of gold wrapped in a rag. This he placed in one of the scales which the shop-keeper weighed down with raisins in the other, much to the satisfaction of the customer. The Indian, fearing the other might repent of his bargain, suddenly seized the paper of raisins and disappeared into the woods with the speed of a deer. Of course, the Yankee did not pursue him, the raisins costing him about five cents and the gold amounting to more than thirty dollars.

"... Near here (Tuolomne River and Woods' Creek) we witnessed an instance of the habitual gallantry of the California miner. A party, among whom were two ladies, were traveling through the mines and visited a well-known claim near Jacksonville, to see how gold was dug. One of the ladies, a celebrated beauty, went by invitation into a formidable-looking tunnel where she caused so much excitement that one of the proprietors, filling a pan with earth, promised her all the gold it might contain if she dared soil her hands by washing it out.

"She gayly consented and went through the operation amidst the laughter of her companions. As the earth was gradually reduced so that the bottom of the pan could be seen, the rattling of gold nuggets could plainly be heard on the tin and when thoroughly washed, there remained nearly fifty dollars' worth of gold.

"This is the special prerogative of ladies who are always at liberty to wash out a pan of earth at any claim they may honor with their presence, and the miners take special care that the labor shall be well rewarded."
—Harper's Monthly (1860)

The Colorado Gold Fields

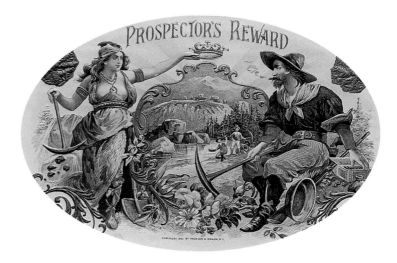

"The popular theory among the miners that a camp will be a success only after it heralds its third murder assures the brilliant future of the Cripple Creek gold fields of Colorado. Although the actual life of this gold camp dates back but a trifle over a year, the required murder record has been passed and now it is sobering down to prove its boast of developing into the greatest gold camp in the West.

"The interest Cripple Creek has aroused in the United States and abroad is due, after its phenomenal worth, to the fact that with the closing of the principal silver mines in Leadville, Aspen and other silver-producing points, hundreds of miners flocked to these mountains in El Paso County on which they have pitched their tents and pitted the country for miles about with prospecting scars.

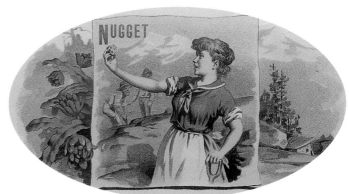

"About sixteen months ago, where today stand the camps of Poverty Gulch, Victor, Pharmacy, and Squaw Gulch—all forming Cripple Creek proper— was a vast grazing plain. The story runs that a cow puncher, while rounding up cattle, picked up several stones to throw at a straying steer. He was attracted by the formation of the stone and when it was as-sayed, it gave a value of $4,800 to the ton. That was only a few months ago; today one of the principal mines is picking ore which runs close to $20,000 a ton.

"The people of Cripple Creek camp talk only in thousands above the ten figure and at night, when they center from the hills in the hotel lobby, the noise and bustle would do credit to the New York Stock Exchange. Miners, cowboys, gamblers, English lords, and German counts meet on a common plane in the barter and sale of nature's most precious metal.

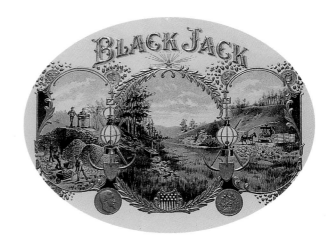

"Cripple Creek is well equipped with the typical mining dance hall and gambling saloon. Its inhabit-ants are taken from almost every walk of life and are arrayed in mining costume, topped off with the cowboy felt hat and top boots with a liberal showing of guns. Still, withal, the camp is far above the average.

"The town's elevation is about 10,000 feet above the sea, about the same altitude as Leadville; it is eighteen miles from the railroad. The trip from Divide to Cripple Creek is over a mountainous road and is made by the picturesque old Concord stage whose driver is always equipped and ready for a 'hold-up.'

"Among the principal and stronger mines of the camp are the Anaconda, Buena Vista, Raven, Victor, Zenobia, and Pharmacist. The main stamp mill is the Rosebud which has been erected at a cost of $100,000. Cripple Creek is very young; it is gold-mad and its disease is contagious."

—Harper's Weekly (1893)

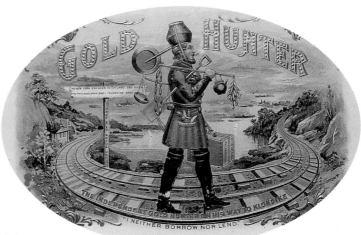

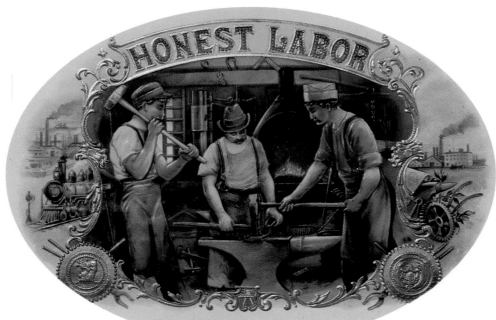

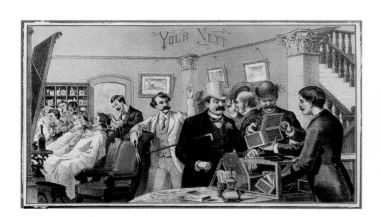

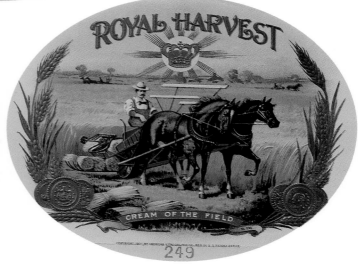

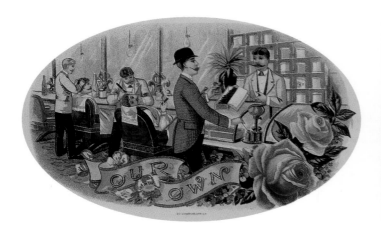

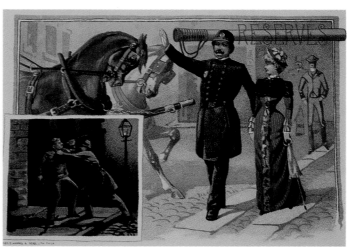

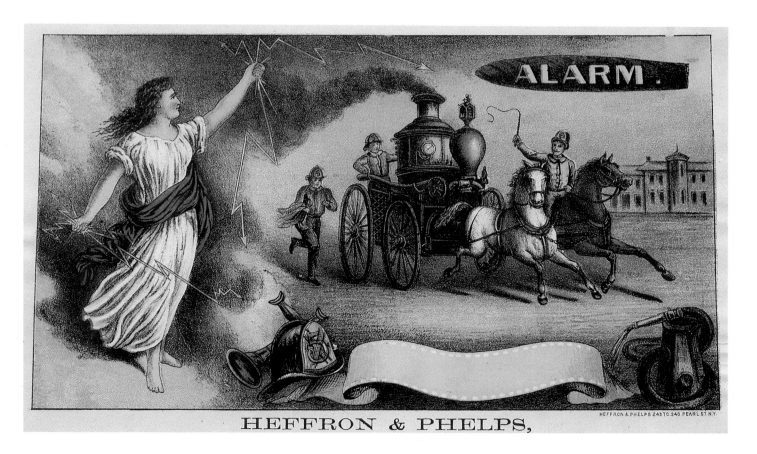

HEFFRON & PHELPS,

Medals for New York Firemen

"Four gold medals were awarded to New York firemen recently in recognition of heroism on the part of two of them, both common firemen. The presentation was made by the mayor of the city at a stand erected on Riverside Drive, overlooking the Hudson. Chief Bonner pinned the medals to the breasts of the brave winners.

"This ceremony was followed by a parade and a very pretty and spirited exhibition in which ten fire engines and two hook-and-ladder trucks were made to answer an imaginary alarm of fire. They went dashing at full speed past the thousands of spectators gathered near the stand, the horses tossing their heads and manes, the apparatus swaying from side to side and spitting clouds of smoke and sparks, bells clanging, whistles shrieking,

and firemen clinging on mysteriously, like flies.

"The awarding of these medals takes place every other year. Medals for two years are then due for it is a singular thing that in the Fire Department of this great city, there are only two rewards open each year to competition and of these only one is for the encouragement of heroic endeavor in saving fire-imperiled human life.

"Patrick F. Lucas, a fireman of Engine 24, won the Bennett Medal for 1891 for bravery at a tenement house fire at 52 Dominick Street. Firemen brought thirty persons out of that fierce blaze. Two of these were unconscious. Two others were dead.

"Lucas climbed up the front fire escape. There were persons in a window on the fifth floor but he could go no further than the fourth. So he placed one foot on the railing

of the fire escape and, leaning far out to one side, rested his other foot on a window sill. Bracing himself with one hand, he reached up with the other and helped four persons from the window. It was a deed of strength and daring."
—Harper's Weekly, 1894

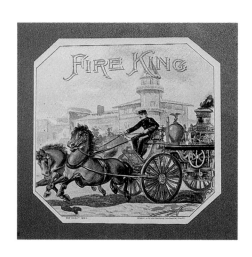

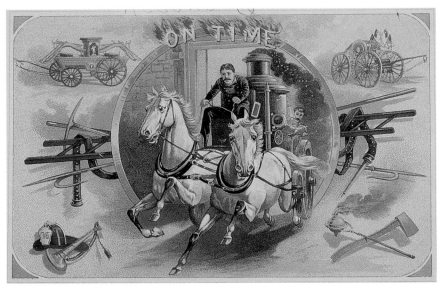

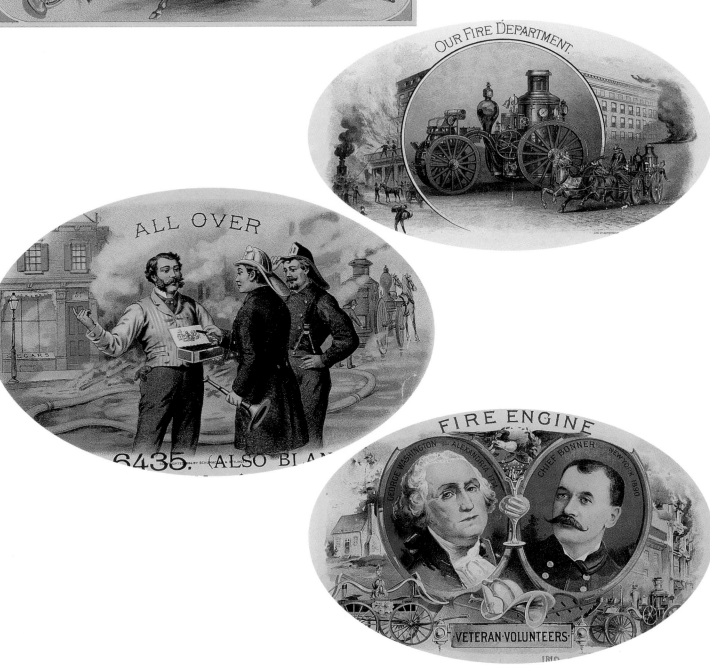

6. America at Play

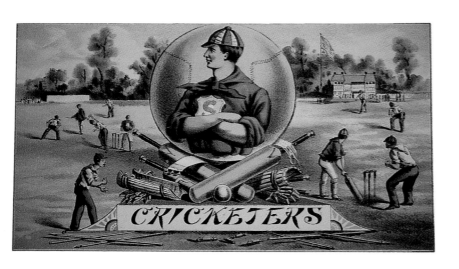

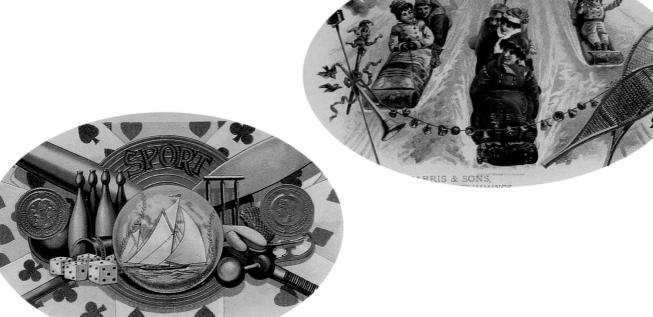

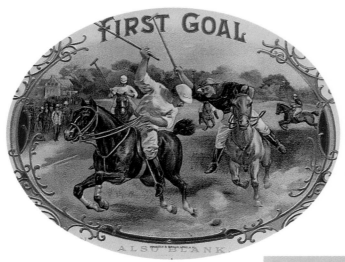

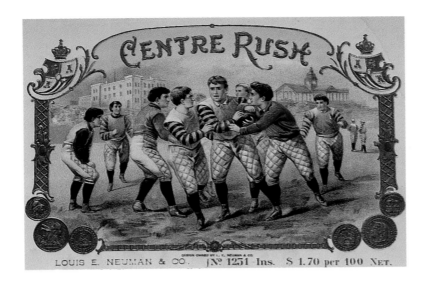

LOUIS E. NEUMAN & CO. N° 1251 Ins. S 1.70 per 100 Net.

The Flying Wedge

The flying wedge, the most diabolical but imaginatively clever running play ever devised in the history of football, has long been outlawed from the sport for the simple reason that it was virtually impossible to stop.

Few people are aware that the play was invented by a man who had absolutely no connection with football whatsoever and that the idea was inspired by Napoleon. The story goes like this:

Lorin F. Deland, a business consultant of Boston, saw his first football game quite by accident in 1890. After viewing a few more games, he began to develop a keen appreciation of the skill required in executing the different plays. Deland spent a good deal of his spare time studying the principles of the game and decided that the actions and strategies engaged in by opposing teams in football were no different than those of two opposing armies in battle.

Being a student of warfare, the Bostonian remembered well the lessons taught by Napoleon. One of the great French general's strategies was to mass a large number of troops, drive them through the enemy's weakest point, gain the rear, and then cause disarray in the enemy's ranks.

Following this example, Deland put his idea first onto paper and then into actual practice on the football field. The play took advantage of the rule keeping opponents on side until the ball was put into play, allowing the entire offensive team, eleven players in all, to grab one another and form a human wedge. Then, running at full tilt, they forced a hole through the opponent's line and ran interference for the ball handler who was assured of gaining good yardage (if not a touchdown) every play.

The flying wedge was first showcased by the Harvard football team in the fall of 1892. It was an instant success and was widely copied all over the nation. It was so successful, in fact, that it quickly became the subject of much argument among fans, players, and football coaches. Eventually, the controversial play was deemed totally unfair and unsportsmanlike by rule makers and was declared illegal.

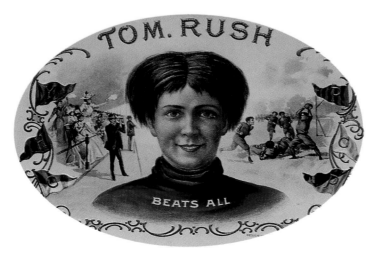

Lawn Tennis

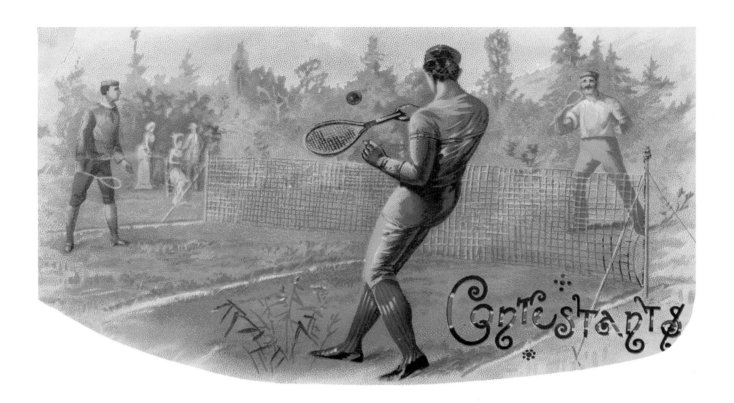

Bowling

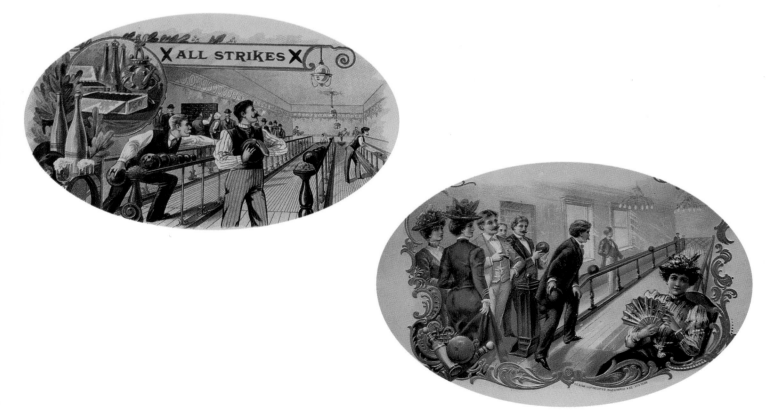

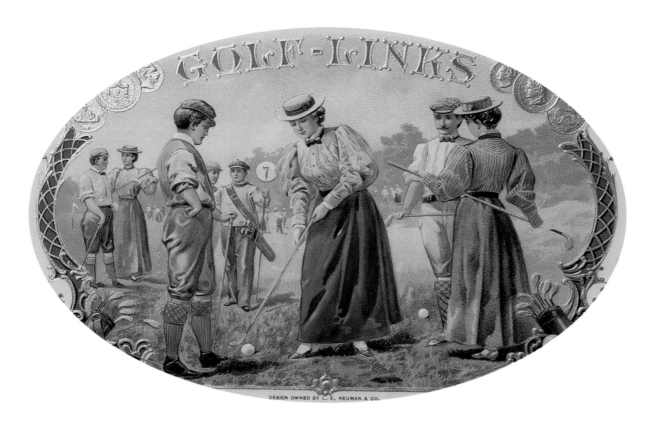

DESIGN OWNED BY L. E. NEUMAN & CO.

The Golf Ball

"Everybody knows that the original golf ball was made of leather stuffed with feathers. In spite of its shortcomings, there was nothing better than this 'feather' ball and it held the field alone for an odd century or so.

"And then in 1848, a formidable rival appeared. Sir Thomas Moncrief, an ardent and ingenious lover of the sport, conceived the idea that golf balls might be made of gutta percha, and having secured a piece of this raw material, he gave it to Willie Dunn of Musselburgh and asked him to make the experiment.

"The lump of India rubber was roughly fashioned into shape and given a fair trial, but it would not fly. It would start away from the club all right and then suddenly 'dook,' or pitch downward. Nobody could account for these erratic movements but the fact remained that it could not be driven and it was then contemptuously thrown away.

"The legend goes on to say that the caddies began to play with the discarded ball for want of anything better, and as they hacked away at it with their irons, they made a curious discovery. The more the ball was cut up, the better it flew.

"Experiments were renewed and some one suggested that the ball should be nicked into lines with a shoemaker's hammer. This was accordingly done and with the happiest results: the flight was now all that could be desired and the days of the feather ball were numbered.

"It was some time, however, before the battle was finally decided in favor of the new ball. Allan Robinson was bitterly opposed to the innovation on the very reasonable ground that his 'feather' ball business would be ruined if the 'gutty' came into general use. For the time being, he tried to check the rising tide by buying up all the gutta percha balls that he could find and destroying them. And yet, ten years later, we find him making his famous 79 over

the old St. Andrews course and using one of the very balls he had done his utmost to discredit.

"It is generally supposed that the gutta percha ball ousted its rival on the strength of its longer carry. But 'Old Tom' Morris seems to think that the carry of the two balls was much the same and certainly a well-made 'leather-and-feather' ball went off very sweetly from the club. It was simply the question of durability and, above all, the difference in price that turned the scale. A 'feather' ball cost three shillings and sixpence while the gutta percha could be turned out at a shilling.

"The life of a 'feather' ball was not long at the best and a heavy 'top' in a bunker was liable to extinguish it at any time. Finally, the 'feather' ball was at a severe disadvantage in wet weather for it quickly absorbed moisture and became sodden and overweight."

—Harper's Weekly (1899)

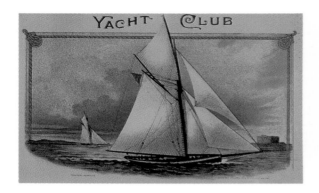
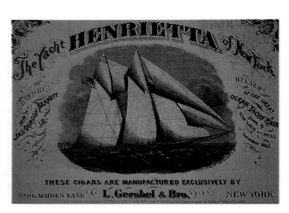
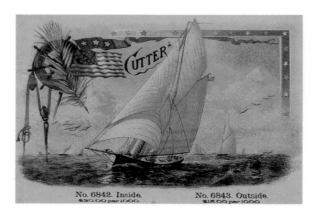
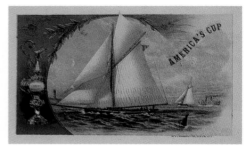

Cup Defending

"... Indeed, it will be noticed that yachtsmen rarely refer to these craft as 'boats,' evidently feeling that racing machines of their types can scarcely be considered as coming readily under such designation. 'Cup defenders' is the most popular appellation, although that is an honor that will be borne by only one of them after the trial races. But it more aptly describes them than any other easily handled combination of words.

"A yacht is popularly supposed to be a pleasure boat; but the only pleasure to be derived in sailing one of these vessels is that to be derived from beating the others, and eventually the English. They are not beautiful on the water which they ride at anchor with all the grace of a Reina Victoria, the hollow lines of the bow having been carefully eliminated in order to cheat the measurement when the vessel lies over on her side in sailing on the wind or beating to windward.

"In fact, these yachts are not adapted to the ordinary uses of yachting. But they have been built at great expense by patriotic and enthusiastic American yachtsmen to preserve the prestige of American yachting and to keep the America's Cup from being wrested from our shores. That such will be the proud privilege of the best of them is the earnest wish of every patriotic and enthusiastic America, be he yachtsman or landsman.

"Sport today, afloat and ashore, is pursued with all the earnestness that is met with in the keenest business competition. The winning boat, the winning horse, the winning man, is a specialist who can do but one thing but do that to perfection. This is inevitable in this age of steam and electricity and for the general result that is obtained doubtless it is best.

"Yet the true sportsman who feels that something more in sport than the mere beating of somebody else will have a sense of intense satisfaction if the final result proves that the best boat, after all, is the one which, with a set of working sails and the prefix of the definite article, most nearly approaches the yachtsman's ideal of a speedy cruiser; while he will give every credit to the unselfish enthusiasts who have gone to any length and undertaken the most costly experiments to keep up the supremacy of the American yacht."

—Harper's Weekly (1893)

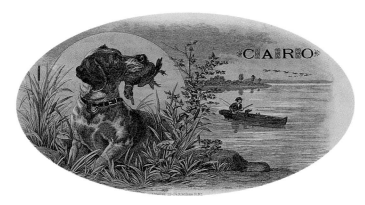

Duck Shooting in the West

"The exciting sport of shooting is full of anomalies, one of them being that the amateur duck-shooter has yet to be born who succeeds in visiting the shooting grounds at a time when the professional gunners will admit that he has come in season to hit the flight. Now, I happen to be personally acquainted with many sportsmen—good shots and ardent lovers of wild-fowl shooting—men who for many years have been in a chronic state of 'laying low' and daily hobnobbing with the decoys from Canada to Texas, who say that although they have made innumerable excursions to the most famous ducking grounds of this country, it has been their uniform experience to learn on their arrival that they had come either too early or too late to secure the cream of the shooting.

"For some unaccountable reason—probably unknown even to themselves—'bagmen' and professional duck-hunters are proverbial for dilating upon the past and on the future. About the present, their opinions appear to be very uncertain. An old sportsman declared to me:

"There is only one way to satisfy yourself, and that is by going to the shooting place before the birds arrive and shoot until they have gone. Then it is a hundred to one the inhabitants will tell you that you ought to have been there in 1863 when everyone was at the war, or that you should wait until another one broke out. Try your best, you can't please the gunners, so go ahead and please yourself.'

"A short time after bottling these sage remarks on a February morning of last year, the wires brought reports of the coming great inundation in the West. That evening I started for the Illinois River, determining for once to be on hand for the spring migration of the fowl on their way from their winter resort in the sunny lagoons of the South to their love bowers in Symsonia and Labrador.

"The point selected for my stay was the vast submerged lands some thirty or more miles down the river from Peoria which section has been patronized by the fowl as a half-way house from time immemorial. This section for many years and especially that in the vicinity

of Clear Lake has been a famous ducking ground. Comparatively speaking, it is the Havre de Grace of the West where wild celery and wild rice grow in great abundance and where for a brief period every spring, the royal canvasback and his prime minister, the redhead, come to hold their court and exact homage of a web-footed retinue and anseric families, from the stately swan to the diminutive page—the green-winged teal.

"The sport of duck-shooting, as carried on by the Illinois River gunners, is divided into what is known as lake shooting and timber shooting. In the former, the fowl are shot either from blinds made in the branches of the submerged willows, or from sink-boxes located in the open water of the lakes. These boxes are constructed to hold the gunner while in a standing position, and by means of four long stout poles firmly planted in the mud are held down almost to the surface of the water. This contrivance, of course, can only be employed in waters where there is no tide.

"The decoys are anchored in a circle around the box. For comfort, these boxes are a great improvement over the coast batteries in which the gunner is obliged to lie at full length in a cramped and awkward position while the sink-box admits of the gunner's whirling with great rapidity and shooting in every direction. When the sink-box is used, the gunner must have a 'tender,' that is, a man in a boat to pick up the dead fowl which are drifted away with the current and the wind.

"The best bags of canvasbacks and redheads made in the West are secured from the sink-box, although the birds that first come from the South readily approach the blinds along the shores. Later on, when they have been shot at,

they become very shy and then remain in the middle waters of the lakes. The broadbills and scaup-ducks (whose local appellation is 'Black Jack') are easily killed in immense numbers from blinds made in the branches of trees where the gunner 'crotches' his boat.

"The timber shooting at mallards is distinctly a Western sport and is only attainable when the forest lands are submerged. In this kind of shooting, half a dozen decoys are found to be sufficient or, what is better yet, a pair of live mallards. The duck is tied by one leg in the bow of the boat while the drake is placed in a little box with a small opening in the lid for his head. The box is painted 'log-color' and is placed on a stump.

"The ducks, being thus separated, keep up a continuous 'quacking' and call down the passing flocks. The gunner whose concealment is not absolutely necessary, providing his clothes are the color of the surroundings, stands quietly by the roots of a fallen snag on the windward side of the decoys, and keeps banging away at the ducks as they swoop down through the tree tops. The bags made by an expert in this kind of shooting frequently exceed one hundred head."

—Harper's Weekly (1885)

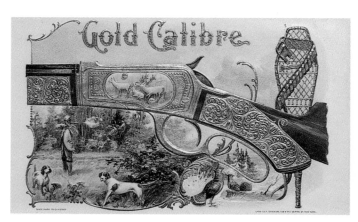

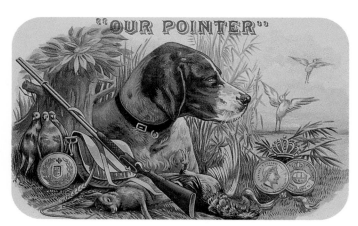

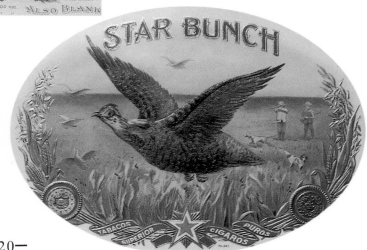

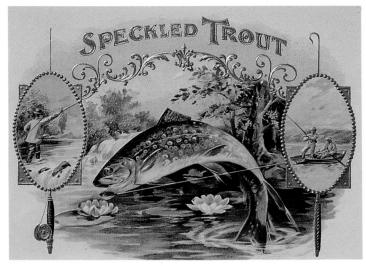

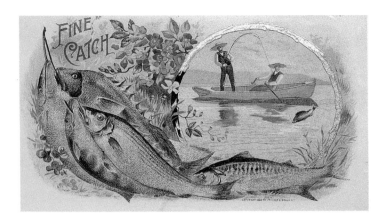

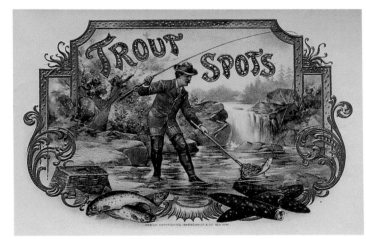

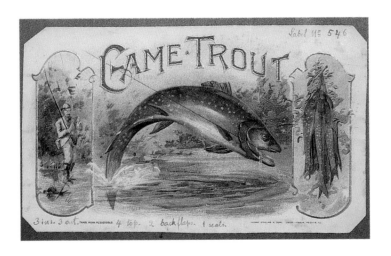

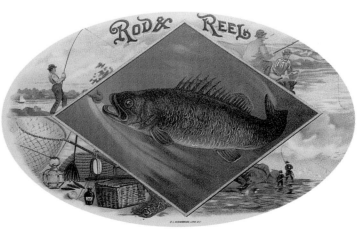

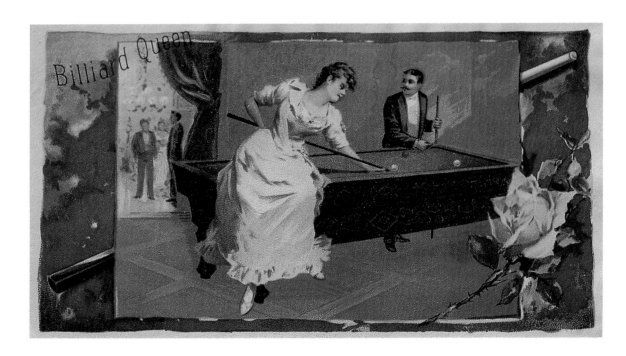

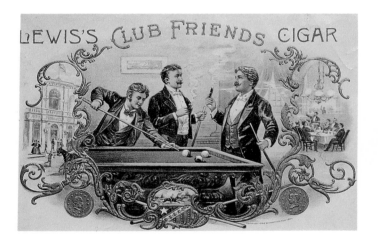

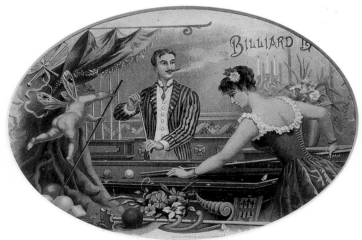

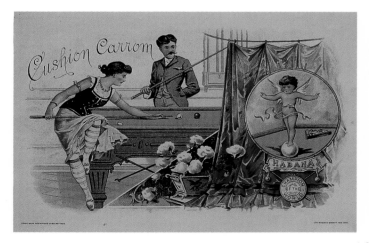

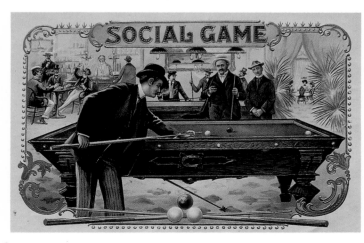

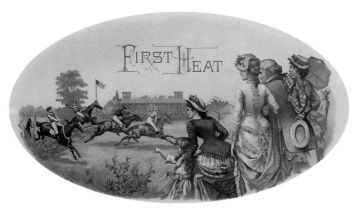

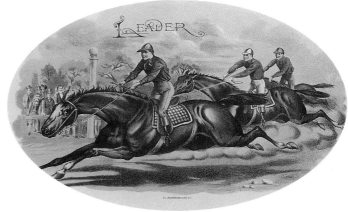

Racing at Monmouth Park

"The opening of the midsummer racing meeting at Monmouth Park on July 11 was, as is usual, the occasion for the flocking of folly and fashion and the lovers of the sport to the New Jersey resorts, not to Long Branch only, but also to all the others that are within easy reach of the course.

"The midsummer Monmouth meeting is always an 'event.' Trains of fifteen cars or more, packed with expectant and streaming humanity, run down to the Park, and all kinds of vehicles from phaetons to wagons convey men, women, and bookmakers to enjoy the sport or to engage in 'business.' It was a fair day for the opening and neither ladies nor dudes nor jockeys nor losers could lay blame on the weather for any damage that gear or purse suffered.

"The greatest excitement of the opening day this year was caused by the winning of the Stockton stakes by Tyrant, the California colt, over seven other three-year-olds selected from 103 original nominations. There was the usual Saturday programme of seven races. Of all, the handicap steeplechase is most interesting to mere spectators. It was won (purse, $600) on the opening day this year by Mr. Drysdale's Echo. The race was made the more exciting by the bolting of Kisber who, when he came to the water the second time, threw his rider."

—Harper's Weekly (1885)

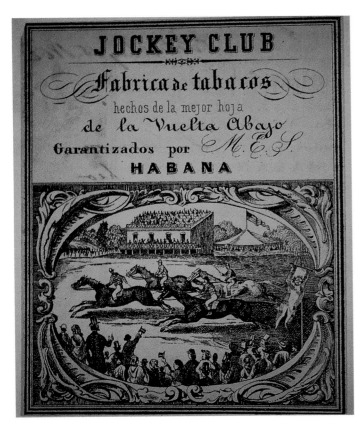

—123—

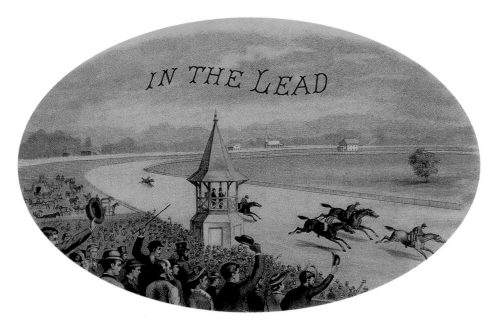

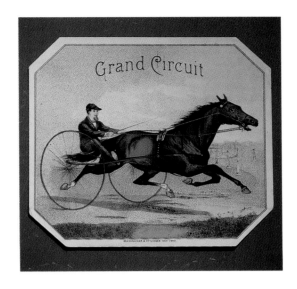

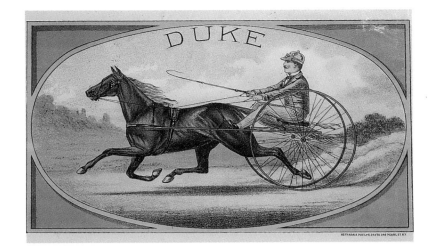

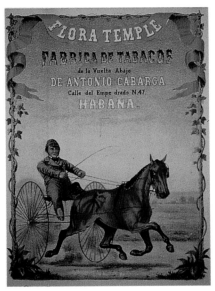

Five Record Horses

"The two-minute trotter is no longer a mere prospect of the dim future; his day is coming upon us almost as rapidly as the records have been going up the scale in the past few years.

"The development of marvelous speed, especially in the last three years, has simply taken us off our feet with a whirl, and left us ready to expect and believe the trotting-horse capable of reaching almost any figure. The days when 2.10 was considered by many the limit of the trotter's speed are easily within recollection; but all calculations were, to borrow a bit of appropriate slang, knocked silly when the great Maud S. brought the time for a mile below that figure.

"The development of the trotter, while always an American industry of great promise, was comparatively slow in time results up to, say, twenty years ago. Edwin Forrest was the first trotter to establish a record; he did a mile in 1834 in 2.31. In '43, Lady Suffolk made the figures 2.26, and here they practically remained with slight change until old Dexter—a dear remembrance of our school-boy days—became a household byword by trotting in 2.17 in 1867.

"The trotting record table may indeed be divided into about five great epochs, led by as many great trotters. Dexter was superseded by Goldsmith Maid, the famous mare which clipped over three seconds off the record, and in '74 brought it to 2.14.

"Rarus in '78 made it still better, trotting in 2.13; and a year later, in 1879, St. Julien marked up 2.12 on the record table. After him came the great and only Maud S., the first to get below the 2.10 mark, and open the eyes of horsemen the world over by her, at that day, remarkable record of 2.08.

"From that day to this, the record has been getting nearer and nearer the two-minute mark by fractions of a second, and Nancy Hanks, Directum, Sunol, and Stamboul have shown the world the possibilities in the highest development of the trotter. And these four great trotters are yet in their prime.

"What may we not expect from them in the present or next season? And which one of them shall first reach the two-minute gait? At the present time, Nancy Hanks occupies the premier position by the fact of her having done a mile last September against time at Terre Haute, Indiana, in 2.04, and by her grand work at Fleetwood Park last week, when she trotted the mile in 2.06 on a course that could not by any means be called fast, and again by her 2.04 last Thursday."

—Harper's Weekly (1893)

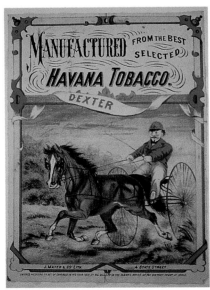

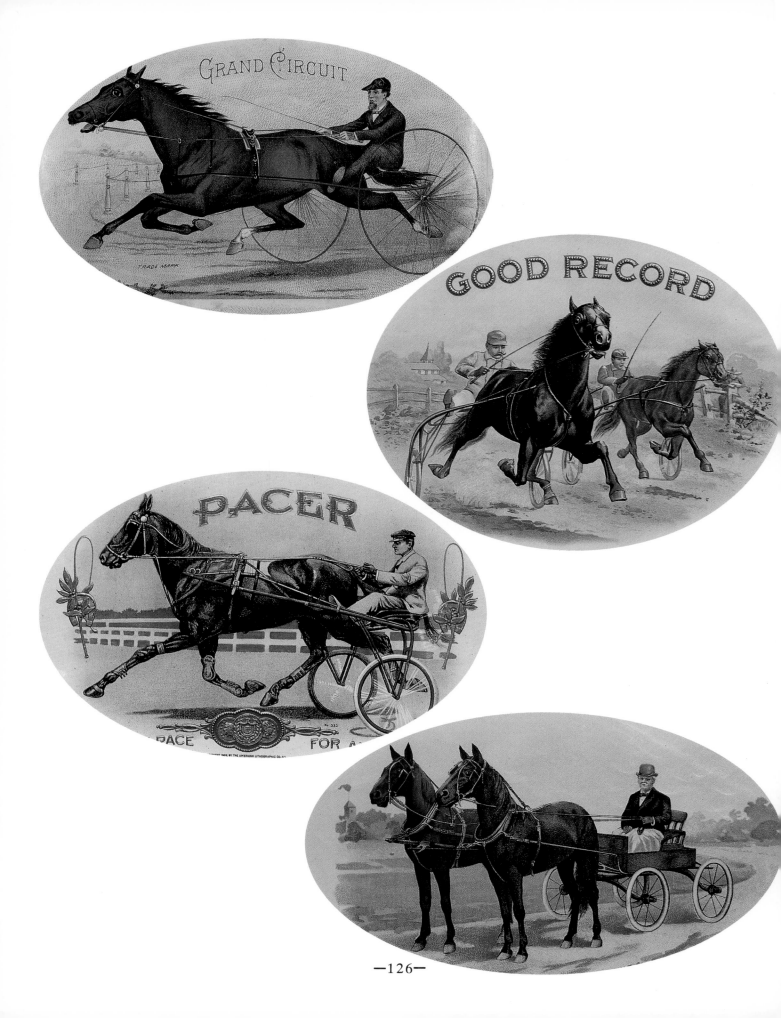

Horseback Riding

CROSS COUNTRY

An Equestrian Adventure

"Tarrytown on the Hudson has a quiet reputation. In fact, there are facetious persons who say that the last time anything happened in the neighborhood was when the famous Headless Horseman of Sleepy Hollow chased Mr. Ichabod Crane.

"There lives at Tarrytown a young man named Arthur L. Oxford. He is a good deal interested in amateur sports and holds the best record in the gentlemen's Suburban for catching the 9:58 train, or something of this sort. Lately, Mr. Oxford has developed a fancy for horseback riding and a month ago bought a fine saddle animal from a Sing Sing man.

"The man recommended the horse in language which in its intensity bordered on blank verse. Mr. Oxford now says privately that the Sing Sing man ought to be shut up in the well-known institution of his town for the term of his natural life, the first woman writing a letter to the newspapers demanding his release to be subjected to solitary confinement with mice in the cell.

"One day last week, Mr. Oxford determined to try his new horse which was named Achilles. The stable man saddled the beast and Mr. Oxford found no difficulty in mounting and starting off. The horse seemed slightly irritated about something and had a tendency to throw his weight on either his forward or rear pair of legs, and then describe the arc of a circle with the other end; but though the young man was not accustomed to riding, he felt no alarm.

"He galloped out past the Andre monument and the cemetery and then started back. While returning, it occurred to him that it would be a clever idea to ride around and make a short call on Major Penhollow's daughter, a young lady whom he hopes some day to make his wife. He dashed up in front of the house with considerable eclat, both to impress the young lady with the idea of danger and to show the major that, though he might be a civilian, he knew how to handle a paltry horse. He drew the animal up and started to dismount with an easy swing, when Achilles leaped violently sidewise and snorted fiercely.

"The young man was somewhat surprised and patted the horse on the neck while he glanced furtively about. The major and his daughter were looking out of a front window. He also noticed an ash cart man and two boys observing him with interest.

"It struck him that he had perhaps attempted to dismount on the wrong side. He tried the other side, but the horse leaped in the opposite directon as fiercely as before and reached around and tried to nip his rider's leg with his teeth. Mr. Oxford struck the animal with his spurs but he refused to budge an inch. The only thing that started him was when the young man tried to get off at which he would instantly begin to jump about, snort, champ the bit, switch his tail, and otherwise show a vicious temper.

"A considerable crowd soon gathered and Mr. Oxford observed the Penhollow family servants at the basement windows. Several attempted to assist him but after one man had been bitten and two others kicked, the unruly beast was avoided. One old veteran, wearing his trousers in his boots, approached and announced that he knew what was the difficulty.

" 'What is it?' asked Mr. Oxford, somewhat curtly.

" 'Why, you've got on one o' those 'ere hosses that ye can't get off of. I seen lots of 'em on the plains in '48.'

" 'Well, what did you use to do?' inquired the young man.

" 'Stay on,' returned the patriarch, solemnly, as he sat down on the curb stone and awaited developments.

"For two hours, Mr. Oxford remained stationary on the horse, occasional attempts to dismount being fruitless. The major and his daughter looked out now and then and the servants retained their places at the windows. The crowd gradually increased and offered advice, comments and consolation. A grocer's boy proposed to 'move 'em up to the Square and use 'em for a hossback stature of Washington.'

"The only solution the survivor of '48 could see was a 'berloon' to descend from above and take off the rider. A German barber suggested having Major Penhollow come out with his 'rifles' and 'shoot der tam peast.'

"Another hour passed and the Chief of Police arrived. This intelligent official announced that he was going to arrest Mr. Oxford for obstructing the streets and a moment later was kicked twenty feet by Achilles for his pains. But it was a lucky kick for the rider as the reaction threw him over the horse's head where he landed in the lap of the ancient plainsman. The horse took another kick at the efficient chief and galloped away in the direction of Sing Sing. Mr. Oxford disentangled himself from the old gentleman and walked home.

"We must crave the indulgence of the reader for referring to this matter at such length, but the approach of the horseback-riding season would seem to justify it. If it shall save any others from the annoyance, not to say danger, of attempting to ride one of this sort of horses 'that ye can't get off of,' we shall consider the space devoted to Mr. Oxford's experience well employed.

"For that such an animal might be actually dangerous can easily be seen, had it not been for the timely arrival of the self-sacrificing police officer, Mr. Oxford might have been obliged to follow the advice of the small boy and take up the quite permanent but highly monotonous position of equestrian statue; and a person has only to look at the average work of art of this character as it appears in our larger cities, to be deeply impressed with the horror of such a fate."

—Harper's Weekly (1893)

The Cincinnati Red Stockings

Baseball officially became a professional sport in 1868 when the first team of salaried players took the field against all comers under the auspices of the Cincinnati Base Ball and Cricket Club (nicknamed the Red Stockings), captained by a former cricket player, Harry Wright. The Cincinnati club conducted a nationwide tour from the closing months of 1868 through June, 1870. Traveling throughout the East and then to the Pacific Coast, the Red Stockings played a total of sixty-five games without sustaining a single loss.

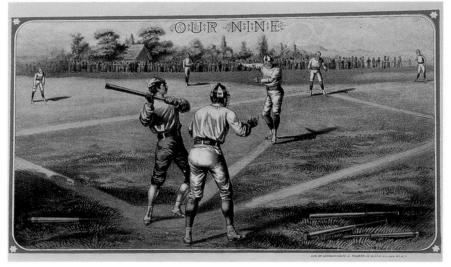

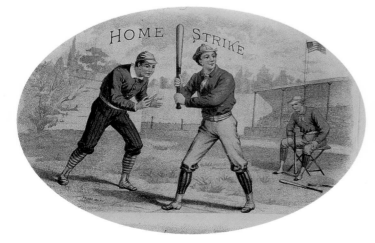

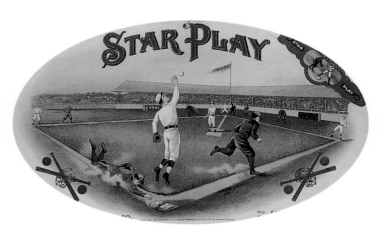

7. Seductive Sentimentality

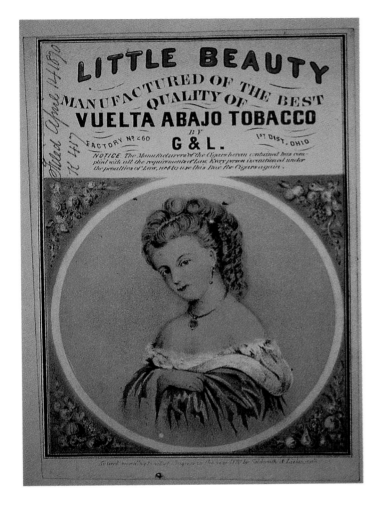

Postbellum beauties *of the 1868-1870 period.*

A. The Face of a Pretty Woman

The most popular symbol in American advertising history was, is, and always will be the face of a pretty young woman. Sexism aside, it has been used to sell practically every product known with the possible exception of convertible debentures and steam-powered cranes.

Nothing caught the eye, riveted the gaze, or raced the pulse of men more than a romantic feminine portrait. Ever since color printing became the rage in the 1870s, the female face and form, more than any other merchandising theme, has dominated cigar box label art.

Vibrant colors were added *to enhance the appeal of labels in the 1880s.*

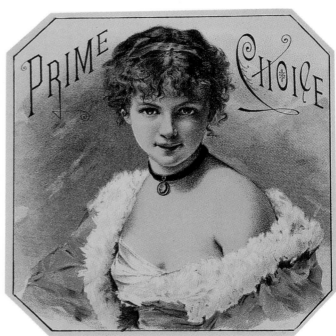

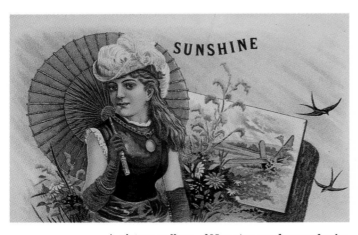

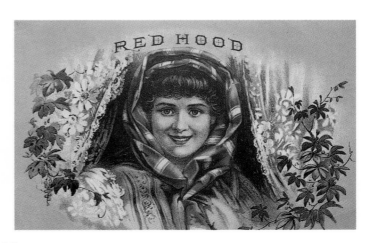

A **picture gallery** *of Victorian-era femmes fatales.*

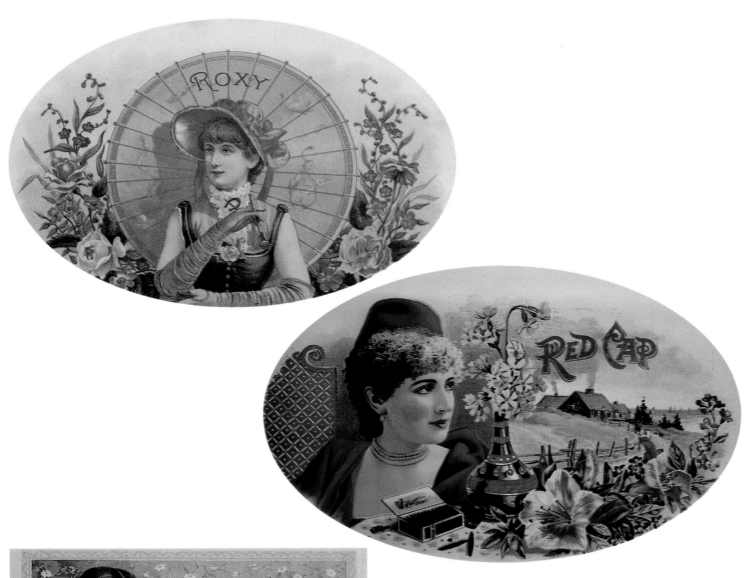

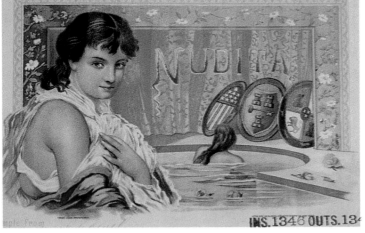

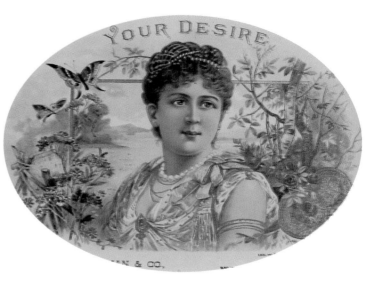

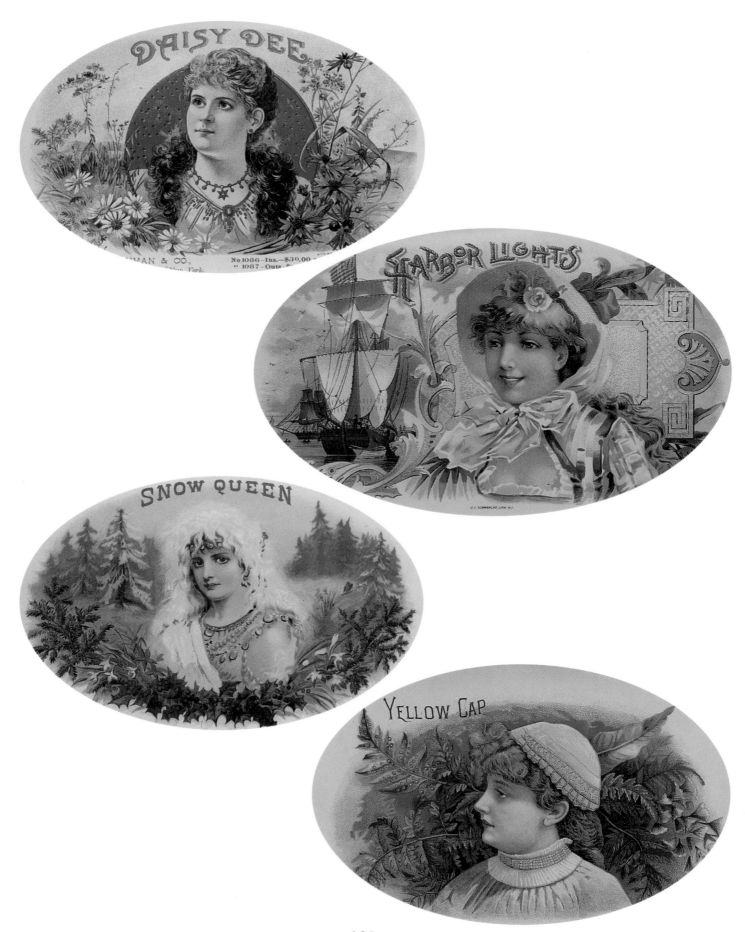

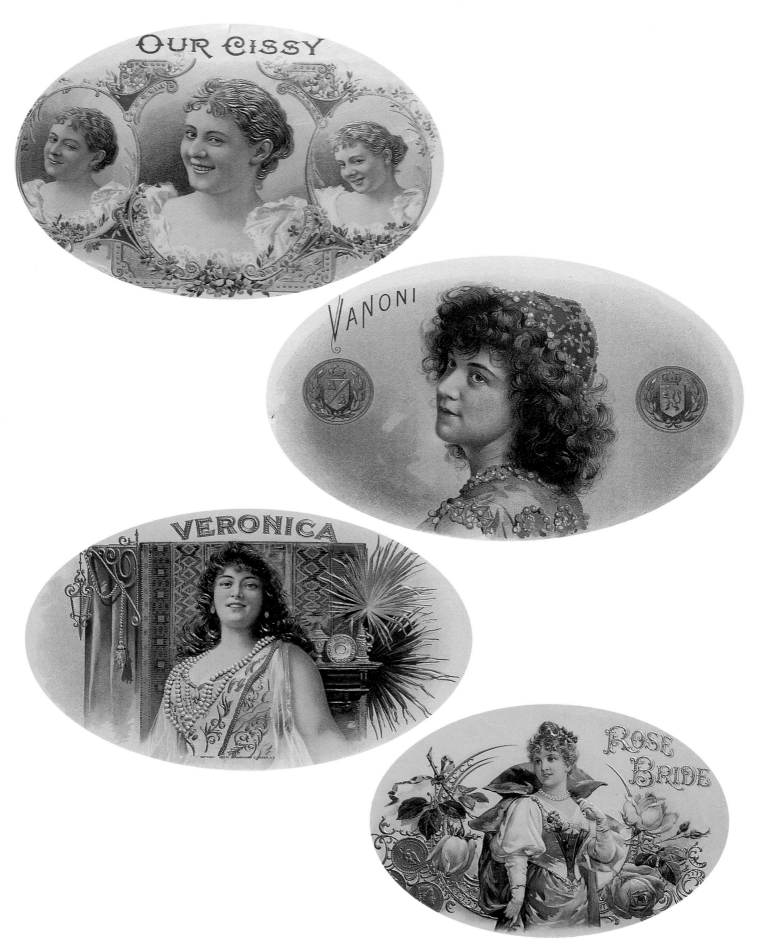

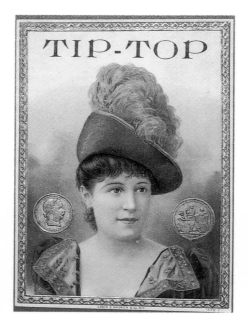

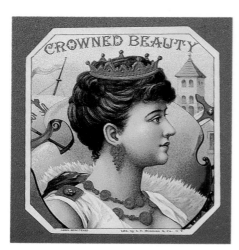

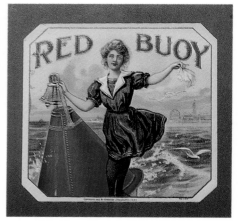

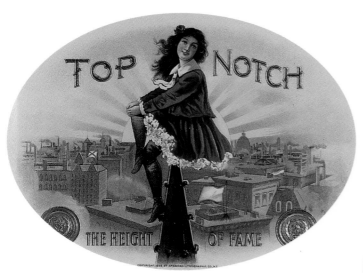

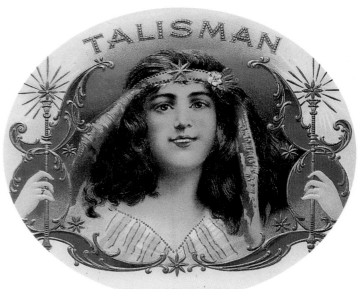

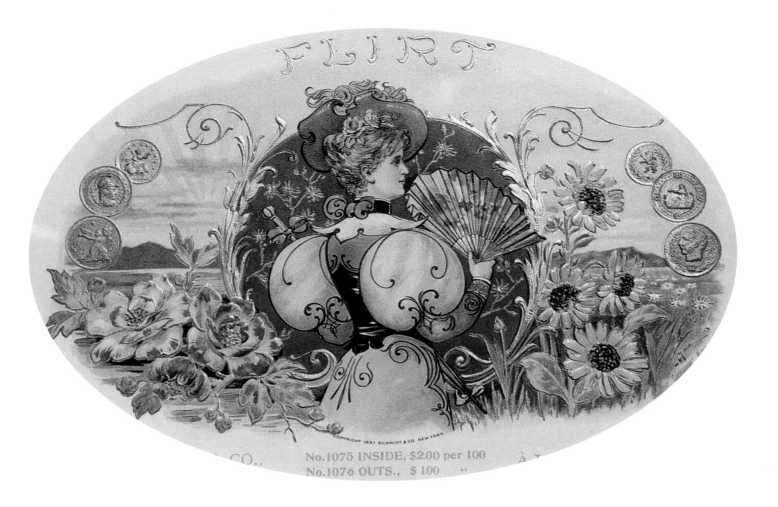

FLIRT

COPYRIGHT 1897 SCHMIDT & CO. NEW YORK.

CO., No.1075 INSIDE, $2.00 per 100 Â
No.1076 OUTS., $1.00 "

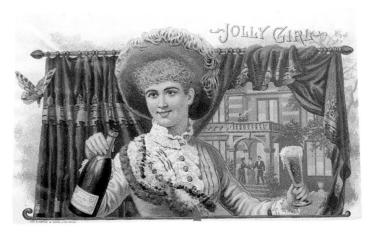

JOLLY GIRL

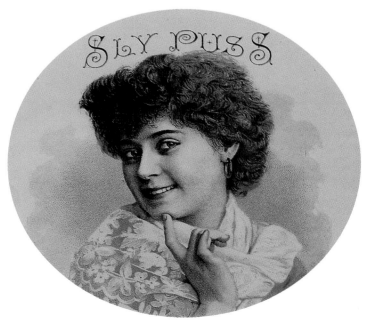

SLY PUSS

An inevitable break *from the seemingly endless flow of sweet and innocent female faces adorning cigar box labels was that of the feminine tease, proving that not all Victorian artists (or cigar smokers, either) were hopeless prudes. The seductive effects ranged from the sly, "come hither" look to the uplifted skirt and naughty flash of ankle to the relatively bawdy portraits of women in negligees or garters to the downright provocative and free-living "jolly girl," the Victorian equivalent of today's "party girl."*

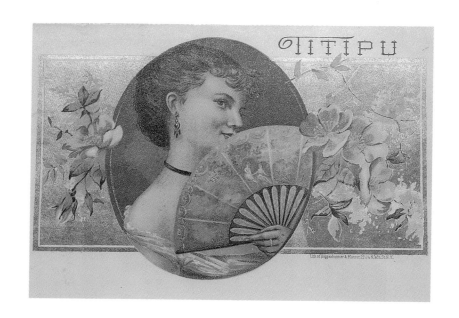

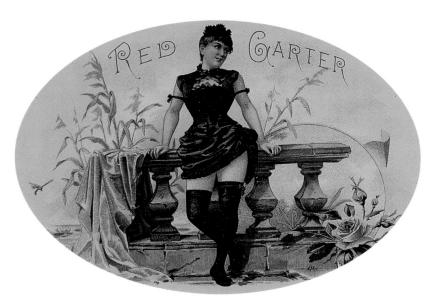

Complimenting the profuse images *of feminine charm and guile were those depicting the sweet innocence of youth, another theme that plucked merrily away upon the heartstrings of male consumers.*

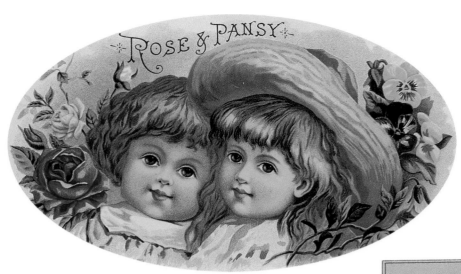

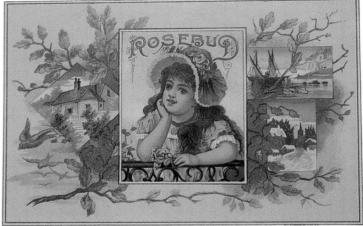

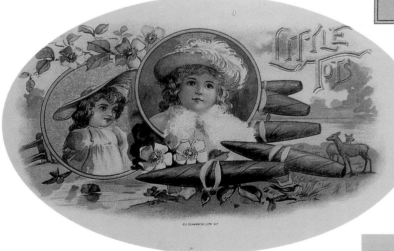

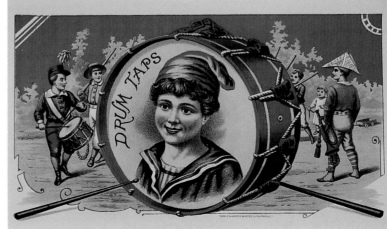

Frog Corner

This subject *is one of the most popular collecting themes of cigar label art.*

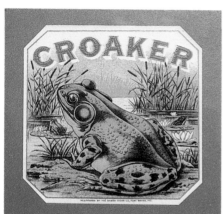

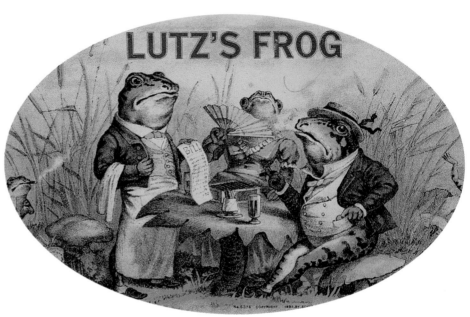

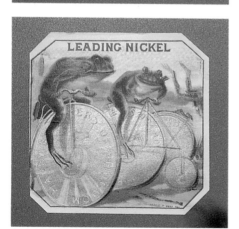

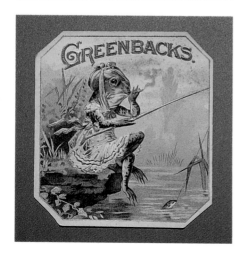

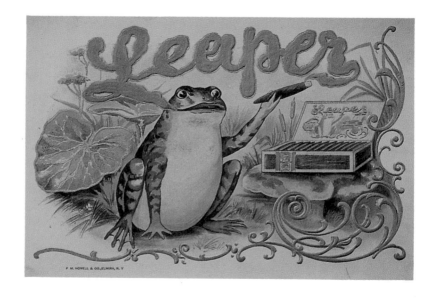

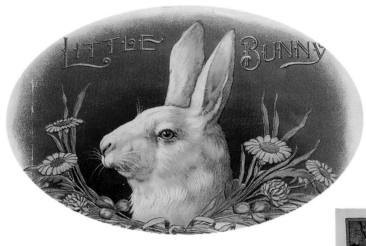

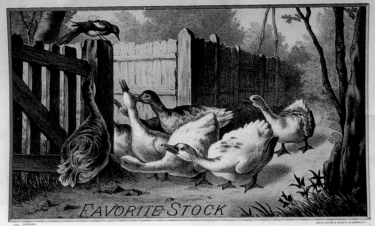

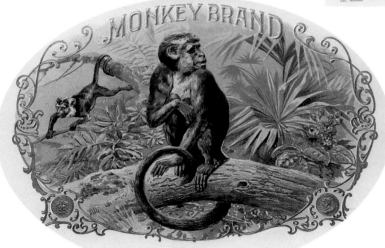

8. Love and Courtship–Victorian Style

The social interplay between man and woman, vital to propagation of the species, is as old and traditional as humanity itself. Victorian-age lithographers found in the time-honored pursuit and romancing of the female sex a wealth of material for artistic expression.

A noticeable and somewhat distracting intrusion in these portraits of otherwise sweet, tender, and private moments was the working in of the hand-held cigar, as if it were some sort of vital instrument of courtship. It certainly mocked social convention, namely, the impropriety of men to smoke in the presence of ladies, which may have been the aim in the first place. Petty objections aside, however, some of the best cigar label artwork was devoted to the themes of love and romance.

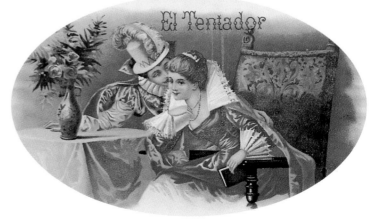

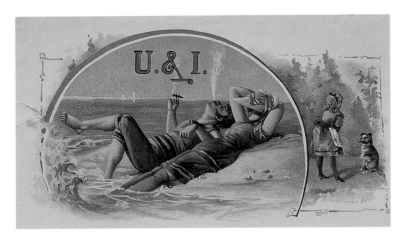

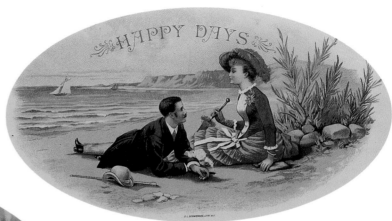

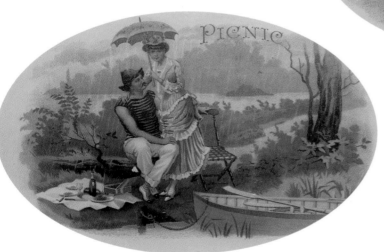

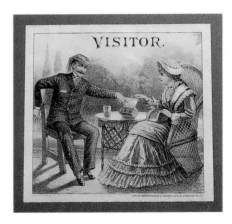

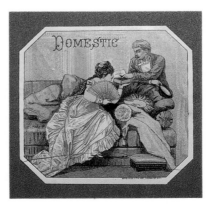

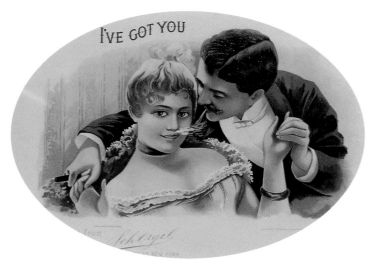

It is preposterous to think *that blowing suffocating wisps of cigar smoke into a woman's face was ever cool or romantic.*

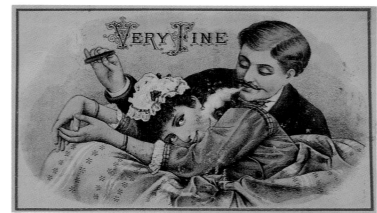

Not all marital unions *resulted in a lifetime of bliss. Divorce was always an unplanned and unwelcome turn of events, sometimes for painful reasons, as illustrated here.*

"*Fops and dudes preferred cigarettes, in general to please the ladies. Even among the ranks of cigar smokers there was the occasional dandy who decked himself out with the weed as the jackdaw of the fable. He only smoked his cigars in fashionable resorts where 'men do congregate' and proved to be an indifferent indulger, smoking only for show. At the appointed moment, he pulled his cigar from a jewelled silver case and flourished it like a personal adornment or military decoration.*

"*He didn't kiss the cigar; he didn't even suck it. He merely showed it off like a thief and never blushed at the dishonesty. His demonstrativeness was translated as follows:*

"'*Look at me. The stunning cigar I am smoking is one of a sample intended for the Captain General of Cuba and the King of Spain, and positively cost twenty coppers. Oh, I have some more dearer at home. Yes, the expense is frightful but damn it! who can smoke the monstrous rubbish of the shops!*'"

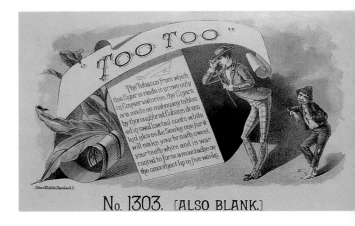

No. 1303. [ALSO BLANK.]

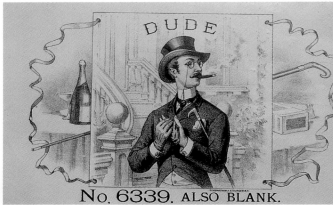

No. 6339. ALSO BLANK.

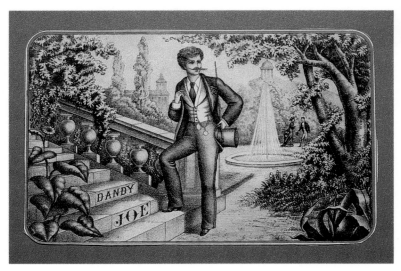

10. In Praise of Good Cigars

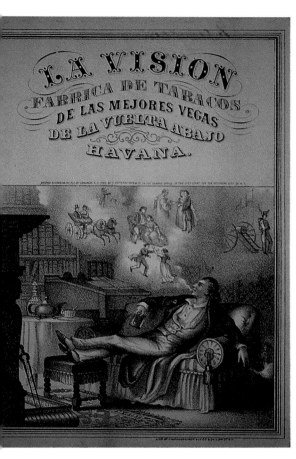

A Good Cigar

Oh, 'tis well enough
A whiff or a puff
 From the heart of a pipe to get;
And a dainty maid
Or a budding blade
 May toy with a cigarette;
But a man, when the time
Of a glorious prime
 Dawns forth like a morning star,
Wants the dark brown bloom
And the sweet perfume
 That go with a good cigar.

To lazily float
In a painted boat
 On a shimmering morning sea,
Or to flirt with a maid,
In the afternoon shade,
 Seems good enough sport to be;
But the evening hour,
With its subtle power,
 Is sweeter and better far,
If joined to the joy
Devoid of alloy,
 That lurks in a good cigar.

When a blanket wet
Is solidly set
 O'er hopes prematurely
grown;
When ambition is tame,
And energy lame,
 And the bloom from the
fruit is blown;
When to dance and to dine,
With women and wine,
 Past poverty pleasures are,
A man's not bereft
Of all peace, if there's left
 The joy of a good cigar.
—Norris Bull

A roaring fireplace, a soft armchair, and a fragrant cigar formed a seductive and irresistible combination that made philosophers, poets, and everyday men exalt the cigar and the pleasures of smoking it to a sublime, almost otherworldly, status.

Business-wise, it really wasn't necessary for cigar manufacturers to suggest that smoking cigars in general was a good thing (some said that to do so was redundant, anyway) but, when it came down to smoking a specific brand, it was a different ball game.

Among the many themes utilized by cigar manufacturers over the years, one of the most widely used was the lighted and unlighted cigar depicted in a number of imposing and flattering poses.

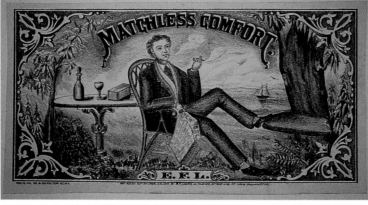

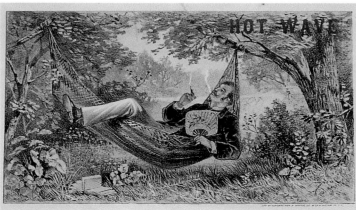

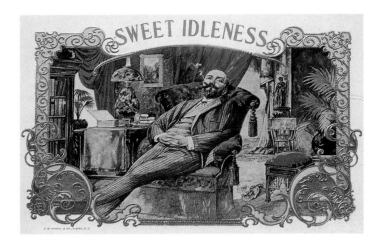

When the race is run and the day is done,
Comes a time for rest and reflection;
When one can recall the faults of today
And hope for tomorrow—perfection.
During this hour, light a cigar
And watch its smoke ascend,
Its flavor and taste will your trials erase
And your yoke of cares transcend.
—Harry Schagrin, Jr.

To My Cigar

"The warmth of thy glow,
Well-lighted cigar,
Makes happy thoughts flow,
And drives sorrow afar.

"The stronger the wind blows,
The brighter thou burnst!
The dreariest of life's woes,
Less gloomy thou turnest.

"As I feel on my lip
Thy unselfish kiss;
Like thy flame-colour'd tip,
All is rosy-hued bliss.

"No longer does sorrow,
Lay weight on my heart;
And all fears of the morrow,
In joy—dreams depart.

"Sweet cheerer of sadness!
Life's own happy star!
I greet thee with gladness,
My friendly cigar!"
—Friedrich Marc

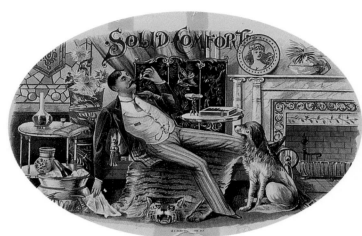

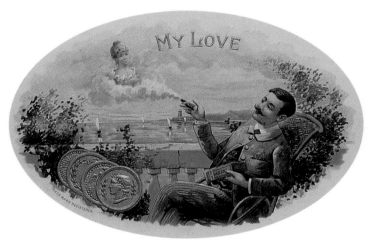

My Last Cigar

The mighty Thebes and Babylon the great,
Imperial Rome, in turn, have bowed to fate;
So this great world and each particular star
Must all burn out, like you, my last cigar;
A puff—a transient fire, that ends in smoke,
And all that's given to man—that bitter joke—
Youth, Hope, and Love, three whiffs of passing zest,
Then comes the ashes, and the long, long rest.
—Henry James Meller: *Nicotiana* (1832)

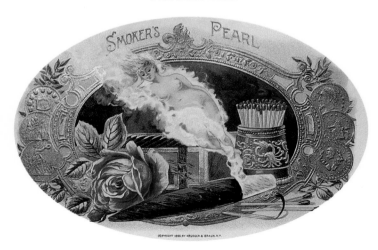

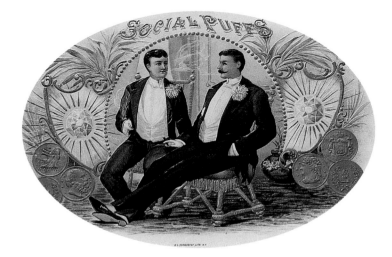

The Social Smoke

"Honest men, with pipes or cigars in their mouths, have great physical advantages in conversation. You may stop talking if you like, but the breaks of silence never seem disagreeable, being filled up by the puffing of the smoke; hence there is no awkwardness in resuming the conversation, no straining for effect—sentiments are delivered in a grave, easy manner.

"The cigar harmonizes the society, and soothes at once the speaker and the subject whereon he converses. I have no doubt that it is from the habit of smoking that the Turks and American Indians are such monstrous well-bred men.

"The pipe draws wisdom from the lips of the philosopher, and shuts up the mouth of the foolish; it generates a style of conversation, contemplative, thoughtful, benevolent, and unaffected; in fact, dear Bob—I must out with it—I am an old smoker. At home, I have done it up the chimney rather than not do it (to which I own is a crime).

"I vow and believe that the cigar has been one of the greatest creature-comforters of my life—a kind companion, a gentle stimulant, an amiable anodyne, a cementer of friendship."

—William Makepeace Thackeray

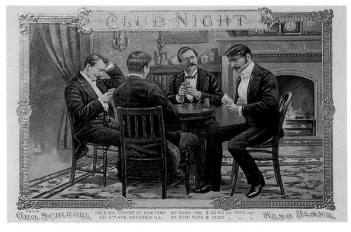

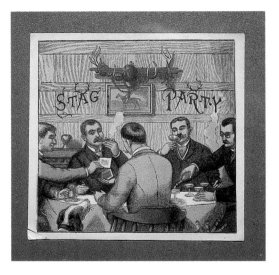

One of the most important messages *of label advertising was to cement the notion that a cigar was the common denominator, an indispensable aid, to good old-fashioned male social companionship.*

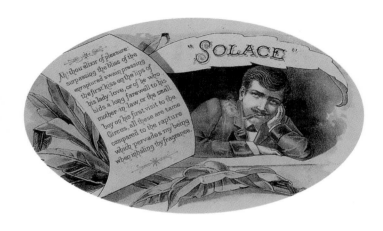

"SOLACE"

Ah thou elixir of pleasure surpassing the bliss of the enraptured swain pressing the first kiss on the lips of his lady love, or of he who bids a long farewell to his mother-in-law, or the small boy on his first visit to the Circus, all these are tame compared to the rapture which pervades my being when inhaling thy fragrance.

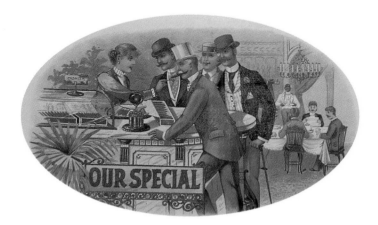

OUR SPECIAL

The Scent of a Good Cigar

What is it comes through the deepening dusk,
Something sweeter than jasmine scent,
Sweeter than rose and violet blent,
More potent in power than orange or musk?
The scent of a good cigar.

I am all alone in my quiet room,
And the windows are open wide and free
To let in the south wind's kiss for me,
While I rock in the softly gathering gloom,
And that subtle fragrance steals.

Just as a loving, tender hand
Will sometimes steal in yours,
It softly comes through the open door,
And memory wakes at its command,
The scent of that good cigar.

And what does it say? Ah! that's for me
And my heart alone to know;
But that heart thrills with a sudden glow,
Tears fill my eyes till I cannot see,
From the scent of that good cigar.
—Kate A. Carrington

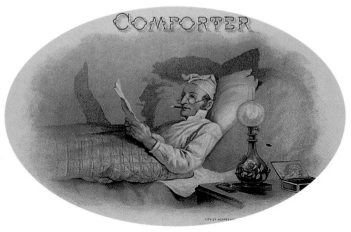

COMPORTER

Elihu Root on Morning Cigars

The well-known American lawyer and statesman thought that a cigar after breakfast was the smoke of the day. He said:

"My breakfast is a very simple meal, and consists of a cup of coffee or chocolate and a roll. When I have finished it, I light my cigar. I find that it assists me in my work. It does not aid me in the creation of ideas so much, nor in reading or actual writing; but when I want to prepare my plans for the day, when I want to arrange and put in shape the work I have before me, I find that smoking is a valuable assistant.

"I never smoke a large cigar in the morning, and usually do not prolong the smoke beyond the time it takes me to arrange my day's programme. Altogether I should say that I smoke five cigars a day. I have smoked steadily for the past thirty years, and during the first ten years I smoked a pipe. It has been my experience that smoking relieved me at any time when I felt overworked. Consequently, if I find at any time of day that my brain is getting tired, and that my ideas are getting muddled, I stop and light a cigar. I don't think that smoking has a sedative effect upon me, but it composes my thoughts and soothes me to some extent."

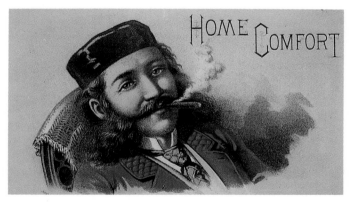

HOME COMFORT

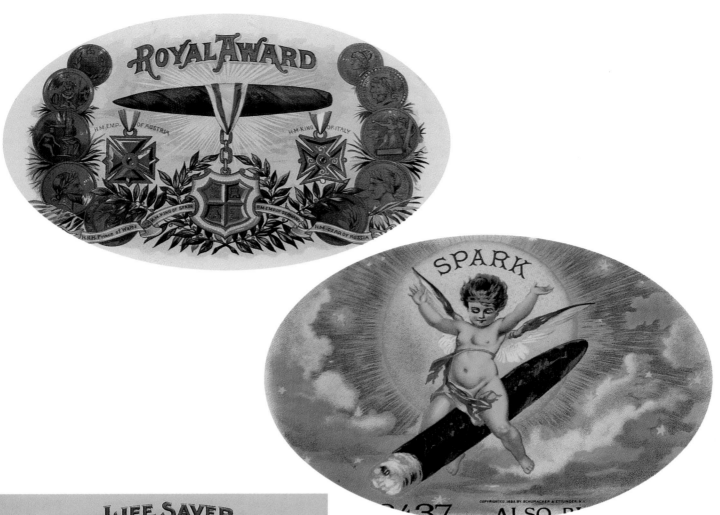

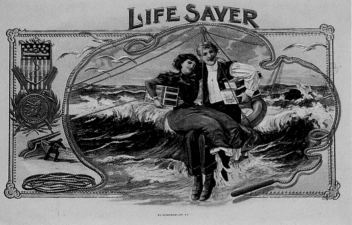

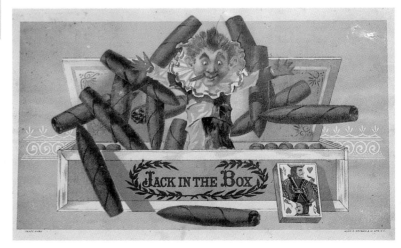

The cigar was often portrayd *as a thing of great value, both symbolically and in fancy.*

Tobacco Hearts

"O, she was a gay little cigarette,
 And he was a fat cigar;
And side by side on a tabouret
 They stood in a ginger jar.

Though never a word could I understand
 (For they spoke in auto-bac),
Yet wonderful things they surely planned,
 As lovers will, alack!

Now, she is a sad little cigarette,
 For gone is her fat cigar;
And all alone on the tabouret
 She stands in the ginger jar.

Ah, love is a wonderful thing, 'tis true,
 And many a fault 'twill cloak;
But it often ends, like the dream of these two,
 In nothing at all—but smoke."
 —Irish Tobacco Trade Journal

Untitled

A few more whiffs of my cigar,
And then in Fancy's airy car,
Have with thee for the skies:
How oft this fragrant smoke upcurl'd
Hath borne me from this little world,
And all that in it lies!"
 —From *Odes and Addresses to Great People*,
 Thos. Hood and G. Reynolds

She

Yes, dear,
 I fear
I love another, strange to say
 Brunette,
 This pet,
And I am with her night and day.

Just now
 I vow,
I pressed her fondly to my lips;
 The kiss
 Was bliss
And thrilled me to my fingertips.

Don't out!
 She's out
And you are sweeter, love, by far
 Altho,
 By Jo!
She was an awful good cigar!
 —Carl Werner

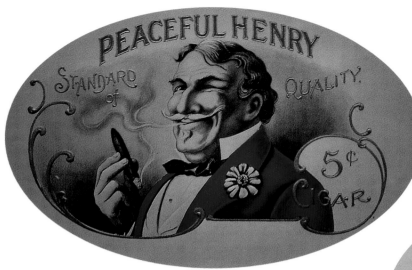

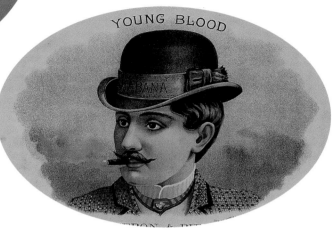

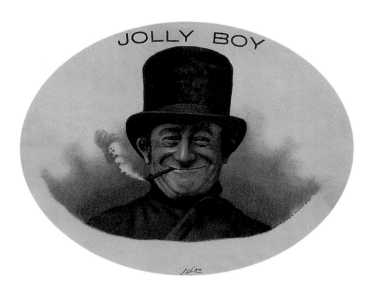

The poet may sing of the leaf of the rose,
And call it the purest and sweetest that blows;
But of all the leaves that ever were tried,
Give me the tobacco leaf rolled up and dried.

—Anon.

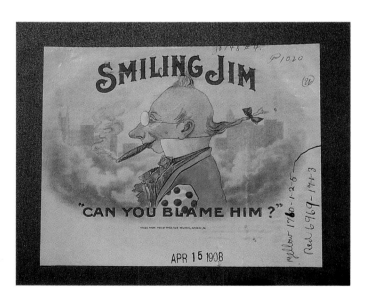

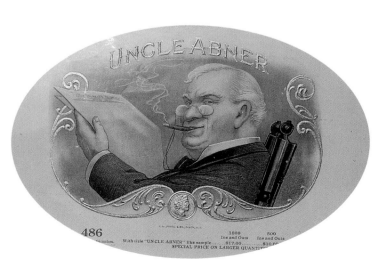

The best advertisement *for a good brand of cigars, though, was the face of a contented smoker.*

Bad Cigars

"It's an ill weed that nobody can smoke."

—Anon.

Not all cigars made in America were of prime quality. As with any other kind of manufactured goods, there were always good ones and there were always bad ones. It was never any different with cigars.

Nothing annoyed a smoker more than a cigar wrapped so tightly that it did not draw well. With puckered cheeks and bulging eyes, these hardy souls tried in vain to draw a breathful of smoke into their mouths. Of course, rank tobacco, the essential ingredient of all bad cigars, always left an unpleasant aftertaste on the conneisseur's palate as a painful reminder of poor judgment and parsimonious habits.

Then there were the little things—strange bits of unidentified material drawn into the mouth from the filler that were spit out in disgust, dried wrapper leaves that unravelled in the smoker's fingers and fireproof models that never seemed to stay lit.

Historically speaking, about the worst and certainly, next to stogies, the cheapest cigars ever produced came from southeastern Pennsylvania. There, in the late 1870s, a thriving cigar making industry sprang to life, due in large part to its sizeable non-unionized labor pool, eager and willing to work for less than union scale.

This unusual situation proved an inviting opportunity for big Philadelphia manufacturers who established branch factories at all stops along the railroad line from Allentown to Philadelphia. Consequently, what had started out in small communities such as Red Lion, Doylestown, York, Lancaster, and East Greenville as essentially a cottage industry, had become, by the turn of the century, major sites of cigar production.

The only problem lay in the quality of tobacco used. In the notorious First and Ninth Internal Revenue tax districts, the so-called country districts, farmers grew a barely passable grade of leaf tobacco useful only as a filler. Seated around fireplaces during the cold winter months, these enterprising cigar makers supplemented incomes by hand-rolling the tobacco into noxious firebrands so vile to the taste that salesmen were physically unable to smoke the samples.

Many were disposed of nationally as "scheme cigars," meaning they were offered as come-ons in the pushing of unrelated merchandise such as cheap watches, clocks, and gaudy parlor pictures.

The Dealer's Dupe

A fool there was, and he spent a dime
 (Even as you and I)
 For a weed that smelled like burning twine
 (We called it a sin, a shame, a crime);
 But the fool he called it Havana, fine
 (Even as you and I).

Oh, the grudge we make and the smudge we make,
 Is due to the dealer brand,
Who swore that the filler was genuine "clear"
(He lied like sin, but he showed no fear),
 So the fool he bought the brand.

A fool there was, and his coin he blew
 (Even as you and I),
'Twas one cigar for the price of two
(But that was as much as the darn fool knew),
He puffed away till his face turned blue—
 (Even as you and I).

Oh, the fun he lost, and the "mon" he lost,
 And the heavy head he had
Belong to the dealer who didn't care
(As long as the fool didn't smoke it there)
 Though he knew the stock was bad.

The fool was fooled and he gave up "ten"
 (Even as you and I),
For Havana clear from the land of Penn
(He knows it now, but he didn't know then)
He smoked it, too—but he won't again
 (Even as you and I).

And it isn't the shame or it isn't the blame
 That stings like a white-hot brand.
It's the fact that the poor man never knew
The weed that he smoked or the place where it grew
 (Kipling quit here, so I'll quit too)
 And never could understand.

—Carl Werner

Bad cigars also provided inspiration for literary humor:

In Praise of Bad Cigars

"Strictly speaking, there is no such thing as a bad or a good cigar. There are cigars that one man likes and another detests, but one is intrinsically as good or as bad as the other. The taste for tobacco in any form being wholly an acquired taste, all tobacco, to the man who has neglected to acquire this taste, is equally nauseous.

"We learn with much pain and expenditure of money the taste for expensive cigars and a dislike of all others, and we then assume that high-priced cigars are good and that all others are bad. Had we reversed this process and acquired a taste for cheap cigars, we should call them good and high-priced cigars bad.

"Now, there are many reasons why we should all smoke the so-called bad cigars instead of the good ones. Of course, the most obvious reason is that the former are the cheaper. But it is the holy and inestimable influence exerted by the bad cigar in promoting the love of home and family that constitutes its chief virtue.

"Among those who are familiar only with good cigars or those who, whether through misfortune or vicious propensities, have acquired the detestable habit of never using tobacco, the perfume of bad cigars is held to be objectionable and the smoker thereof is an unwelcome guest. Hence he refrains from going outside his own home to smoke. He reserves the penetrating odor of his cigars for those whom he loves best. It is the incense which he offers only in his own domestic temple.

"It has also been commonly observed that bad cigars are invariably selected by women who wish to give welcome presents to the men whom they love. When the wife of the smoker of good cigars gives him a box for which she has paid one dollar, he must either make a hypocritical pretense of being pleased or he must show his disappointment and wound his wife's affection.

"No one can tell how many happy homes have been broken up because the husband was a smoker of good cigars and his wife gave him bad ones. But to the experienced smoker of bad cigars, all gifts of cigars are equally welcome and whenever his wife or his sweetheart gives him a box of the cheapest cigars in the market, he is filled with gratitude and both giver and receiver are happy.

"There is little variety to be found in smoking good cigars but the bad cigar is full of incident. There are certain cigars which are nearly jet black and have the appearance of being excessively strong. In point of fact, they are really the mildest cigars that are made and their color is due to the licorice and molasses in which they are soaked during the process of manufacture.

"For the ambitious young man who wishes the credit of smoking strong cigars without the internal remorse which too often results therefrom, these cigars are obviously just the thing. This particular "weed" is rolled more carelessly than any other cigars if we may judge by the curious substances which find their way into it.

"At one moment a bit of woolen yarn will blaze up in his cigar; at another the rich flavor of smoldering bits of leather will mingle with the original flavor of the tobacco. Occasionally small pieces of India rubber find their way into these cigars. The flavor of burning rubber is seldom relished by one who is accustomed to it. But one cannot deny that when it comes to the smoker unexpectedly, it adds greatly to the wealth of incident which characterizes this remarkable brand.

"But it is useless to attempt to mention the different brands of bad cigars that offer attractions to bold and enterprising men, lovers of adventure and research. The smoker of good cigars can never know the infinite variety which is to be found in every bad cigar. He treads only the straight and narrow pathway set around with Havanas and knows not of the alluring bypaths that wind in and out amid the endless variety of bad cigars and their strange and pungent perfumes."

—W. L. Alden, Washington Post (1907)

Paper Cigars

"There's no cigar but can assume,
Some mark of virtue on its outward parts."
—Anon.

The old adage that you can't tell a book by its cover applied itself to cigars far more often than anyone cared to admit. The problem was that basically all cigars looked alike and until they were smoked their qualities could neither be determined nor compared. A cigar may have looked, felt, and smelled good, yet possessed a taste that was utterly harsh and foul ("a goodly apple, rotten at the core").

It was generally assumed that all cigars sold on the open market were made entirely of tobacco, but in an industry where cheapness ruled and corners were cut with predictable regularity, this was not always the case. At any place and time in America, a few unscrupulous individuals could be found hard at work in the devious and time-honored practice of giving the public less than what it paid for.

A good example occurred in the late 1870s when a crooked but quite successful cigar making operation was exposed by a New York newspaper. It seems that a group of mysterious entrepreneurs were conducting a lively business selling cigars partly made of paper.

With chilling frankness the article pointed out that hardly a steamer pulled anchor in New York harbor bound for Havana which did not carry in its hold as much as 30,000 reams of brown wrapping paper. What this everyday material was used for was next revealed in shocking detail—the manufacture of so-called "pure Havana cigars"!

The paper, upon reaching cigar manufactories in Havana, was steeped in a strong solution of tobacco stems. The paper was then cut up and pressed in special wooden molds which imparted vein patterns of genuine tobacco leaves to each sheet.

The nicotine-impregnated paper was then used either as a filler or a wrapper (or both) in the manufacture of cigars. In the latter instance it was virtually impossible to detect the delicate film of paper interwoven with real tobacco leaves in the finished product.

In fact, when they were smoked, the similarity to the real article was so great that expert tobacco men and cigar smokers could hardly tell the difference. For reasons that can only be guessed at, not confirmed, the bogus cigars sold especially well in London.

The Saloon Cigar

For many years in America, a notoriously bad cigar passed over the counters of dramshops, taverns, and other public watering holes after tobacco and alcohol had become inseparable social companions.

It was the saloon cigar. Typically light in color and loosely wrapped, it came out of a box with gold embossing and bright colors, but the general consensus was that it was made of cabbage leaves, not tobacco. The long roll was filled with mysterious, only-God-knows what kind of ingredients (worthless bits and stems of old tobacco, if smokers were lucky; floor sweepings and rat droppings, if not).

Notwithstanding these minor detractions, however, the saloon cigar was special in that it was cheap, selling for a penny or two, and when incinerated, smoked strong—perquisite requirements for male customers with thin wallets, cast iron palates, and permanently dulled senses of smell. A real Havana, many people said with a smile, wouldn't have been wasted on any sincere bar drinker working at his trade.

Needless to say, smoking tastes of barroom crowds were not exactly discriminating and probably more bad cigars were fobbed off on an unsuspecting public in saloons than any other business setting in history.

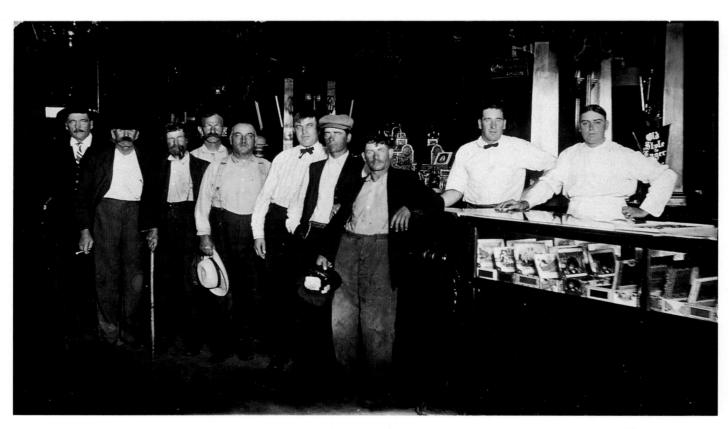

This formal barside portrait, *circa 1910, shows a convivial working class crew ready to celebrate the holidays. Those wishing to upgrade their smoking pleasures made selections from a wide assortment of fancy boxed goods, luring patrons with all sorts of glittering labels.*

Stogies: Those Other Cigars

Among the various types of cigars that evolved in history, one stands out differently from the rest which, as it turned out, did not particularly work to its advantage. It was the stogie, the only cigar that can truthfully be called the all-American cigar.

A certain manly mystique developed around the stogie that simply was not surpassed by any other cigar. In fact, any cigar smoker, if he was honest, admitted to having smoked a stogie at least once in his life, especially the rum-soaked kind.

Stogies were distinctively shaped cigars—long, straight, thin, hard, and tapered—and differed from other cigars in that neither end was provided with a hole. Because of this oversight, tradition called for the ends to be bitten off and spit out in a variety of artful ways prior to smoking, a ritual that endeared itself to many young men seeking to project a more masculine image.

But the harsh smoke of stogies did not suit every palate and because of this they achieved an undeservedly tarnished reputation. Even today, despite having attracted a sizeable and fiercely loyal group of devotees, stogies remain the most maligned cigar in history and the object of both curiosity and derision among cigar connoisseurs everywhere.

Perhaps it is due to the fact that, since their inception, stogies have never been regarded as a fine smoking article. No one ever argued this point since their universal price a century ago, three or four for a nickel, demonstrated this beyond any reasonable doubt.

In addition, no flavorings, coloring agents, or adulterants of any kind were used in making stogies, a fact that would please fastidious smokers today. Lest these cigar makers of long ago be given undue credit for being environmentally correct, however, be advised that the tobacco was just too cheap to justify such manufacturing extravagances, or else they would have done it.

Cheap and crude-looking though they were, stogies and tobies (the two were exactly the same) must have been good smokes or else they would not have achieved the widespread popularity in America that they did. By 1900, for example, it was estimated that the states of Pennsylvania and West Virginia were producing about 200 million stogies annually.

It took visitors from the East a long time to understand how the utterly plebian, ragged- and cheap-looking apology of a cigar, the toby, had achieved such a lofty smoking status among well-dressed gentlemen of Pittsburgh whose outward appearances otherwise suggested good breeding and impeccable tastes.

Observers were tempted to believe that the toby was a truer index of the social standing of the user than his clothes, language, and bearing, and just a brief acquaintance with the man who smoked a toby tended to reduce the visitor to a state of wanting to enjoy one himself. There were cases on record of New Yorkers, previously fanciers of fifty-cent cigars, who came to Pittsburgh, saw, smoked, and were conquered by the toby, became devotees and looked back in wonder and regret to that wasted time in their lives when only an imported Havana was worthy of being placed between their lips.

And so when Pittsburghers read in 1898 that Speaker Reed was seen one day smoking a toby in the lobby of the House of Representatives in Washington, D. C., they were not surprised. Rather, it was proof to them that the Speaker knew a good smoke when he saw one and actually felt sorry for Reed in that it had taken him so long to become acquainted with the toby's special smoking qualities.

There was a time when the toby was known in only the two places where they were originally manufactured—Pittsburgh and Wheeling, West Virginia, known in the latter place as stogies. But by degrees, the fame and use of the cigar spread to nearby towns and cities, and from there to many points across the country. High and low, rich and poor, people in Pittsburgh smoked tobies and people in Wheeling smoked stogies. Of course, there were always those who could afford to— and did—smoke expensive imported cigars, but it was always nice to vary their favorite indulgences with an occasional whiff from a toby (or a stogie).

As already mentioned, the terms toby and stogie were synonymous. The two cigars looked alike and smoked alike which was not surprising since both were exactly alike, but tradition caused them to bear different names depending on the place of manufacture. With time, however, the word stogie fell into far more popular public usage and eventually usurped the place of

"tobies" in the trade lingo of Pittsburgh cigar merchants.

Stogies were originally made from a mediocre grade of Pennsylvania leaf tobacco that, once lit, never went out. Their long, slender form was as instantly recognizable across a barroom floor as a brass spittoon and had a history almost as old as the country itself, but far more colorful. Few would admit it, but the early frontiers of America were literally enveloped in the pungent smoke of stogie cigars.

Derivation of both names are steeped in long and honorable legends. The story of the toby is an involved and fanciful one and, as such, of dubious authenticity, going back to the time when Pittsburgh was a mere village. The tale concerned an aged and cantankerous town burgess, his lost volume of Laurence Sterne's "Tristram Shandy," a character in that novel called Uncle Toby, and Tom Jenkins, a local wagon driver and part-time cigar maker who offered the suffering burgess solace with one of his strange-looking cigars. From that story (far too long and involved to be recounted here) emerged the name of the cigar, toby.

Wheelingites, on the other hand, bragged of a more believable origin for the name, stogie, which in their minds justified it as the only authentic one. This story of how stogies came into existence is known to every true and dedicated smoker in America who has ever taken a cigar to his (or her) lips. Today these unique rolls of tobacco conjure up images of the old frontier when long lines of large wooden wagons driven by mule skinners and wagon masters hauled thousands of settlers and tons of freight from the Eastern seaboard to regions far beyond the Appalachians.

In those days the drivers of the wagons (called carters and, later, teamsters), with a proverbial blindness to quality, developed a liking for cheap cigars to keep them company on long, dusty trail rides. With nothing to do all day except talk to their mules, these men, to kill time, rolled the leaves of tobacco into the rough form of a cigar which was also found, by accident, to be quite useful in driving away pesky flying insects. The tobacco was procured from farmers' barns as the teamsters passed through the rolling hills of eastern Pennsylvania.

There is another old story which credits the invention of the stogie to an enterprising cigar manufacturer of Washington, Pennsylvania (his name is lost in history), who made "roll-up" cigars from local leaf and peddled them for a penny apiece. This story, however, is on shaky ground because it is a well-known fact that many wagon drivers took back part of their freight bills in tobacco.

Anyway, as fate would have it, the teamsters made far more cigars than they needed and, with the lavish generosity for which these old carters were famed, they distributed samples of the long rolls to the idle crowds of men who tended to hang around freight stations in Wheeling.

It so happened that the large, canvas-covered wagons the carters drove were known as Conestoga wagons, then simply as "conestogas." To brand the crude cigar a conestoga was, of course, an appropriate step to take and was indeed taken. Then the characteristic American habit of abbreviating things shortened the name to "stogas" and, just as the strong perfume of its smoke charmed those who used it, the fond diminutive, "stogie," became its final nickname and has stuck ever since.

As so often happens in matters of little importance, however, there arose among sticklers for proper terminology the following question: If the word stogie stood for a conestoga, a wagon, then how could the word stogie stand for something that was clearly not a wagon but a cylindrical roll of tobacco?

These logicians, as it turned out, were the same so-called experts who also claimed that since toast was toast and cheese was cheese, then a dish composed of both ingredients could not possibly be a Welsh—or any other kind of—rabbit, but a "rarebit." Consequently, no one paid a bit of attention to them and the word stogie became forever entrenched in the happy hearts of cigar smokers everywhere.

Cigars That Go Bang

We three kings of Orient are,
Tried to smoke a rubber cigar,
It was loaded and exploded,
Oh, what fools we are!
 —Choir boy's version of
 an old Christmas carol

The loaded cigar as a fiendish form of practical joking has been around the Western world a long time. No one knows when, or who the first person was to roll a leaf of tobacco around a small quantity of explosive chemical, but we all know why it was done.

When the cigar was smoked to a certain point, the incendiary charge (usually fulminate of silver) ignited, which caused a long hissing noise culminating in a loud bang and a sudden flash of light as the firmly wrapped article detonated in the victim's mouth.

The small but powerful chemical reaction was guaranteed not only to surprise the hapless victim, but also to cause physical injuries not unlike receiving a face full of napalm, all amid great peels of laughter from sadistic onlookers.

Loaded cigars were in vogue in the 1870s because they were the subject of an occasional humorous literary anecdote. The items were called "explosive cigars" in those days, or went by the more imaginative term, "torpedoes."

Despite their presumed innocence, cigars that went bang were truly dangerous instruments and it was certainly no fun at all to be on the receiving end; many bruised feelings and unfortunate injuries resulted. The perpetrator, if found out, also caught his share of damage, too, in the spirited bout of fisticuffs bound to follow.

Happily, the hour of the exploding cigar as an implement of social mischief came and went. In Victorian times, Lord Chesterfield and other paragons of proper gentlemanly conduct did their best to

discourage the habit of passing loaded cigars; such vulgar behavior marked the low and uncultured ranks of society.

However, an exception was permitted in 1886, only because of the fame of the participants. That was the year a funny thing happened to Bill Nye, the noted American humorist and contemporary of Mark Twain.

It seems that after giving a performance in Bloomington, Indiana, Nye was given three cigars by a friend and, after smoking one, discovered much to his chagrin that they were the exploding kind. Nye carried the other two around with him for many weeks, looking for a suitable target.

Finding none and growing weary of the cigars, he tried to offload the articles by purposely leaving them on his hotel nightstand in Cedar Rapids, hoping the chambermaid would take them. She did not.

But then, quite unexpectedly, Nye happened to run into the great Hoosier poet, James Whitcomb Riley, also on tour. What happened next was published in Nye's nationally syndicated newspaper column:

"I noticed as I entered our room that Mr. Riley was smoking, but I little thought that he would appropriate one of my cigars without permission from me. Judge of my surprise, therefore, when James Whitcomb Riley, a man for whom I have the profoundest respect, and a poet whose glowing words have laid strong hands upon my inmost soul, rose to his full height and said something that I never saw in any of his poems—a term which I shudder to repeat to myself even in the silent watches of the night— while a dark-red glare shot out from his features with a low, hissing k-s-s-s-t-t-t that filled the room. Several journalists who were present said that they would never mention it, but they forgot their promise, and in their estimable papers afterward, alluded to it in a way that implied a put-up job on my part.

"I now wish to say that I am as innocent of that act as an unborn child. Mr. Riley once wrote a poem regarding me which was well calculated to throw ridicule and contumely and a few more ingredients of that kind on me, but I never laid it up against him, for I know that he would not willingly wound the feelings of a man who was larger than he. So I hope that if you should ever hear of this incident, you will take occasion to set me right before the public. Meanwhile, I beg leave to subscribe myself yours, in a ruddy glow and a pair of cool pantaloons."

Cigar Butt Trivia

When cigars were king in America, few people really cared about the billions of wet, slimy cigar butts tossed to the ground by unthinking smokers, left to litter city streets and sidewalks and produce disgusting sights.

Cigar butts represented problems to Victorian society in several ways: For one thing, they were a public health hazard. Not uncommonly, discarded butts (also called snipes, stubs, or stumps in Victorian-era vernacular) were picked up and smoked by people in low and desperate straits. Tuberculosis and syphilis were rampant diseases in those days and it took no stretch of the imagination to see how these dread communicable diseases, both untreatable and ultimately deadly, could be acquired by innocent victims in this manner.

The greatest evil of discarded butts, however, concerned children. Some of the street people who found and smoked leftover cigar butts (cigarettes were not passed over, either) were young boys. In fact, the problem of juvenile smoking became so great in the 1890s that the Women's Christian Temperance Union, a potent suffrage and anti-tobacco force, did something about it.

These unofficial guardians of the public good made it a dedicated mission to regularly police urban areas and pick up and destroy discarded cigar and cigarette butts in the hopes of removing temptation from the paths of the young. The collected items were tailied by the Union and the figures proudly announced in club bulletins.

There was a time, however, when cigar butts were not always regarded as the unsightly, loathsome offal and objects of grave social concern that they really were, but as sources of revenue.

Big-city newspapers carried the alarming news. In 1885, the New York Herald reported the sad case of a group of Italian youngsters who were forced to pick up discarded cigar butts in order to supplement family income. A man in a wagon passed through the streets daily who paid fifteen cents a pound for the used tobacco which was retreated and then recycled into the clandestine manufacture of all-tobacco cigarettes, snuff, and cheap cigars.

Likewise, in 1897, the Chicago Tribune ran a front-page story on how "refuse tobacco" made its way back into the market. It cited the plight of certain poor people who scoured city streets in search of snipes which were sold to sleazy tobacco manufacturers.

These stories paled in comparison to what went on in Europe. It is hard to believe that in Paris in the late 1880s there was a club called the Parisian Cigar Stump Exchange, one of the most curious social organizations to ever exist. Members met every afternoon on the steps leading from the ancient Place Maubert to the Boulevard St. Germain where they brought paper boxes full of cigar butts retrieved from the streets, cuspidors, and ash cans, and sold them.

Unscrupulous wholesalers paid about a franc a pound for the butts, cleaned and chopped them up and resold the product as "smuggled tobacco" in packages covered with pretty labels for three or four francs a pound, making a hefty profit in the transaction.

The illegal business was brisk because tobacco in France, as in many European countries, was strictly controlled by a government agency called the "regie" and tobacco of comparable quality from this source was much more expensive. The marketplace also attracted average citizens who purchased cigar butts for their own consumption.

According to police records, some 1,500 professional gatherers of cigar butts belonged to the Exchange. Most were ordinary street scavengers but many were waiters in fine restaurants. Prices for cigar butts varied according to the law of supply and demand. They were predictably ten to fifteen percent higher in winter when fewer persons smoked out of doors and fewer discarded butts could therefore be found.

11. Compliments of the Season

For many years in Victorian America, a box of cigars, next to socks and neckties, was one of the most popular and traditional birthday and holiday gifts that men received. The custom certainly made shopping a snap for unimaginative women faced with the annual quandary of what to get the men in their lives.

To facilitate sales at Christmas, many cigar store proprietors had special boxes of cigars made up and adorned with glittery holiday labels.

In many cases, however, the smoking qualities of the cigar fell far short of the visual qualities of the label, but what callous and unthinking man would dare insult a gift-giver by voicing disapproval of a boxful of free cigars?

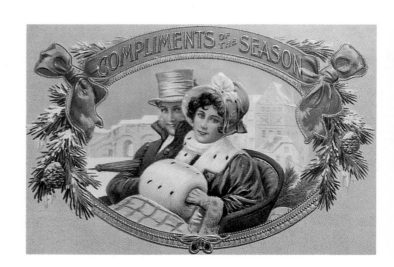

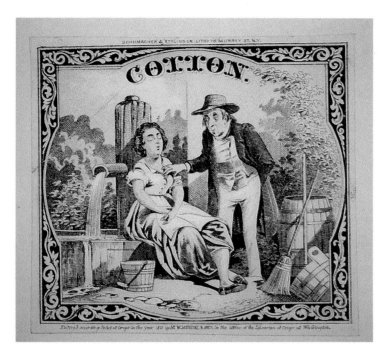

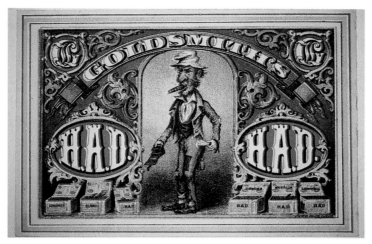

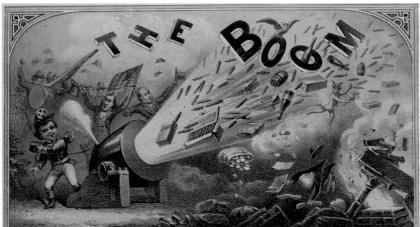

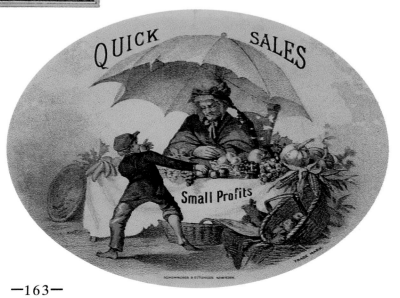

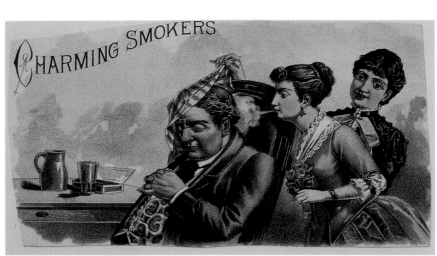

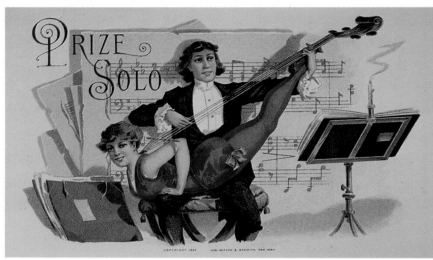

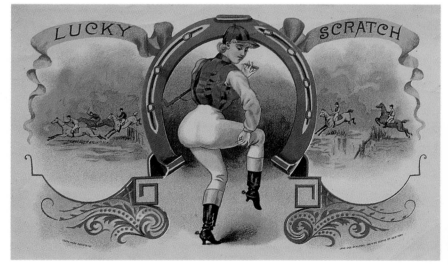

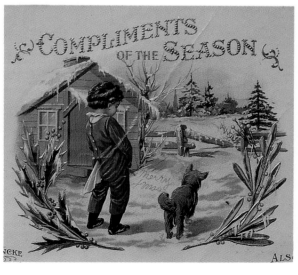

13. Being Socially Incorrect

A. Innocence Lost: Juvenile Smoking

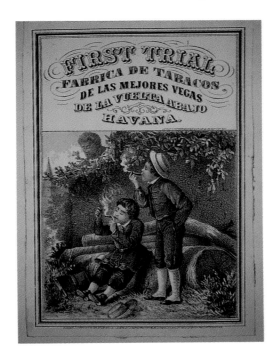

One of Victorian America's pressing social problems was teenage smoking. As early as the 1870s, newspapermen reported the appalling sight of youngsters smoking discarded cigar and cigarette butts in plain sight on city streets. Reaction from education groups, women's societies, religious leaders, and anti-tobacco activists prompted a storm of public disapproval which gathered momentum and finally resulted in, by 1910, the passage of anti-smoking laws in most states of the Union.

While cigar makers were certainly not interested in bringing unwanted criticism upon themselves in this period of great social reform, they were also not going to let the impropriety of the subject deter them from advertising their wares.

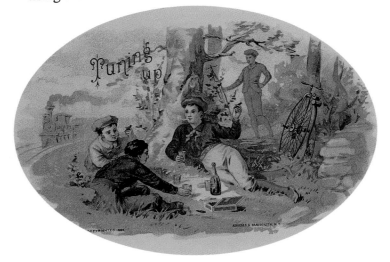

My First Cigar

Twas just behind the woodshed,
One glorious summer day,
Far o'er the hills the sinking sun
Pursued its westward way.

And in my one seclusion,
Safely removed afar,
From all of earth's confusion,
I smoked my first cigar.

"Ah, bright the boyish fancies
Wrapped in the wreaths of blue;
My eyes grew dim, my head was light,
The woodshed round me flew.

Dark night closed in around me,
Rayless without a star,
Grim death I thought had found me,
And spoiled my first cigar.

I heard my father's smothered laugh,
It seemed so strange and far;
I knew he knew, I knew he knew
I'd smoked my first cigar."

—Burlington Hawkeye, *Cope's Tobacco Planet* (Liverpool, 1875)

And so the depiction of male youngsters smoking cigars was worked into cigar box label themes. However, lithographic artists were careful to couch the potentially explosive subject in humor, whimsy, and sarcasm in order to make the portraits more socially palatable.

"SNAP"

Shoeshine and newspaper boys *were favorite targets of Victorian artists because of the boys' high propensity to smoke.*

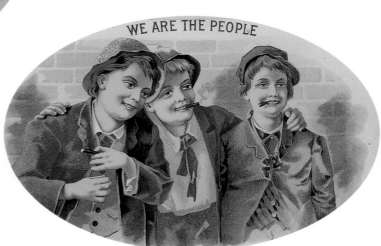

WE ARE THE PEOPLE

DO-U-NO

DO THESE ARE HAND HAVANA

JANUARY 1ST 1900 U-NO CIGARS GUARANTEED MADE FILLER

TAMPA, FLA. S. FERNANDEZ & CO. TAMPA, FLA.

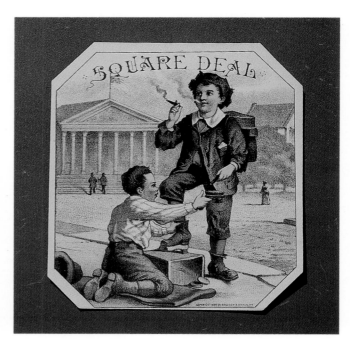

SQUARE DEAL

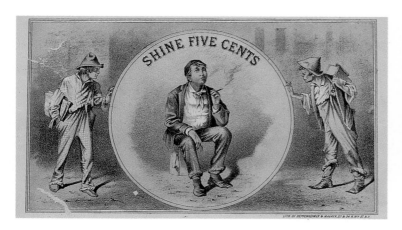

SHINE FIVE CENTS

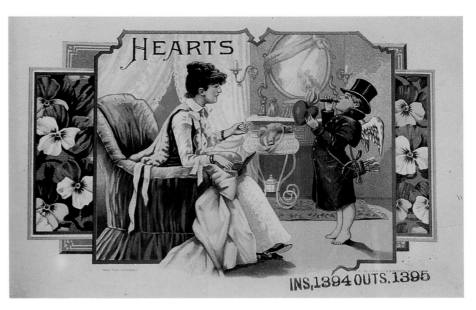

B. Women Who Smoke Cigars

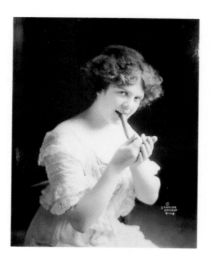

In the 1870s, a New York newspaper printed the following news item under the header, "Maiden's Wish:"

"A thoughtful girl says that when she dies she desires to have tobacco planted over her grave, that the weed nourished by her dust may be chewed by her bereaved lovers."

While the pronouncement may have been romantic in the poetic sense, it surely sparked vigorous denunciation by the majority of Victorian society whose stringent attitudes toward tobacco still prevailed at this time in history. Remember, this was when all prim and proper old ladies proclaimed with great force and pride:

"When I was young, the gentlemen were kept in their manners, that they were I can assure you, and they wouldn't dare to come into the presence of a lady smelling of tobacco—let alone puffing a pipe or a cigar. We should have gone into fits if they had!"

But slowly and surely, rules governing social politeness and propriety underwent dramatic change; one involved tobacco use. Whether due to a kinder indulgence of sweethearts and wives of the present epoch, a natural decay of old manners regarded as too stiff, judgmental, and puritanical, or simply the fact that more women were smoking, a greater social permissiveness was extended to smoking habits. More common by far came intimate verbal exchanges between man and woman as the following: "Is my smoking disagreeable?" "By no means! I rather like it."

Comments like these announced the arrival of the greatest tobacco-consuming era in U. S. history. By 1900, approximately four out of five men were smoking something, mostly cigars, which still reigned as the aristocrat of smokes despite a growing partiality for cigarettes.

Manuals on etiquette reflected this new age of laxity. No longer was it considered in utterly bad taste to smoke in the presence of ladies. No greater exponent of this newfound freedom could be found than among the English.

Mrs. Humphry's "Manners for Men," set to print in London in 1897, made a number of startling revelations. The example set by Albert Edward, the Prince of Wales, Queen Victoria's son and soon-to-be King Edward VII, was largely instrumental in brushing aside the suffocating social restrictions that had marked his mother's reign.

"On one occasion at the Ranelagh Club," Mrs. Humphry related, "I noticed that he (the Prince) consumed four cigars in rapid succession almost without five minutes' interval between them. The only time he remained in the Pavilion with the Princess and other ladies was for ten minutes when tea was handed round."

Public morals had, indeed, hit rock bottom.

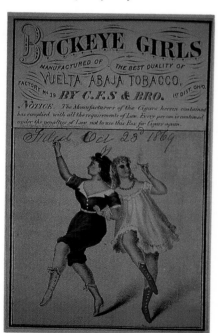

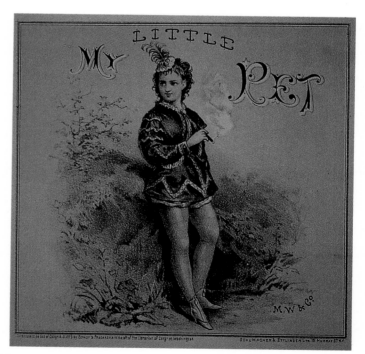

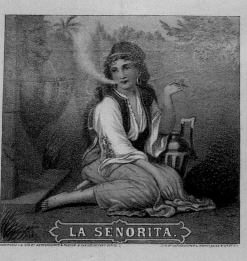

LA SEÑORITA.

It was all right *for lithographers to depict women of foreign nations smoking cigars. Outside of England and the U. S., such behavior was considered quite normal.*

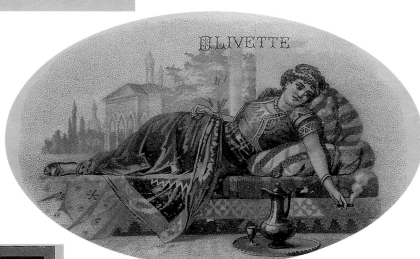

OLIVETTE

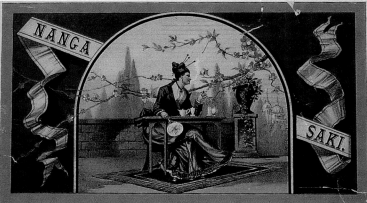

NANGA SAKI.

SPANISH PUFFS

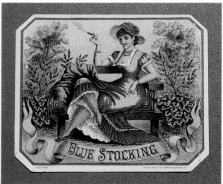

The suggestion that puffing a cigar
*surrounded the feminine user with a certain
air of sexiness, allure, and mystique, whether
intentional or not, has been around since the
1880s when these images first appeared.
Cigars in this scenario have long since been
replaced by cigarettes.*

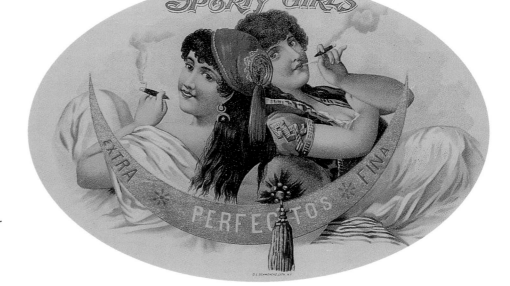

"The gentleman visitor should be certain that smoking is not offensive to the various members of the family before he indulges too freely in the pipe and cigar about the house. For the guest, without permission, to seat himself in the parlor and scent the room with the fumes of tobacco is a serious impoliteness."
—Hill's Manual of Social Forms (1887)

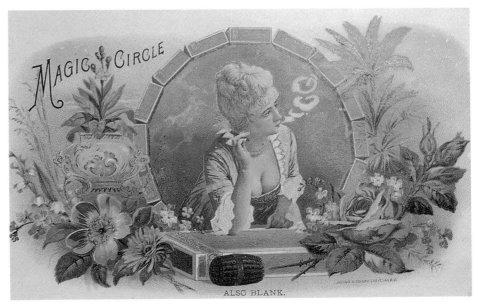

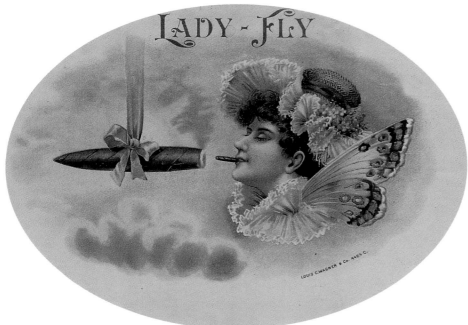

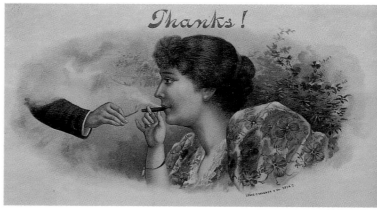

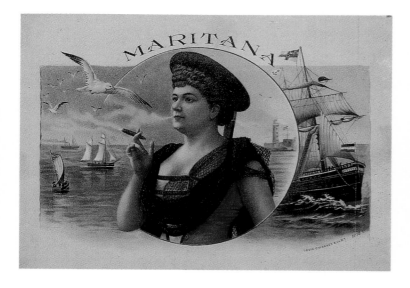

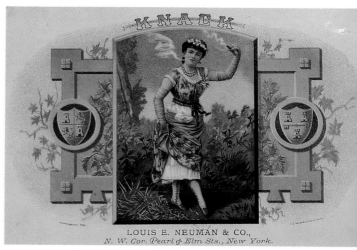

LOUIS E. NEUMAN & CO.,
N. W. Cor. Pearl & Elm Sts., New York.

Few women, in truth, were guilty *of smoking cigars at this time in history. The coming rage, though, was cigarettes and this would become an entirely different and more serious social matter. The portrayal of women drawing on cigars was done only to poke fun at inflexible Victorian mores, not to make a strong social statement.*

Collecting Cigar Box Labels

An estimated four to five thousand people in the United States collect antique cigar box labels today, a figure which experts say is probably low. The pastime has grown by leaps and bounds in the past few years and holds great promise to become an even more popular collecting fad in the future.

Not too long ago, cigar box labels were a glut on the antique paper market, truly unwanted orphans with a dubious past. But those days are gone. Piles of old cigar labels that once languished on dusty shelves in dealers' shops have suddenly "caught on" and achieved a new and lofty status as paper collectibles.

A growing number of dealers across the country are engaged in the full-time business of buying and selling cigar box labels, as well as conducting mail auctions where sales totalling tens of thousands of dollars per auction are hammered down on a regular basis.

Why do people crave these old stone-made lithographs?

Hobbyists, in general, like cigar box labels because they are works of art, they are pretty, they are interesting, they are old, and, in many instances, they are rare. In fact, it is one of the few hobbies where it is possible to obtain a one-of-a-kind specimen at a nominal cost. The fact that these paper images were once used (or meant to be used) as promotions for an article of smoking seems totally irrelevant and inconsequential; it is the artwork that drives the collector's passion.

The hobby is made even more satisfying by the typically fine condition in which practically all of these age-old images are found. The labels look as bright, fresh, and clean as the day they rolled off the presses a century or more ago. For a medium as delicate and fragile as paper, this is astonishing.

The field of cigar box labels is also unique in that collector burnout is rare. With so many labels having been made, it is safe to say that no collector, regardless of time spent in the hobby, will ever "see them all." Previously unknown labels turn up on the market regularly, further whetting the appetite of the collector.

Cigar box labels, as the dinosaur, are relics of a bygone era, a special time in history when the old-fashioned and cumbersome method of stone lithography produced a quality of printed image that has never been equaled by subsequent techniques. It was also a period of time when different values prevailed in the American workplace, one in which the emphasis was on professional pride and craftsmanship, not a profit line.

Much of the hobby's appeal rests with the intrinsic artistic beauty exhibited by these colorful and elegantly decorated paper images and an appreciation bordering on awe of the amount of time, care, and skill that went into their making. This appreciation takes on an added dimension when you consider that to duplicate such paper labels today would be outrageously and prohibitively expensive. No more labels, it is safe to say, will ever be made by this method.

How are cigar box labels collected? Resigned to the fact that it is not humanly possible to obtain a copy of every label ever produced, hobbyists are forced to narrow their interests accordingly.

Most collect by theme, rarely by lithographer. The most popular topics favored by men are sports, transportation, cowboys, Indians, occupations (such as firemen and policemen), patriotism, war, ethnology, and pretty women. Others specialize in proofs, samples, or untitled designs.

Some people prefer small collecting areas such as actors, the Key West cigar industry, and Cuban themes as well as unusual topics such as typewriters, telephones, calendars, and light bulbs. Those with an abiding interest in the technical side of printing like to add sample books and progressive proof books to their collections.

Men outnumber women in this hobby by an approximate 3 to 1 margin, but the gap is slowly narrowing. There are many exceptions, but women tend to favor sentimental subjects such as animals, children, and cupids or heavily gilded examples of Victorian fluffery.

Present-day collectors obtain cigar box labels from a variety of sources. Images can be purchased directly from dealers or through regularly-held mail auctions while others swap and sell labels among themselves.

What determines the value of a label? In short, three things—nature of the image, scarcity, and condition of the label. Those labels that portray popular topics are sought the most.

In the end, however, the hobby, like any other field of collectibles, is driven by the laws of supply and demand. The highest price paid to date for a cigar box label is $10,000 for Red Stockings, a baseball image that dates to the early 1870s.

Cigar Box Labels: Alphabetical Listing and Values

Values are approximate for labels in fine condition and are meant as a guide only. Labels from the Library of Congress (afterward abbreviated as LOC), are not assigned values since they are one-of-a-kind specimens. When known, the lithographers and years of manufacture are noted.

Label	Lithographer/date	Value	Page
A Huis Clos	Johns	$75	171
A Symphony in Smoke	Heppenheimer & Maurer	$100	152
Absaraka		$150	106
Aero	Schlegel	$1,000	97
Affectionate		$150	137
After The Hunt	Krueger & Braun	$500	120
Alameda		$75	170
Alarm	Heffron & Phelps	$1,500	111
All Over	Schumacher and Ettlinger	$1,000	112
All Strikes	Schwencke	$600	116
America	Heppenheimer & Maurer	$200	85
America's Cup	Heppenheimer's Sons	$300	118
Amerca's Pride		$10	87
American Crown	Harris	$100	86
American King		$100	87
American Sweeper	Harris	$75	87
Angora		$200	140
Anti-Microbe	Schumacher & Ettlinger	$600	56
Arabia	Witsch & Schmitt	$200	37
Auto	Krueger and Braun	$500	98
Automobilist	Schlegel	$500	98
Automotor	Neuman	$500	98
Baggage	Harris	$500	93
Battle Leaders	Schmidt, 1898	$150	82
Belle of the Season	1868	LOC	22
Bicycle	Harris	$1,000	95
Big Horn	Schumacher & Ettlinger	$700	105
Bill Nye		$100	159
Billiard Light	Harris	$600	122
Billiard Queen	Western Label	$1,000	122
Black Hawk		LOC	68
Black Jack	Schlegel	$300	109
Blondes, The	Nevin & Mills, Detroit, 1870	LOC	28
Blue Stocking	Witsch & Schmidt	$100	170
Board of Health	Witsch & Schmidt	$600	56
Bohemia, Kate Sparks	Wilmanns Bros.	$200	120
Boom, The	Heppenheimer's Sons	$200	163
Bouncer, The	Schumacher & Ettlinger	$1,200	78
Brunswick	Witsch & Schmitt	$200	39
Buckeye Girls	1869	LOC	168
Cabin Home	Schumacher & Ettlinger, 1883	$150	44
Calendar Cigars	1883	$500	42
Camp Life	Schlegel	$400	120
Can Can	Pool, Nazro & Kimbal, 1870	LOC	28
Can't Be Beat	Tuchfarber, Walkley & Muellmann 1869	LOC	94
Capital	Schwencke	$100	62
Capital Joke	Heppenheimer & Maurer	$500	45
Capt. Jack	Witsch & Schmidt	$500	139
Captain Jinks	Hay Bros., N.Y., 1868	LOC	18
Carnival	Strobridge, 1870	LOC	26
Caro	Heppenheimer & Maurer	$150	119
Casino Beauty		$65	58
Caught On (boy and dog)		$800	46
Caught On (couple in boat)			
	Wm. Steiner & Sons	$450	145
Centre Rush	Neuman	$600	115
Charmer	Heppenheimer & Maurer	$200	35
Charming Sight		$200	32
Charming Smokers		$150	164
Chasers	Heppenheimer's Sons	$150	124
Cigarettos de la Siesta	W. Faust, N.Y., 1864	LOC	49
Cinderella	Heppenheimer, 1869	LOC	21
City Cousin		$150	42
Cloud Scout	Howell	$400	97
Clover Queen		$100	140
Club Favorites	Krueger & Braun	$300	113
Club Friends	Schmidt	$700	122
Club Night	Schlegel	$500	149
Color Bearer	Schumacher & Ettlinger	$500	79
Columbia	1869	LOC	17
Comforter	Heppenheimer & Maurer	$200	150
Commander in Chief		$300	66
Commodore Watson		$125	83
Compliments of the Season (three women)		$75	161
Compliments of the Season (flowers, cigars)			
	Heppenheimer's Sons	$75	161
Compliments of the Season (1895)			
	Schmidt	$75	162
Compliments of the Season (couple in sleigh)			
	American Litho. Co.	$200	162
Compliments of the Season (boy, dog & snow)			
	Schwencke	$1,500	164
Conductor		$200	92
Conscript, The	1863	LOC	79
Cotton	Schumacher & Ettlinger	LOC	163
Contestants		$500	116
Cow Boy		$700	103
Cowboy Girl		$700	103
Cream of Society	Wagner	$100	54
Crescent Queen	Harris	$75	37
Crest of Quality	Wagner	$75	58
Cricketers		$1,000	113
Croaker		$150	141
Cross Country	Harris	$200	127
Crowned Beauty	Neuman	$50	134
Cuban Cousin		$95	47
Cuba Libre	J. M. V. Ross, 1869	LOC	47
Cushion Carrom		$1.000	122
Cutter		$300	118
Daisy Dee	Neuman	$75	132
Dandy Joe		$300	146
Dandy Shape	Neuman	$125	61
Dandy Smoke	Schumacher & Ettlinger	$200	139
Derby King	Schumacher & Ettlinger	$200	124
Dexter	J. Mayer, 1869	LOC	125
Divorce	Heppenheimer & Maurer	$300	145
Do-U-No	Schlegel	$200	166
Doctor's Special	Moehle	$300	56
Domestic	Boyd	$150	144
Drum Taps	Harris	$400	138
Dude	Schumacher and Ettlinger	$200	146
Duke	Heffron & Phelps	$300	125
Easy Winner	Schwencke	$300	145
El Cammanche	Geo. Seeman, 1867	LOC	105
El Dante	1857	LOC	15
El Persuado	Morse & Williams, 1868	LOC	21
El Tentador	Heffron & Phelps	$150	143
El Vaquero	Witsch & Schmidt	$300	99
El Veranico	Harris	$75	60
Ex.	Harris	$850	42
Fair Exchange	Schwencke	$250	64
Fairy Prize	Harris	$400	38
Fanchon	S. Lowenthal, 1868	LOC	9
Far West	Schwencke-Pfitzmeyer	$1,000	103
Fast Mail	Harris	$700	92
Favorite Stock	Witsch & Schmidt	$300	142
Fern Pinks	Schmidt	$125	29
Fine Catch		$300	121
Fine Point		$150	171
Fire Engine	Schlegel	$1,000	112
Fire King	Schmidt, 1895	$500	111
First Goal	Krueger & Braun	$800	114
First Heat	Neuman	$300	123
First Nine, The		LOC	128
First Puff	Boyd	$200	45
First Trial	1870	LOC	165
Fleur de Cuba	Strobridge, 1869	LOC	49
Flirt	Schmidt	$150	135
Flora Temple	1859	LOC	125
Four Cornered Habanas		LOC	20
Full Bloom		$50	130

Name	Maker / Date	Price	Page
Gallant, The	Heppenheimer & Maurer	$150	143
Game Trout	Henry Hoklas & Son	$200	121
General Putnam	Harris	$100	11
Genuine Havana	Heppenheimer, 1868	LOC	48
Gesundheit	Johns	$300	43
Go Ahead		LOC	68
Gold Calibre	Schlegel	$1,000	120
Gold Hunter	Schlegel	$400	109
Gold Nugget	American Litho. Co.	$700	108
Golden Knight	Wagner	$150	58
Golden Links	Harris	$75	87
Golf Links		$500	117
Good Record	Schwencke	$300	126
Grand Circuit (inner)	Schumacher & Ettlinger	$300	125
Grand Circuit (outer)		$150	126
Grand Union		$100	85
Grass Widow	Heppenheimer & Maurer	$150	129
Great Bird	Heffron & Phelps	$200	88
Great Chief	Otis	$600	104
Great Chief	Schwencke	$500	104
Great Eastern	1859	LOC	16
Great Promiser	Steiner	$400	96
Great Western	Harris	$100	102
Green Cloud	Witsch & Schmidt	$200	107
Greenbacks		$200	141
Grisette	Heppenheimer's Sons	$200	136
Grotesque	Neuman	$150	170
H. A. D.	1860s	LOC	163
Happy Days	Schwencke	$300	144
Happy New Year	Schlegel	$150	162
Harbor Lights	Schwencke	$125	132
Head Lights	Schwencke	$250	43
Hearts	Schlegel	$300	167
Helen Blazes	Johns	$200	142
Henrietta	L. Gerschel & Bro., 1867	LOC	118
Helping Hand		$150	64
Here's Luck	Schwencke	$300	149
High Grade	Schwencke	$500	96
High Life	Schwencke	$300	143
Holiday Greetings	Schmidt	$200	162
Holly Junior	Calvert	$40	161
Home Comfort	Johns	$50	150
Home Strike		$2,000	128
Honest Labor		$500	110
Hopla!		$150	124
Hoosier Bard		$200	159
Hot Springs	Harris	$200	38
Hot Wave	Heppenheimer & Maurer	$200	147
Idol		$65	44
I Like It	1872	LOC	25
In The Lead		$300	124
Indian Pride		$300	107
Indian Princess		$400	105
Indra	Heppenheimer & Maurer	$85	37
Insurgent		$400	65
Invincible Schley, The		$150	83
Iron Horse	Schumacher & Ettlinger	$500	92
Iron King, The	Heffron & Phelps	$750	93
It's Capital		$150	171
I've Got You	Schlegel	$250	145
Jack in the Box	Neuman	$500	151
Jacob Puff	Howell	$100	152
Jerome Park	Heppenheimer & Maurer	$300	123
Jockey Club	1862	$75	123&124
Jolly Boy	Wagner	$150	153
Jolly Girl	Harris	$150	135
Joseph E. Johnston	Lipman & Hogan, 1865	LOC	80
Juveniles	Heppenheimer & Maurer	$200	137
Katy		$500	103
Key West Favorites	Schmidt	$100	53
Key West Traficante	Schwencke	$150	53
Kid, The	Schlegel	$700	99
Kid The Cowboy		$500	99
Klondike		$700	108
Knack	Neuman	$150	172
La Americana	Krueger & Braun	$150	89
La Belle Creole		$50	58
La Estrella Fija	Schumacher & Ettlinger, 1873	LOC	137
La Herald	Monsch Bros., 1869	LOC	20
La Magdalena	1869	LOC	20
La Nata	Wagner	$100	59
La Normandi		LOC	12
La Palmiera	Heppenheimer & Maurer	$50	60
La Senorita	Heppenheimer & Maurer	$150	169
Last Round	Schwencke		114
La Thais	Wagner	$150	54
La Veloce	L. B. Grim, 1869	LOC	94
La Vesta	1870	LOC	129
La Vision	1868	LOC	147
La Vivandera	Heppenheimer & Maurer	$125	60
Lady Fly	Wagner	$300	171
Last Round		$800	114
Latest, The	Schmidt	$75	172
Leader (Dewey)		$150	82
Leader (horses)	Schwencke	$200	123
Leader, The	Moehle	$150	88
Leading Lady	Heppenheimer's Sons	$25	60
Leading Nickel	Harris	$400	141
Leaper	Howell	$300	141
Leviathan	1864	LOC	14
Liberty Pole	Schumacher & Ettlinger	$300	86
Life Saver	Schwencke	$400	151
Light Brown	1860	LOC	154
Lillian Russell			68
Lily of Key West	Schlegel	$150	53
Limited	Schlegel	$750	92
Little Beauty	1870	LOC	129
Little Brown Jug	Harris	$150	44
Little Bunny	American Litho. Co.	$200	142
Little Chicks	Harris	$100	140
Little Satan	Heppenheimer & Maurer	$350	36
Little Tots	Schwencke	$200	138
Little Wolf	Heppenheimer & Maurer	$300	31
Long John	Monsch Bros., 1870	LOC	27
Love's Incense	Boyd	$100	152
Lucky Scratch	Schlegel	$300	164
Lutz's Frog (on box)	Schumacher & Ettlinger	$600	68
Magic Circle	Johns	$100	171
Maid to Order	Schumacher & Ettlinger, 1895	$100	61
Main Line	Heppenheimer's Sons	$300	97
Manhattan	Schwencke		88
Manhattan	Van Saun & Co, 1868	LOC	104
Maritana	Wagner	$200	172
Mary's Lamb		$200	139
Matchless Comfort	E.F. Lazer, 1874	LOC	147
May Violet	Neuman	$75	59
Mechanic's Choice	Schumacher & Ettlinger, 1886	$400	32
Merry Christmas & Happy New Year (dove)	Schwencke	$50	162
Merry Christmas & Happy New Year (cherub)	Schmidt	$100	162
Military Brand	Heppenheimer & Maurer	$250	80
Miss Prim	Schlegel	$100	59
Monkey Brand		$150	142
My Girl	Schwencke	$150	59
My Little Pet	Schumacher & Ettlinger, 1873	LOC	168
My Love		$150	148
My Pet	1869	LOC	22
Nanga Saki	Heppenheimer & Maurer	$200	169
Narrow Gauge	Neuman	$500	46
Nation's Pride	Johns	$150	86
Navy Pride	Schmidt	$400	83
New Bricks	Witsch & Schmitt	$150	39
New Cuba		$85	52
Nobby	Harris	$75	170
No Name	1870	LOC	25
Nonpareil	1870	LOC	25
Nudita	Schlegel	$200	131
Nugget	Johns	$400	109
Off Duty	Harris	$200	43
Old Fort	Heppenheimer & Maurer	$150	35
Old Specs		$100	44
Old Sports	Schwencke	$300	114
Old Staple	Krueger & Braun	$100	64
Olivette	Boyd	$150	169
On Time	Schwencke	$1,200	112
Our Candidates			68
Our Chief	Schlegel	$500	104
Our Cissy	American Litho. Co.	$100	133
Our Fire Department	Heppenheimer & Maurer	$1,000	112
Our Jack	Harris	$200	140
Our Latest	Schwencke	$500	95
Our M. C.	Heppenheimer & Maurer	$300	46
Our Nine	Heppenheimer & Maurer	$1,500	128
Our Own	Schwencke	$250	110
Our Parson	Heppenheimer & Maurer	$200	34
Our Patriots	1863	LOC	79
Our Platform	Schumacher & Ettlinger, 1883	$300	97
Our Pointer	Schwencke	$150	120
Our Pride	Schwencke	$125	87
Our Special	Schwencke	$250	150
Pacer	American Litho. Co.	$150	126
Pacific	Geo. Seeman, Kansas	LOC	91
Peaceful Henry		$25	153

Title	Lithographer	Price	Page
Pearl of Key West	Schmidt	$40	53
Pearl of the Orient	Major & Knapp, 1860s	LOC	18
Peeler	Schumacher & Ettlinger	$700	167
Piccolo	Schmidt	$30	167
Picnic	Heppenheimer & Maurer	$400	144
Pickwick	1868	LOC	18
Pledge of Honor	American Litho. Co.	$300	89
Plucky Admirals	Neuman	$400	82
Pocket Pieces	Schwencke	$150	66
Pocohontas	Heppenheimer's Sons	$400	106
Pond Lily	Heppenheimer & Maurer	$200	34
Poster	Heppenheimer & Maurer	$200	34
Prairie King		$500	101
Pride of Columbus		LOC	22
Pride of Liberty	Schumacher & Ettlinger	$200	90
Prime Choice	Witsch & Schmidt	$75	130
Prince Carnival		$200	46
Prize Solo	Witsch & Schmidt	$300	164
Prospector's Reward	Kruger & Braun	$1,000	109
Puffs	Johns	$150	45
Putnam Battalion	1867	LOC	11
Queen of the Ring	Neuman	$250	32
Queen of the Snow	Harris	$200	129
Quick Sales	Schumacher & Ettlinger	$150	163
Railroad	1864	LOC	91
Recognized	Heppenheimer & Maurer	$200	34
Red Bow	Witsch & Schmidt, 1891	$400	44
Red Buoy	American Litho. Co., 1903	$200	134
Red Cap		$60	131
Red Garter	Witsch & Schmidt	$400	136
Red Hawk	American Litho. Co.	$500	105
Red Hood		$75	130
Red Skin	Johns	$500	106
Reina Columbia	American Litho. Co.	$400	90
Reserves	Harris	$700	110
Road Queen	Schlegel	$500	96
Road Runners	Schmidt	$700	98
Robert E. Lee	Lipman & Hogan, 1865	LOC	80
Rod & Reel	Schwencke	$200	121
Roma	Heppenheimer & Maurer	$50	60
Rose & Pansy	Harris	$200	138
Rose Bride	Schmidt, 1898	$100	133
Rosebud	Schwencke	$150	138
Rotten But What's in a Name		$100	154
Roxy	Heffron & Phelps	$125	131
Royal Award	Schwencke	$100	151
Royal Harvest	American Litho. Co.	$300	110
Royal Punch		$500	41
Royal Ribbon	Schwencke	$250	79
Royal Trophy	Wagner	$100	57
Safety	Schumacher & Ettlinger	$500	96
Sailing	Harris	$300	46
Sampling	Johns	$200	167
Sans Souci	1868	LOC	16
Santiago	Schwencke	$300	52
Scotty Philip	American Litho. Co.	$150	100
Sea Beach	Heppenheimer & Maurer	$200	34
Shake	Schmidt	$150	73
She's a Daisy	Harris	$75	61
Shine Five Cents	Heppenheimer & Maurer	$200	166
Short Horn	Schumacher & Ettlinger	$100	102
Silver Belle	Wagner	$125	59
Signet	Donaldson & Elmes, 1868	LOC	15
Siren, The			68
Sky Writing Stogies		$20	157
Sly Puss	Schumacher & Ettlinger	$75	135
Smiles	Neuman	$200	41
Smiling Jim	1908	$200	153
Smoke?	Moehle	$150	152
Smoker's Pearl	Krueger & Braun, 1895	$200	148
Snap	Johns	$200	166
Snow Belle	Schwencke	$450	130
Snow Queen	Heppenheimer & Maurer	$150	132
Social Game	Schwencke	$1,000	122
Social Puffs	Schwencke	$200	149
Social Smoke	Schwencke	$300	149
Solace	Johns	$100	150
Solid Comfort	Schwencke	$300	148
Something Fine	Witsch & Schmidt	$200	37
Spanish Maid		$10	158
Spanish Puffs	Schwencke	$75	169
Spark	Schumacher & Ettlinger	$500	151
Special	Howell & Co.	$400	93
Special (train)	Heffron & Phelps	$200	91
Speckled Trout	Schmidt	$300	121
Spinaway	Schlegel	$400	95
Sport	Schwencke	$500	113
Sporty Girls	Schwenke	$150	170
Square Deal	Krueger & Braun	$300	166
Stag Party		$200	149
Standard, The	Brown & Page, 1868	LOC	19
Star Banner	American Litho. Co.	$200	86
Star Bunch	American Litho. Co.	$200	120
Star Club	1867	LOC	128
Star of the Evening	Strobridge	LOC	27
Star Play	Moehle	$1,500	128
Star Spangled Banner	Witsch & Schmitt	$500	89
Startwell	Schmidt	$200	167
State Flyer	Schmidt	$400	93
Stonewall Jackson	1866	LOC	80
Straight	Harris	$200	41
Sunshine		$75	130
Sure Pop	Johns	$700	103
Sweet Havanas	Schumacher & Ettlinger	$75	50
Sweet Idleness	Howell	$200	148
Take No Dust	Harris	$600	43
Take Your Pick	Harris	$150	64
Talisman	Schumacher & Ettlinger	$250	132
Tenderloin	Witsch & Schmidt	$300	61
Terrier, The		$300	146
Thanks!	Wagner	$200	172
Three Leaders, The	Harris	$300	81
Tioga Chief	Howell	$300	106
Tip Top	Howell	$50	134
Titipu	Heppenheimer & Maurer	$150	136
Tobogganing	Harris	$1,000	113
Tom Hale		$300	99
Tom Rush	Schmidt	$600	68
Tom's Trick	Harris	$200	31
Too Too	Johns	$200	146
Trail Finder	Schmidt & Co.	$300	107
Trans-Continental	Schumacher and Ettlinger, 1896	$150	102
Trolley	Schwencke	$1,000	97
Trout Spots		$300	**121**
Try 'Em	Mayer & Co., 1868	LOC	13
True Blue	Heppenheimer & Maurer	$300	36
Tuning Up	Kruger & Braun	$600	165
Twin Roses	Johns	$50	61
U. & I.	Harris	$400	144
Uncle Abner	Howell	$75	153
Union Glory	1897	$150	86
Up To Date	Schwencke	$500	98
Upper Deck	Schlegel	$200	43
U. S. A.	Heppenheimer & Maurer	$400	84
Vanoni	Johns	$50	133
Vaudeville	Strobridge Litho, 1871	LOC	25
Vega Rita	Moehle	$50	52
Velocipede	Schuneman Bros., 1869	LOC	94
Velocipedist	Monsch Bros., 1869	LOC	94
Veronica	Schumacher & Ettlinger	$100	133
Very Fine	Witsch & Schmidt	$250	145
Victor Dewey, The	Schmidt	$150	83
Vigorosa	Schumacher & Ettlinger	$60	31
Visitor	Heppenheimer & Maurer	$100	144
Volumo	Schmidt	$50	52
Volunteer		$200	82
Vuelta News	Schmidt, 1908	$75	48
War Hero		$150	82
We Are The People	Schlegel	$200	166
Welcome	1871	LOC	27
Wheel Queen	Neuman	$700	95
Whip	Johns	$100	45
White Fawn	1868	LOC	17
Wild Duck	Neuman	$100	119
Wild Oats	Heppenheimer & Maurer	$200	36
Winning Colors	Schwencke	$300	114
Wise Guy	Howell	$400	141
Xmas Bells	Schwencke	$75	161
Yacht Club	Schlegel	$300	118
Yawcob Strauss	Schlegel	$300	10
Yellow Cap	Johns	$75	132
Yes or No?		$100	143
Yessir		$300	85
Young America	1867	LOC	89
Young Blood	Heffron & Phelps	$150	153
Your Desire	Neuman	$100	131
Your Next		$600	110

Untitled

Title	Lithographer	Price	Page
Bowling Scene		$700	116
Duck Hunting		$100	119
Duck on Rise	Harris	$100	119
Star Spangled Banner	Harris	$200	90s